Paradoxes

Paradoxes

Their Roots, Range, and Resolution

NICHOLAS RESCHER

OPEN COURT
Chicago and La Salle, Illinois

To order books from Open Court, call toll free 1-800-815-2280

Open Court Publishing Company is a division of Carus Publishing Company.

Copyright © 2001 by Carus Publishing Company

First printing 2001

Printed and bound in the United States of America.

Library of Congress Cataloging-in-Publication Data

Rescher, Nicholas.
 Paradoxes : their roots, range, and resolution / Nicholas Rescher.
 p. cm.
 Includes bibliographical references and index.
 ISBN 0-8126-9436-8 (alk. paper) — ISBN 0-8126-9437-6 (pbk. : alk. paper)
 1. Paradox. I. Title.
 BC199.P2 R47 2001
 165—dc21 2001021224

For Rudolf Haller

Brief Contents

Detailed Contents

Preface

The principal aim of the book is to show that a wide variety of cognitive issues—not only the standardly recognized paradoxes but also counterfactual conditionals and various sorts of self-reference problems—can all be accommodated by common analytical means and have their perplexities resolved by use of the same machinery of inconsistency management. On this basis aporetics emerges as a versatile and fruitful instrumentality of issue clarification and problem solving.

More than a hundred and thirty major and minor paradoxes are analyzed in the course of the discussion—including virtually all of the best known instances of this phenomenon. Entire books can and have been written about many of these individual paradoxes, so it should be clear from the outset that none of them will be dealt with in their full and often complex detail. Our interest here is in the general theory of paradoxes—in those shared and common features in virtue of which a generic approach to paradox analysis can be articulated. On this basis, consideration of individual paradoxes will be merely illustrative. They will be treated not in their full and idiosyncratic detail but as case studies that exemplify significant aspects of a general theory of paradox analysis. So I must plead for understanding and forgiveness if the reader is disappointed to find his or her own favorite solution of a particular paradox overlooked. For the aim here is entirely *methodological*. It is the generic procedure of dealing with paradoxes that is at the forefront here, and particular paradoxes are treated merely as illustrations and not with a more specifically doctrinal end in view. The aim of the present discussion is to present a way of handling paradoxes in general.

The book aims to provide some significant innovations regarding the subject at large. These innovations specifically include:

- The standardization of paradox analysis through the machinery of general aporetics.
- The exploration of the distinction between truth and plausibility as an instrument of paradox analysis.

- The utilization of epistemic prioritization in paradox resolution and the exploration of the role of plausibility rankings in this regard.
- The specification of acceptance profiles for the comparative assessment of alternative resolutions of a paradox.
- Introduction of the idea of cycles of inconsistency into paradox analysis and implementation of the corresponding distinction between simple and complex paradoxes.
- Adoption of the Successful Identification Requirement (SIR) as an instrument of paradox resolution adequate to deal with the entire range of mathematical paradoxes.
- The use of the Viable Introduction Principle (SIP) as a simpler and more natural replacement for Russell's Vicious Circle Principle and its congeners in resolving semantical paradoxes.

All in all, the aim of the book is to show that paradox analysis is a more straightforward matter than is generally thought—and yet not just to maintain this in the abstract but to illustrate it in comprehensive and diversified detail.

I am grateful to several colleagues who have read the book in manuscript and have suggested corrections and improvements, in particular Carl Davulis, Peter Davison Galle, Alexander Pruss, and Neil Tennant.

Index of Paradoxes Discussed

Summary of Symbols, Technical Terms, and Principles

SYMBOLS

Standard logic symbols

- propositional logic: ~, &, v, →, ↔
- quantificational logic: ∃, ∀
- identity (or definition): =
- deductive entailment: ⊢
- inductive implication: ⇒

Priority ordering: >

Set-theoretic notation: $\{\}$, \in, $\{x: Fx\}$

Item identification: $(\iota x)Cx$
NOTE: $\{x: Fx\} = (\iota y)\forall x(x \in y \leftrightarrow Fx)$

TECHNICAL TERMS

aporetic cluster: a set of propositions that are individually plausible but collectively inconsistent. [NOTE: An aporetic cluster constitutes a paradox.]

MCS (maximal consistent subset): any consistent subset of an aporetic cluster that becomes inconsistent through the addition of any one of its other members.

inconsistent n-et: a group of *n* collectively inconsistent propositions that becomes consistent if *any one* of its members is omitted.

R/A-alternatives (retention/abandonment alternatives): any alternative for rendering an inconsistent set maximally consistent that is the result of retaining some of its members and omitting others. [NOTE: such an R/A-alternative can be presented in the format . . . /. . . , by indicating to the left of the slash the propositions that are retained and to its right those that are abandoned.

cycle of inconsistency: a minimally inconsistent subset of an inconsistent set of propositions. [NOTE: Any such cycle of inconsistency constitutes an inconsistent *n*-et.]

priority ordering: a specification of the retention-priority relations among the propositions of a set. For example the inconsistent quartet $\{p, q, r, s\}$ might have the priority order $[p, r] > s > q$ indicating that *p* and *r* have a like priority status, superior to that of *s* which in turn is superior to that of *q*.

retention profile (of an R/A alternative): a specification of the proportion of propositions in the successive priority categories whose retention that R/A-alternative permits. [Thus in the preceding example, of the R/A-alternative *p, q, r/s* would have the retention profile $\{1, 0, 1\}$ indicating that it provides for the retention of all of the priority-1 statements, none of the priority-2 statements, and all of the priority-3 statements.]

PRINCIPLES OF IDENTIFICATORY MEANINGFULNESS

VIR (Valid Identification Requirement): For something to be appropriately characterized by an identifactory specification of the format "the *x* that satisfies the condition *C*—(symbolically $(\imath x)Cx$—the existence of a unique item of this description

must be independently pre-established. Otherwise this supposed item remains undefined.

SIP (Successful Introduction Principle): For something to be successfully introduced into the discussion as: "the item x that satisfies the condition C," the identifying condition C at issue must not itself presuppose the existence of this item. A meaningful introduction cannot presume that the item being introduced has *already* been identified. (This goes back to the "*independently* pre-established" of VIR.)

VCP (Bertrand Russell's Vicious Circle Principle): No collection can contain members defined in terms of itself.

Paradoxes Considered in Chapter 1

- "Never Say Never"

- Sense-Deception Paradoxes

- Discrepant Information Paradoxes

- The Paradox of the Horns (Eubulides)

- The Truth Paradox

- The "Who is the Engineer?" Paradox

- The Deduction Paradox

- The Exception Paradox

- Paradoxes of Self-Contradiction

Aporetics

1.1 Apories and Paradoxes

Every era in the history of philosophy has seen a concern with paradoxes. To be sure, the pioneering Zeno of Elea (born ca. 500 B.C.) never called his paradoxes by that name, and even Aristotle often referred to them simply as "arguments" (*logoi*), though he denounced them as fallacies (paralogisms, *paralogismoi*). Another term used for such phenomena by Plato and Aristotle was "sophisms" (*sophismata*)—though it is doubtful that the Sophists themselves had employed it to characterize their arguments. These *apories* (*aporia*)—paradoxes by another name—concerned Aristotle in his *Sophistical Refutations* and the Stoics also devoted much interest to this subject—not to speak of the Sceptics to whose mill it brought much grist. The medieval schoolmen were also enthralled by it, and some of their principal thinkers wrote extensively on *insolubilia*, as they somewhat pessimistically characterized such puzzling modes of argumentation. Kant treated the cognate issues under the title *paralogisms* and *antinomies*. In the nineteenth century, however, the term "paradox" ultimately established itself as standard for the phenomena at issue. But even as a rose by any other name would smell as sweet, so it is that throughout this long history one and the same thing—paradoxical argumentation—has been at issue throughout. In this regard the same fundamental problems—and often the same standard examples—have preoccupied logically acute thinkers since the dawn of philosophy.

⊘ The word "paradox" derives from the Greek *para* (beyond) and *doxa* (belief): a paradox is literally a contention or group of contentions that is incredible—beyond belief. In the root sense of the term, paradoxes are thus a matter of far-fetched opinions,

curious ideas, outlandish occurrences and such-like anomalies in general that run counter to ordinary expectations.[1] The paradoxes discussed by the German polymath Max Nordau in his book of that title[2] are hardly more than eccentric opinions.

• One must distinguish between logical and rhetorical paradoxes. The former type is a communicative predicament—a conflict of what is asserted, accepted, or believed. The latter is a rhetorical trope—an anomalous juxtaposition of incongruous ideas for the sake of striking exposition or unexpected insight. That waking life is but a dream or that the painter immobilizes and renders lifeless the living subject he is trying to portray are paradoxes alright, but in the merely rhetorical mode. And much the same is true of Schopenhauer's thesis that suicide is the supreme expression of the will-to-live. People often say things like "Freud was no Freudian" or "That poem of his was no poem." Paradoxes of this rhetorical sort—"Nature imitates art"—are pieces of descriptive perversity, instances of what G.K. Chesterton called "Truth standing on her head to elicit attention."[3] This clearly holds for Shakespeare's "There's method in his madness" as well as such obiter dicta as G.B. Shaw's "The Golden Rule is that there is no Golden Rule" or Oscar Wilde's "I can resist everything except temptation," or Chesterton's own "Spies do not look like spies." As with Sam Goldwin's classic "Include me out," what we have here are duplicitous formulations that skate on the thin borderline between sense and nonsense.

Rhetorical paradoxes often pave the way to logical paradoxes. Consider a dictum like "A driver is just an automobile's means for transporting itself to another place." This picturesque version of the usual auto-driver relationship of means and ends runs afoul of our realization that automobiles are inert instrumentalities and drivers are purposive agents, so that it is the drivers who are bound to occupy "the driver's seat."

1. Augustus de Morgan's *A Budget of Paradoxes* (London: Longmans Green, 1872; 2nd ed. 1915) is replete with material of this sort, largely drawn from mathematics and natural science. Travel to the moon and shopkeepers who write books on Kant's philosophy are among the innumerable paradoxes proposed by the authors of intellectual curiosities cited by de Morgan.

2. Max Nordau, *Paradoxes* (Chicago: Laird and Less, 1886).

3. G.K. Chesterton, *The Paradoxes of Mr. Pond* (New York: Dodd Mead, 1937), p. 63. Chesterton went on to observe that "Most fellows who talk paradoxes are only trying to show off" (p. 95).

Not only are there extensive scholarly discussions *about* paradoxes, but there is also a literature that revels in paradoxes and unfolds episodes and narratives based on them. Belletristic writers such as Rabelais, Cervantes, and Sterne as well as G.K. Chesterton and J.L. Borges come to mind here. An excellent study by R.L. Colie examines the early phases of this literature which does, however, fall outside the focus of present concern.[4]

The metaphysical poet George Herbert in his devotional poem "Providence" wrote: "Thou art in all things one, in each thing many/For thou art to infinite in one and all" (Lines 43–44). Christian discourse is full of such rhetorical paradoxes. Thus Sebastian Franck (1499–1542) published in 1534 his book *Paradoxa*, a collection of 280 "paradoxes" culled from biblical texts.[5] These include such dicta as "Victory is with the vanquished" (*Triumphos penes victos*) and "God is never nearer than when far away" (*Non est proprior quam procul absens deus*) and "Faith believes in unbelief" (*Fides in incredulitate credit*). But Christian discourse has its logical paradoxes as well. St. Paul explained to the Athenians that he came to make known to them an unknown and unknowable God. And at the religion's center lies the great Christian paradox that death is the gateway to eternal life. However it is not with the preachers but with the theologians that we generally encounter actually communicative paradoxes, the doctrine of the Trinity being a classic case in point. It was with a view to issues of this sort that the theologian Tertullian was led to his notorious dictum: *credo quia absurdum* ("I believe because it is absurd").

The technical literature of logic, mathematics, and philosophy is also rife with discussions of various types of paradoxes. But these are generally dealt with as so many individual and isolated episodes, each requiring its own characteristic mode of approach. There has been no attempt at an uniform, across-the-board approach to the subject of paradoxes and their resolution. By contrast, the present discussion sees paradox as a generically uniform

4. Rabelais, *Gargantua and Pentagrual*; Cervantes, *Don Quixote*; Laurence Sterne, *Tristram Shandy*; G.K. Chesterton, *The Paradoxes of Mr. Pond*; and Jorge Luis Borges, *Labyrinths*, are prime examples of paradox-oriented literature. See also Rosalie L. Colie, *Paradoxia Epidemica* (Princeton: Princeton University Press, 1966).

5. Sebastian Franck, *280 Paradoxes or Wondrous Sayings*. Translated by E.J. Furcha (Lewistown, NY: Edward Mellen Press, 1986).

phenomenon that calls for a uniform treatment. It sets out to
sketch a discipline (*aporetics* one may call it) concerned specifi-
cally with the general issues that arise with paradox resolution
across-the-board.

In the common usage of everyday discourse a paradox is a
judgment or opinion that is contrary to the general opinion or
"common sense."[6] A *paradox* on this basis would be an obviously
anomalous contention that someone seriously propounds despite
its conflict with what is generally regarded as true. Cicero thus
sensibly observed that "what they, the Greeks, call *paradoxes*, are
what we Romans call *marvels*."[7]

Among philosophers and logicians, however, the term has
come to acquire a more specific sense, with a paradox arising
when plausible premises entail a conclusion whose negation is
also plausible. We thus have a paradox when a set of individually
plausible theses $\{P_1, \ldots, P_n\}$ validly entails a conclusion C whose
negation non-C is itself plausible. And this means that the set $\{P_1,
P_2, \ldots P_n, \text{non-}C\}$ is such that all of its members are individually
plausible while nevertheless logically inconsistent overall.
Accordingly, a variant but equivalent way of defining the term is
by specifying that *a paradox arises when a set of individually plau-
sible propositions is collectively inconsistent*.[8] And the inconsistency
at issue here must be real rather than merely seeming. Paradox is
the product not of a mistake in *reasoning* but of a defect of sub-

6. It is ironic that one of the first uses of the word in English recorded in the Oxford
English Dictionary is for the 1616 definition of Bullokar's *Chapbook*, which reads as fol-
lows: "Paradox, an opinion maintained contrary to the commonly allowed opinion, as if
one affirme that the earth doth move round and the heavens stand still."

7. Hae *paradoxa* illi, *admirabilia* dicamus, and again, admirabilia contraque opin-
ionem ommium; *Paradoxa*, Prooem, 4. (*Scripta quae manserunt omnia*, IV/III, ed.
C.F.W. Mueller (Leipzig: Teubner, 1878), p. 198. See also *Academicorum priorum*, II
44, §136 [ibid IV.I, p. 81].

8. An edition of Webster's dictionary defines *paradox* (in the logical sense) as "an
argument that apparently derives a self-contradictory statement by valid deduction from
acceptable premises"(a definition that would be closer to the mark if that "apparently"
were shifted from qualifying *derives* to qualifying *acceptable premises*. *Webster's Ninth New
Collegiate Dictionary* (Springfield, MA: Merriam-Webster, 1983), p. 853. The present
definition differs from this specification in two main respects: (1) It speaks of *plausible*
propositions or premises instead of "acceptable" ones, the reason for this being that
"acceptability" is a matter of yes-or-no—a thesis is either apparently acceptable or not—
while plausibility is clearly a matter of degree since a thesis can be more or less plausible;
(2) The present definition would substitute "derives" for "*apparently* derives." With fal-
lacies we have apparent rather than real derivation, but the reasoning of a genuine *para-
dox* must be cogent.

stance: a dissonance of endorsements. A variant way of looking at a paradox is therefore as a conflict-engendering *argument*, a piece of deductive reasoning to a contradictory result. The several theses that compose the paradox are its *premisses*, and its *conclusion* is uniformly a statement of the format: "Premiss X is incompatible with Premiss Y." For already Aristotle characterized as "dialectical" arguments those which create a paradox by deriving a contradiction from generally accepted opinions.[9] The expression *antinomy* is also used to characterize the assertions giving rise to such anomalous situations.

When claims involve a conflict or tension that stops short of actual logical conflict—of strict inconsistency—this is generally indicative of irony rather than paradox. It is ironic (rather than paradoxical) that the competent general must both protect his soldiery and endanger them by use, and that he cannot do the one without foregoing the other. It is ironic (rather than paradoxical) that the individual soldier cannot pursue glory without putting his life at risk.

Moreover, what Communist theoreticians called a "contradiction"—that is, a conflict or tension between discordant factors or opposing forces, a phenomenon they thought to find in capitalism—is not the sort of "inconsistency" at issue with actual paradoxes. Mere tensions as such do not engender paradox. If the lesson of Bernard de Mandeville's "Fable of the Bees" is correct, it will be ironic (rather than actually paradoxical) that the conditions needed for a society to flourish economically demand a comparatively low level of such traditional economic virtues as frugality, prudence, and frivolity-avoidance.

Paradoxes thus arise when we have a plurality of theses, each individually plausible in the circumstances, but nevertheless in the aggregate constituting an inconsistent group. In this way, logical paradoxes always constituted aporetic situations, an *apory* being a group of acceptable-seeming propositions that are collectively inconsistent. Viewed separately, every member of such a group stakes a claim that we would be minded to accept if such acceptance were unproblematic. But when all these claims are conjoined, a logical contradiction ensues.

9. *Soph. Elen.*, 165b1–5.

Sensory illusion paradoxes, for example, occur in situations in which we cannot even "trust our own eyes," so to speak, as in the well-known case of the straight stick that looks bent when held at
✓ an angle under water. Sight tells us it is bent; touch insists that it is straight. Or again consider the situation of looking at a landscape over a fire or a hot radiator. The trees and buildings vibrate and shake, while nevertheless "we know perfectly well" that they are immobile. Here we confront a *Sense-Deception Paradox* where one sense affirms what the others deny. In all such cases we have to make up our minds about how to resolve the inconsistency.

Since logical paradox arises through the collective inconsistency of individually plausible propositions, it is clear that the individual premisses of a paradox must be self-consistent ✓ (Otherwise they could hardly qualify as plausible.) And this means that those self-inconsistent propositions that are commonly characterized as paradoxical, have to be viewed in a larger context before actual logical paradox ensues. ✓

Thus consider the proposition

(N) It is never correct to claim that something is never the case. ("Never say never!")

To make manifest that an actual (logical) paradox is at issue here we can elaborate the situation as follows:

(1) *N* makes tenable claims.

(2) *N* is a statement of the "it is never the case" format.

(3) If *N* is correct, then every statement of the "it is never the case" format is false.

(4) *N* entails its own falsehood. By (2), (3).

(5) *N* does not make a tenable claim. By (4), since no claim that entails its own falsehood is tenable.

(6) (5) contradicts (1).

It is this expanded account which elaborates the contradiction to which *N* gives rise, rather than simply *N* itself, that represents the paradox at issue.

1.2 Paradoxes Root in Overcommitment

Since paradoxes arise through a clash or conflict among our commitments, they are the product of cognitive overcommitment. We regard more as plausible than the realm of fact and reality is able to accommodate, as is attested by our falling into contradiction. Paradox thus roots in an information overload, a literal embarrassment of riches.

In theory, three sorts of cases can arise, according as the data at our disposal provide enough, too little, or too much information to underwrite a conclusion. The general situation at issue here can be seen in the following example of three pairs of equations in two unknowns, which poses the problem of determining the values of the parameters x and y:

Case I (Too Little)	Case II (Enough)	Case III (Too Much)
$x + y = 2$	$x + y = 3$	$x + y = 4$
$3x + 3y = 6$	$x - y = 3$	$2x + 2y = 5$

In the first case there is too little information to make a determination possible, in the second case just enough, and in the third too much. For the information overload of case III creates an inconsistent situation. This inherent conflict of the claims at issue renders them collectively inconsistent and thereby paradoxical.

The prime directive of rationality is to restore consistency ✓in such situations. To be sure, it is a *possible* reaction to paradox simply to take contradictions in our stride. With Pascal we might accept contradictions for the sake of greater interests, and say that "à la fin de chacque vérité, il faut ajouter qu'on se souvient de la verité opposée" ("after every truth one must be mindful of the opposite truth.")[10] The Greek philosopher Protagoras (born ca. 480 B.C.), the founding father of the Sophistic school,[11]

10. Blaise Pascal, *Penseés,* No. 791; Modern Library edition No. 566, p. 185. Recall the dictum that "consistency is the hobgoblin of small minds."
11. For *Protagoras* see Zeller, *Philosophie der Griechen*, Vol. I/2, pp. 1296–1304. See also Plato's dialogues *Protagoras* and *The Sophist.*

notoriously held that the human situation was in this way para-
doxical throughout, and that *anything and everything* that we
believed could be argued for *pro* and *con* with equal cogency. And
he was perfectly prepared to accept the deeper paradoxical conse-
quence that this holds also for the very thesis at issue.[12] But this
sort of resignation in the face of inconsistency is hardly a comfort-
able—let alone a rational—posture. Even if one's sympathies were
so inordinately wide, inconsistency tolerance should be viewed as
a position of last resort, to be adopted only after all else has failed
us.[13]

Yet once consistency is lost, how is it to be regained? Any and
every paradox can be resolved by simply abandoning some or all
of the commitments whose conjoining creates a contradiction. In
principle, paradox management is thus a straightforward process:
to appraise the comparative plausibility of what we accept and
restore consistency by making what is less plausible give way to
what is more so. It is this generic and uniform structure of para-
dox management that makes a generic and uniform approach to
their rational management possible, paving the way to that single
overarching discipline of *aporetics* (to avoid using the somewhat
barbarous "paradoxology").[14] The exploration of this domain is
the principal task of the present book whose central thesis is that
there indeed is such a general and uniform approach to the ratio-
nal management of paradoxes.

Consider an example. Let it be supposed that three (reason-
ably reliable) sources report on a sighting of birds flying by. The
first says there were around three of them; the second says there
were around five; the third says that there was "a small flock" and
that it was odd in number. Now suppose further that it is impor-
tant for us to have a definite estimate. What is it to be?

12. "*Protagoras ait, de omnis re in utrumque partem disputari posse ex aequo, et de hac
ipsa, an ominis res in utrumque partem disputabilis sit.*" Seneca, *Epistola moralia*, XIV, 88,
43.
13. Compare N. Rescher and Robert Brandom, *The Logic of Inconsistency* (Oxford:
Blackwell, 1979).
14. The terminology is adapted from the Greek *aporetikê technê*, the "aporetic art" of
articulating, analyzing, and resolving *aporia* or paradoxes. The conception of such an
enterprise as central to philosophy figured prominently in the work of the German philoso-
pher Nicolai Hartmann (1882–1950). See his *Grundzüge einer Metaphysik der Erkenntnis*
(Berlin: de Gruyter, 1921; 5th ed. 1965).

✓ The situation is aporetic. We have three contentions:

(1) There were around three birds (that is, 2, 3, or 4).

(2) There were around five birds (that is, 4, 5, or 6).

(3) The number of birds was smallish but odd (that is, 3, 5, or 7).

We clearly cannot accept all of these claims since there is no number common to them all. Though each has a basis of evidential support, they are collectively incompatible. Any two of them yield a conclusion that is destabilized by the other. With such *Discrepant Information Paradoxes*, as with all paradoxes, we have a situation of cognitive dissonance.

In confronting an aporetic inconsistency we have no sensible alternative but to jettison something, to abandon or at least modify one or another of the theses involved in the collision. At this point there is a decisive difference between theoretical and practical contexts. In practical contexts there is a possibility of compromise—of effecting a division that enables us in some way and to some extent "to have it both ways", say to proceed *A*-wise on even days and *B*-wise on odd ones. But we cannot rationally do this with beliefs. In theoretical contexts we must choose—must resolve the issue one way or another.[15]

However, logic alone will not help us to choose how a conflict of inconsistency should be resolved. It does no more than tell us that we must forego one of the claims, but affords no hint as to which one. The best we can manage here is to accept two of our three conflicting theses, viz., either (1) and (3) with the resulting estimate of 3, or (2) and (3) with the resulting estimate of 5, or (1) and (2) with the resulting estimate of 4. Which route shall we choose? Here we are simply at sea—unless and until we have some further guidance. For note that the moment we learn that one of our sources is less accurate or reliable than the others a definite resolution is at our disposal. ✓

15. For a fuller treatment of this issue see the author's "Ueber einen zentralen Unterschied zwischen Theorie und Praxis." *Deutsche Zeitschrift fuer Philosophie*, vol. 47 (1999), pp. 171–182.

Greek philosophers of a whimsical tendency were drawn to sophisms (*sophismata*) along the lines of *The Paradox of the Horns* (*keratinês*) discussed by the Megarian philosopher Eubulides of Miletus.[16] It was based on the reasoning:

(1) You have no horns.

(2) If you have not lost something, you still have it.

(3) You have not lost any horns.

(4) Therefore: you (still) have horns. (From (2) and (3).)

(5) (4) contradicts (1).

Here theses (1), (2), and (3) are all supposed to be factual truths. However, (2) of course obtains only under the proviso that the thing in question is something you have had in the first place. Seeing that this paradox rests on a presupposition which, as it stands, is simply false, it is readily resolved.[17]

Again the following *Truth Paradox* affords an instructive example:

(1) Truth is a property of sentences and only of sentences.

(2) Sentences are elements of human language.

(3) Human language cannot exist without humans.

(4) Truth cannot exist without humans.

Some philosophers are beguiled by this line of thought into accepting an anthropocentrism of truth: accepting (1)–(3) they

16. For Eubulides see pp. 102–04 below. Diogenes Laertius, *Lives of Eminent Philosophers*, II, 111 and IV, 39, reports that some think that this sophism is a joke aimed at the cuckold. It was also attributed to Chrysippus.

17. On the various ancient discussions of *The Paradox of the Horns* see Prantl, *Geschichte*, Vol. I, p. 53. The paradox is almost as bizarre as the sophistical *Dog Paradox* that turns on the reasoning:

"That dog is your dog. That dog is a father. Therefore: That dog is your father."

This paradox preoccupied the Megarian paradox-theorists and also the Sophists (see Plato, *Euthydemus*, 299E). (Some elaborated the sophism by adding: "You beat that dog. Therefore: You beat your father.") Another variant of such a paradox was discussed by the Stoics: "He is a bad person; he is a butcher; therefore, he is a bad butcher." (See Prantl, *Geschichte*, Vol. I, p. 492.)

insist that (4) must be abandoned. But there are big problems here. For the reasoning at issue fails to heed the distinction between sentences and statements or abstract propositions (the information that sentences purport). Actually, it is false to say, as per (1), that truth appertains to *sentences* only: it is also a feature of *statements*. And if we substitute "statements" for "sentences" in the argument then (2) fails. For while human-language sentences can express statements, the facts at issue with potentially true statements can—at least in theory—outrun the limits of human language. ✔

As such philosophical paradoxes indicate, the inconsistency at issue need not be obvious, but may well lie hidden from casual perusal. The puzzle of "Who is the engineer?" yields a vivid example of a nonphilosophical paradox of this sort. It envisages a series of reports providing the following background information:

On a train operated by three men, Jones, Smith, and Robinson, as engineer, brakeman, and fireman (but not necessarily respectively), are three passengers: Mr. Jones, Mr. Smith, and Mr. Robinson. The following information is given:

$$\frac{7\text{-}1}{7\text{-}1} = 1 = Mcs$$

(a) Mr. Robinson lives in Detroit.

(b) Mr. Jones receives a salary of $40,000 a year.

(c) Smith beat the fireman at billiards.

(d) The passenger whose name is the same as the brakeman lives in Chicago.

(e) The brakeman lives halfway between Chicago and Detroit.

(f) The brakeman's nearest neighbor, one of the passengers, earns a salary exactly three time as large as the brakeman's.

(g) Smith beat the engineer at tennis.

Here these (a)–(f) make it possible to identify the engineer. This can be shown as follows when we use *R, J, S* to abbreviate the names of the individuals at issue and *f, b, e* to indicate the fireman, brakeman, and engineer, respectively:

FACT	REASON
(1) $S \neq f$	(c)
(2) R is not b's next-door neighbor	(a), (e)
(3) J is not b's next-door neighbor	(b), (f)
(4) S is b's next-door neighbor	(2), (3), (f)
(5) S doesn't live in Chicago	(e), (4)
(6) R doesn't live in Chicago	(a)
(7) J *does* live in Chicago	(5), (6), (d)
(8) $J = b$	(7), (d)
(9) $J \neq f$	(8)
(10) $R = f$	(1), (9)
(11) $S = e$	(8), (10)

Smith is the engineer! But of course when (g) is added with its message that $S \neq e$, a contradiction at once results. The information overload that compromises the (g)-augmented puzzle of "Who is the engineer?" creates an aporetic situation that results in paradox. This fact, however, is well concealed in the fog of complexity that pervades this puzzle's information base.

Consider the statement "All of my statements made on [such-and-such a date] are false." This is in principle altogether unproblematic. Indeed if the date is one on which the only thing I said was "2 + 2 = 5" then the statements at issue is both perfectly meaningful and flat-out true. However, if the date at issue is the one on which I made that very statement, then paradox is the clear result. Thus paradox may well be a matter not only of what a statement *says* but also of the contingent circumstances in which it is made.

Take another example, that of the *Deduction Paradox* which takes the following dilemmatic form:

(1) If a proposed deductive argument is valid, then the conclusion can contain no information that is not inferentially contained in the premisses.

(2) This circumstance means that a deductively valid argument is essentially uninformative—it adds nothing new over and above what is already in hand.

(3) If a proposed deductive argument is invalid, then it is useless. A viable conclusion cannot be based upon it.

(4) A deductive argument is thus either uninformative (as per (2)) or pointless (as per (3)). In either case, it can accomplish no informatively useful work.

That premiss (2) is untenable here is vividly illustrated by the "Who is the Engineer?" Problem. Clearly a distinction must be drawn. Implicit information containment as per premiss (1) is one sort of thing, and cognitively discernible informativeness is something very different, seeing that finite intelligences are not deductively omnipotent.

Paradoxes all arise in one and the same generic way, namely, through aporetic overcommitment. In each case we have a situation in which we are minded to accept as plausible more than the limits of consistency can manage to contain. We can, accordingly, approach paradoxes from the angle of the preceding consideration regarding aporetic analysis subject to the idea that addressing a paradox is a matter of breaking the chain of inconsistency that it involves by seeking out the weakest links of this chain.

1.3 Plausibility

It should be stressed from the very start that the acceptance or assertion of claims and contentions is not something that is uniform and monolithic but rather something that can take markedly different types or forms. For we can "accept" a thesis as necessary and certain on logico-conceptual grounds ("Forks have tynes"), or as unquestionably true, although only contingently so ("The Louvre Museum is in Paris"), or in a much more tentative and hesitant frame of mind as merely plausible or presumably true ("Dinosaurs became extinct owing to the earth's cooling when the sun was blocked by cometary debris").

When a proposition is so guardedly endorsed we do not have it that, à la Tarski, asserting p is tantamount to claiming that "p is

true." What is at issue with the guided endorsement of a claim *p* as plausible is simply the contention that "*p* is *presumably* true." And what this means is that we will endorse and employ *p* insofar as we can do so without encountering problems but are prepared to abandon it should problems arise. In effect we are not dedicated partisans of such a claim but merely its fair-weather friends. We see such a claim as meriting provisional endorsement "under the circumstances." With assertion or acceptance in this third, tentative or provisional mode, what is maintained is to be seen as a matter not of actual truth but of mere plausibility—a contention that we would accept as true "if we would get away with it," that is, if taking this step did not issue in anomalous (that is, unacceptable) consequences. In sum, the claim is made provisionally, subject to the caveat that its retraction may become necessary.

A proposition can be plausible and yet actually false. Consider an example. During the American Civil War there were a few instances in which women managed to disguise themselves as men and serve as soldiers in the Union Army. This makes the thesis "Those who served in the Union army were male" strictly speaking false. Yet while a generalization that fails (only) in extraordinary or anomalous cases may be literally false, this does not annihilate its status as plausible. However, it is a plausible *thesis* and not a plausible *truth.* Strictly speaking it should be characterized as a *plausible falsehood*—but just that is exactly the point at issue: a proposition can be plausible and yet actually false.

Plausible propositions play a very special role in the cognitive scheme of things. We feel free to make use of them as premises when working out answers to our questions. But their use in the setting of particular question-resolving contexts is not predicated on an outright and unqualified commitment to these propositions as true. For we know full well that we cannot accept all those plausibilities as truths since this can and generally would lead us into contradiction.

Plausibilities are accordingly something of a practical epistemic device. We use them where this can render effective service. But we are careful to refrain from committing ourselves to them unqualifiedly and come-what-may. And we would, in particular, refrain from using them where this leads to contradiction. In sum,

our commitment to them is not absolute but situational: whether or not we endorse them will depend on the context. To reemphasize: the "acceptance" that is at issue here represents no more than a merely tentative or provisional endorsement. -

The shift from assertion-as-true to assertion-as-plausible offers us a degree of flexibility with the claims that we make. Thus consider the _Exception Paradox_ which centers on the contention that "All generalizations have exceptions." This leads to the following paradox:

(1) All generalizations have exceptions. (By hypothesis.)

(2) (1) is true. By (1).)

(3) (1) is a generalization. (From (1) by inspection.)

(4) (1) has exceptions. (From (1), (3).)

(5) Any generalization that admits of exceptions is false. (As a principle of logic.)

(6) (1) is false (From (3), (4), (5).)

(7) (6) contradicts (2).

Note, however, that this paradox is immediately dissolved when the thesis at issue in (1) is asserted not as true but merely as plausible. For then the inferential step from (1) to (2), which is essential to deriving the contradiction, is automatically invalidated. ✦

1.4. Plausibility and Presumption

Unfortunately, life being what it is, we cannot always get away with accepting the plausible outright because actual truth is something more selective and demanding than mere plausibility, seeing that plausibilities—unlike truths—can conflict both with truths and with one another. Distributively true statements are of course collectively true: we have $[T(p) \ \& \ T(q)] \rightarrow T(p \ \& \ q)$. But this is emphatically not the case with plausible let alone with merely probable state-

ments. For plausible (and probable) statements can actually come
into conflict with one another, and thereby impel us into paradox.✓

Plausibilities are thus one thing and truths another. We
"accept" plausible statements only tentatively and provisionally,
⌄subject to their proving unproblematic in our deliberations. Of
course, problems do often arise. X says 25 people were present, Y
says 15. Sight tells us that the stick held at an angle under water is
bent, touch tells us that it is straight. The hand held in cold water
indicates that the tepid liquid is warm but held in hot water indi-
cates that it is cold. In such cases we cannot have it both ways.
Where our sources of information conflict—where they point to
aporetic and paradoxical conclusions—we can no longer accept
their deliverances at face value, but must somehow intervene to
✓straighten things out. And here plausibility has to be our guide,
subject to the idea that the most plausible prospect has a favorable
presumption on its side.

Plausibility is in principle a comparative matter of more or less.
Here it is not a question of yes or no, of definitive acceptability,
but one of a cooperative assessment of differentially eligible alter-
natives of comparative advantages and disadvantages. We are
attached to the claims that we regard as plausible, but this attach-
ment will vary in strength in line with the epistemic circum-
stances. And this fact has significant ramifications. For the idea of
plausibility functions in such a way that *presumption always favors
the most plausible of rival alternatives.*

The concept of presumption at issue here is effectively the
same as the traditional legal idea, accurately explained already in
the eighteenth-century textbook of Archbishop Whately as
follows:

> According to the most current use of the term, a "presumption"
> in favour of any supposition means, not (as has been sometimes
> erroneously imagined) a preponderance of probability in its
> favour, but such a preoccupation of the ground as implies that it
> must stand good till some sufficient reason is adduced against it;
> in short, that the *burden of proof* lies on the side of him who
> would dispute it.[18]

18. Roberts Whately, *Elements of Rhetoric* (Urban, 1963; first edition 1846), Pt. I, ch.
III, sect. 2.

It is in just this sense that in Anglo-American law a "presumption of innocence" operates in favor of the accused. The "burden of proof" is carried on the other side, and the presumption stands until it is overthrown by stronger countervailing considerations. In virtually all probative contexts there is, for example, a standing presumption in favor of the normal, usual, customary course of things.

Against the claims of the senses or of memory automatically to afford us the truth pure and simple one can deploy all of the traditional arguments of the sceptics, and take as guide the dictum of Descartes: "All that up to the present time I have accepted as most true and certain I have learned either from the senses or through the senses but it is sometimes proved to me that these senses are deceptive, and it is wiser not to trust entirely to any thing by which we have once been deceived."[19] But of course, such arguments in support of the vulnerability of sensory data serve only to re-emphasize their role as promising truth-candidates in the sense of presumptions rather than outright *truths* as such. A presumption, after all, is to be given *some* credit, even if not a totally unqualified endorsement. Its epistemic standing is not rock-solid, to be sure, but it is enough to call for a sufficient effort for its dislodging. Our commitment to a presumption may not be absolute, but it is nevertheless a commitment all the same.[20]

The plausibility tropism inherent in the principle of a presumption in favor of the most plausible alternative is an instrument of epistemic prudence. It amounts to the sort of safety-first approach that is known in decision theory and the theory of practical reasoning as a *minimax potential-loss strategy*. The guiding idea of such a strategy is to opt in choice-situations for that alternative which minimizes the greatest loss that could possibly ensue.[21]

19. René Descartes, *Meditations on First Philosophy*, No. I, translated by R.M. Eaton.

20. Israel Scheffer makes a similar point in the temporal context of a change of mind in the light of new information: "That a sentence may be given up at a later time does not mean that its present claim upon us may be blithely disregarded. The idea that once a statement is acknowledged as theoretically revisable, it can carry no cognitive weight at all, is no more plausible that the suggestion that a man loses his vote as soon as it is seen that the rules make it possible for him to be outvoted." *Science and Subjectivity* (New York, 1967), p. 118.

21. For the relevant issues at the level of decision theory in general see R.D. Luce and H. Raiffa, *Games and Decisions* (New York: Wiley, 1957).

(The strategy is obviously different from an expected-value approach.) The presumption of veracity is fundamental to the way in which we draw cognitive benefit from our sources of information—human and instrumental alike, our own sensory instrumentalities included. Once we recognize and acknowledge an informative source as such we stand prepared to take its declarations at face value until such time as problems come to view.

1.5. The Acceptability of Contentions

In practical matters we can afford to be flexible and tolerant because the possibility of compromise is in prospect.[22] But matters of truth are something else again; they are hard-edged and inflexible (at any rate in all ordinary cases and situations). As far as *knowledge* is concerned, falsehoods must be consigned to the trash-heap: it no longer makes a useful contribution to our knowledge as such. But as far as *practice* is concerned, the matter is otherwise.✓

Nevertheless, presumption provides us with the prospect of a kind of epistemic compromise. If it transpires that only *almost* all *A*'s are *B*'s, then it is clearly incorrect to claim "All *A*'s are *B*'s." However, in operating with this statement in practice we will (ex hypothesi) almost never encounter problems. Or again, if the *A*'s and the *B*'s are alike in those respects in which we generally deal with them, it makes little difference how different they may be in other respects. If we are cooks or dieticians rather than botanists then we can implement the (false) idea that "Tomatoes are vegetables, not fruits" and almost never run into trouble. No doubt the real and full truth is preferable, but life being what it is, there will be times when it makes sense to let the merely plausible do ✓ duty in its place.

Recognizing that this sort of thing can happen with statements that are merely false, it is worthy of note that this situation can even obtain with statements that are literally self-contradictory.

22. The case for this contention is set out in detail in the author's paper "Ueber einen zentralen Unterschied zwischen Theorie und Praxis," *Deutsche Zeitschrift fuer Philosophie*, vol. 47 (1999), pp. 171–182.

Even such paradoxical theses can have their cognitive use. Consider, for example, the following array of self-contradictory statements:

- Universal claims are never true.

- The unqualified contentions are exaggerations.

- Never-maintaining statements are never correct.

- Predictions are always off the mark.

- General rules always have exceptions.

Construed literally, purely as cognitive *theses*, such statements are self-defeating and thus seemingly absurd. But the situation is different if we look on the matter from the angle of *practice*. For from this angle we can view the issue as one of *practical* ("proceed as though") *epistemic policy*:

- Never to make universal claims.

- Never to make unqualified contentions.

- Never to make never-claims.

- Never to make unqualified predictions.

- Never to lay down altogether unqualified rules.

- Never to make dogmatic claims to knowledge.

Such practical policies of cognitive procedure are certainly not absurd. They may be of questionable logic but they are not without a certain practical wisdom. For the self-defeating nature of such recommendations does not preclude the prospect of their being constructively procedure-underwriting at the level of operative policies. And it is through this fact that they are able to make good a claim to be acknowledged as plausible.

But of course we are skating on thin ice here and must be careful. Thus the medieval philosopher John Buridan discussed

the anomaly posed by the statement: "Every proposition is affirmative."[23] Though false, this self-instantiating claim seems otherwise harmless. But it nevertheless has the logical consequence "No proposition is negative." And *this* statement is not only false but absurd, seeing that it itself provides a counter-instance to its ✓ own assertion.

23. See G.E. Hughes, *John Buridan on Self-Reference* (Cambridge: Cambridge University Press, 1982), p. 34.

Paradoxes Considered in Chapter 2

- The Smashed Vase Paradox

- Mill's Happiness Paradox

- The Paradox of Evil

- The Socratic Ignorance Paradox

- Dilemmatic Paradoxes

- Conflicting Report Paradoxes

- Compound Paradoxes

Paradox Solution via
Retention Prioritization

2.1 Addressing Paradox Resolution via
Priority Ratings

Since a paradox is generated by an inconsistent set of propositions, it is useful to begin with a brief review of some relevant logical ideas regarding such inconsistent sets.

Every set of individually consistent but collectively incompatible propositions engenders a family of *maximal consistent subsets* (MCS's). These are those consistent subsets that are rendered inconsistent by the addition of any of the omitted propositions.

Further every set of individually consistent but collectively inconsistent propositions also engenders a family of *minimal inconsistent subsets* (MIS's). There are those inconsistent subsets that are rendered consistent by the deletion of any one of their members. These minimal inconsistent subsets constitute the "cycles of inconsistency" that afflict an inconsistent set of propositions.[1] A set will be more (or less) extensively inconsistent when it has more (or fewer) cycles of inconsistency. Thus an inconsistent set is maximally inconsistent if *every single pair of its members is inconsistent*. It will then have as many mcs's as it has members, because all but only its individual members constitute MCS's.[2]

1. Most of the paradoxes discussed in the extensive literature of the subject involve only a single cycle of inconsistency and accordingly have as low an index of inconsistency as is possible for an inconsistent set of the size at issue.

2. On this basis, the comparative extent to which a set is inconsistent can be measured by the ratio $(k - 1) \div (n - 1)$, where k is the number of MCS's and n the number of set-members. This inconsistency index of a set can range from 0 in the case of a consistent set to 1 in the case of a maximally inconsistent set of individually consistent propositions.

⟳ An inconsistent *n*-et (quartet, quintet, etc.) is a set of *n* collectively inconsistent propositions that is minimally inconsistent in that the deletion of any one of which will restore overall consistency, so that every *n*-1 sized subset of such a set is a maximal consistent subset (MCS). Thus consider the situation where both {(1), (2), (3)} and {(2), (3), (4)} are inconsistent triads, and we now take into view the set {(1), (2), (3), (4)}. Owing to the overlaps involved this is not an inconsistent quartet, since instead of having the requisite four MCS's (one for each available proposition) it has only three: {(1), (2), (4)}, {(1), (3), (4)}, and {(2), (3)}.

It is a readily demonstrable fact of logic that any inconsistent set of propositions can be decomposed into (potentially overlapping) subset-components each of which is an inconsistent *n*-et. ⁀ Accordingly, an inconsistent set has as many "cycles of inconsistency" (as we have called them) as there are inconsistent *n*-ets to this decomposition.

Paradox solution is in general a matter of bringing consistency to an inconsistent set of propositions. On this basis, there is a generic, across-the-board methodology for analyzing paradoxes of all kinds. For apory resolution becomes an exercise in epistemic damage control: confronting an inconsistent cluster we have to restore a cognitively viable situation. And the object is to achieve this at minimal cost—with the least possible sacrifice among the theses towards which we were, in the first instance, favorably inclined. Yet given the conflict among the propositions involved in an aporetic situation, it is clear that they cannot all be true. (The truth, after all, must constitute a consistent whole.) And so when confronted with an aporetic situation there is really only one way out: some of the theses that engender the conflict must be abandoned—if only by way of restriction or qualification. We have here overextended ourselves by accepting too much—more than a due heed for consistency can possibly support. And this means that one and the same recourse—the abandonment of some of the propositions involved on the basis of their absolute or comparative untenability—can resolve the problem. It also means that paradox resolution never comes cost-free: there is always something that we must give up for the sake of recovering consistency.

Logic can tell us that our modes of reasoning are valid—that when applied to truths they must lead to truths. But it does not—

cannot—tell us that when applied to plausibilities, valid arguments cannot yield implausible (or even self-contradictory) conclusions. (After all, a conjunction is often less plausible than its conjuncts.) Logic thus provides no insurance against paradox. And the reason is simple. Inconsistency requires a choice among alternatives for premiss abandonment. But logic is value-free. It will dictate *that* we must make choices in the interests of consistency resolution, but not *how*. It can criticize our conclusions but not our premisses. And so, as long as we are conjuring with plausibilities, the threat of paradox dogs our steps, irrespectively of how carefully and cogently we may proceed in point of logic.

The long and short of it is that paradox management requires an extra- or supra-logical resource. For the way to restore consistency to an aporetic situation is to implement some sort of *prioritization principle* that specifies how, in a case of conflict, we should proceed in making some of the relevant claims give way to others. What is needed is a rule of precedence or right of way. Considerations of priority are needed for breaking the chain of inconsistency at its weakest link. The guiding ideas of this approach are accordingly two:

> that paradoxes of the most diverse sorts can be viewed in a uniform way as resulting from an aporetic overcommitment to theses which, albeit individually plausible, are nevertheless collectively incompatible. And on this basis—

> that paradoxes of the most diverse sorts can be resolved through a uniform process of weakest-link abandonment in view of the fact that some of the conflicting theses take precedence or priority over others.

And with this second point, considerations of epistemic evaluation—of priority determination—become an inevitable part of paradox management. ✓

The general process at issue is best conveyed via some particular examples, beginning with the *Smashed Vase Paradox* based on the contention "There's no real harm done by breaking the vase—after all, it's all still there." Now consider the theses:

(1) If we smash the vase into bits, the vase no longer exists as such.

(2) There is nothing to the vase over and above the mass of ceramic material that constitutes it.

(3) When the vase is smashed, all the ceramic material that constitutes it still remains in existence.

(4) By (2) and (3), the vase still remains in existence after it is smashed, contrary to (1).

Thus {(1), (2), (3)} constitutes an inconsistent triad. And (1) and (3) are both incontestable facts while (2) is no more than a plausible-sounding principle. We thus have no alternative but to reject (2), as the weakest link in the chain of inconsistency, plausibility notwithstanding. Here presumably we would say something like: "There is more to the vase than merely the ceramic material that constitutes it, namely the organization of that material into a certain sort of vase-shaped configuration." On this basis we reject (2) as untenable, despite its surface plausibility.

In paradox analysis it becomes crucial to list in detail all of the theses and principles that are essential to establishing the aporetic collection at issue. For until the links of that chain of inconsistency are all spelled out explicitly, it is not possible to determine with confidence where exactly is the proper place to break the chain. If we do not have all the links set out we cannot determine which of them is the weakest. ✔

With a view of this methodology, consider the *Happiness Paradox* of John Stuart Mill which goes as follows:[3]

(1) His own happiness is the natural end of any rational agent.

(2) A rational agent will adopt whatever end is natural for a being of his kind.

(3) Therefore (by (2) and (3)) a rational agent will adopt his own happiness as an end).

(4) A rational agent will adopt only those ends that he can realistically expect to achieve by striving for their realization.

3. See Chapter 5 of his *Autobiography*.

(5) Therefore (by (3) and (4)) a rational agent can realistically expect to achieve his own happiness by striving for its realization.

(6) But it is a fact of life that rational people realize that they cannot expect to achieve their own happiness by striving for its realization.

(7) (6) contradicts (5).

Here {(1), (2), (4), and (6)} constitute an inconsistent cluster, (3) and (5) being merely derivative—as indicated. The maximal consistent subsets (MCS's) of this inconsistent quartet are: {(1), (2), (4)}, {(1), (2), (6)}, {(1), (4), (6)}, {(2), (4), (6)}. These engender four corresponding retention/abandonment alternatives: (1), (2), (4)/(6) and (1), (2), (6)/(4), and (1), (4), (6)/(2) and (2), (4), (6)/(1). The problem is to choose one of these R/A-alternatives in preference to the rest.

As regards the status of the propositions involved, Mill himself saw (1) and (2) as basic principles of rationality. And he accepted (6) as a crucial insight into human nature. But (4) is not more than a highly plausible supposition. The ranking of those four theses in point of precedence and priority would accordingly be as follows: [(1), (2)] > (6) > (4). (Note that theses of equal priority are bracketed together.) Accordingly Mill deemed it necessary to abandon any unqualified endorsement of thesis (4) however plausible and sensible it may otherwise seem to be. For the pursuit of even unrealizable ends can—in certain circumstance—yield other incidental benefits.

This example is typical and the process of paradox resolution accordingly has the following generic structure:

1. Setting out the aporetic group at issue in the paradox at hand, via an inventory of the aporetic (collectively inconsistent) propositions involved, and exhibiting how the logical relations among them engender a contradiction.

2. Reducing this inconsistent set to its inferentially non-redundant foundation.

3. Making an inventory of the maximal consistent subsets (MCS's) of the resulting aporetic cluster. And on this basis—

4. Enumerating the various alternatives for retention/abandonment combinations (R/A-alternatives) through which aporetic inconsistency can be averted.

5. Assessing the comparative precedence or priority of the propositions at issue.

6. Determining which among the resultant retention/abandonment alternatives for consistency restoration is optimal in the light of these priority considerations.

It is, of course, possible that some propositions of an aporetic cluster will not figure in the inconsistency that arises. Such "innocent bystanders" will stand apart from the clash of contradiction and thereby belong to every maximal consistent subset (and to no minimal inconsistent subset). For them priority does not matter: they will emerge as immune for rejection, irrespective of any rankings of procedure and priority.

"Paradoxes," one student of the subject writes, "are self-enclosed statements with no external reference point from which to take a bearing upon the paradox itself."[4] And this is true enough. For those paradoxical inconsistencies themselves afford no resources for their resolution—mere logical analysis of their assertoric content is no way out. To resolve paradoxes we need an external vantage point—a means for assessing the cognitive viability of the mutually incompatible theses that are involved, something about which those propositions themselves do not inform us. It is, in general, the relevant principles of precedence and priority that fill the bill here.

Thus consider the following aporetic cluster—the *Paradox of Evil*—from the domain of philosophical theology:[5]

4. Rosalie L. Colie, *Paradoxia Epidemica: The Renaissance Tradition of Paradox* (Princeton: Princeton University Press, 1966).

5. On this paradox and related issues see Richard M. Gale, *The Nature and Existence of God* (Cambridge: Cambridge University Press, 1991).

(1) God is not responsible for the moral evils of the world as exemplified by the wicked deeds of us humans, his creatures.

(2) The world is created by God.

(3) The world contains evil: evil is not a mere illusion.

(4) A creator is responsible for whatever defects his creation may contain, the moral failings of his creatures included.

(5) By (1)–(3) God is responsible for the world as is—its evils included.

(6) (5) contradicts (1).

Let us step back and consider the systemic standing or status of these contentions. Thesis (5) can be put aside as a consequence of others that carry its burden here. Thesis (3) comes close to qualifying as a plain fact of everyday life-experience. Theses (1) and (2) are (or could reasonably be represented as being) fundamental dogmas of Judeo-Christian theology. But (4) is at best a controversial thesis of moral theology, involving a potentially problematic denial that creatures act on their own free will and responsibility in a way that disconnects God from moral responsibility for their actions. We thus have the priority ranking [(1), (2)] > (3) > (4).[6] On this basis it is reasonable to take the line that one of these aporetic theses must be abandoned in this context. And it is easily (4) that should give way seeing that only the R/A alternative (1), (2), (3)/(4) abandons a lowest-priority thesis.

By deleting the less plausible items from an aporetic cluster so as to restore it to consistency we *purify* it, as it were, in the dictionary sense of this term of "diminishing the concentration of less desirable materials." But note that those less desirable materials are not necessarily worthless. For even they themselves are, by hypothesis, supposed to be more or less plausible. Though of lowest priority in one context, a plausible thesis that is caught up in an aporetic conflict may nevertheless be able to render useful epistemic service.[7]

6. To be sure, a committed atheist would have a very different priority ranking—one in which (1) would presumably be the low man on the totem pole.

7. For a concrete illustration see pp. 37–38 below.

2.2 Procedural Considerations

The basic rule for choosing among the appropriate retention/
abandonment alternatives is:

> A1: *Minimize the extent to which you abandon propositions of
> the highest relevant priority level.* (Or equivalently: maxi-
> mize the extent to which you retain propositions of the
> highest priority level.)

Of course, this measure alone may not suffice, since several com-
peting R/A alternatives may tie in the regard. The next rule to
apply is:

> A2: *When (owing to a tie) rule A1 does not settle matters reap-
> ply it at the next lowest priority level.*

And when this does not do the job, we simply proceed to the next
level,

> A3: *Whenever application of the preceding rules of this sequence
> does not settle matters, proceed to apply the same process at
> the next priority level.*

Every retention/abandonment alternative thus has a *retention
profile* in point of prioritization determined by *the proportion of
statements whose retention it allows at the successive priority levels.*
And the optimal R/A-alternative is that whose profile stands last
in the (numerical) lexicographic ordering when one compares
all of the available possibilities. For this means performing opti-
mally at making low-priority theses give way to theses of higher
priority. The resultant procedure minimizes implausibility or—less
elliptically—maximizes the minimal plausibility of the proposi-
tions we propose to endorse. (What we have here is accordingly a
maximin plausibility principle of assessment.) ✓
 An example of this process is provided by the *Socratic
Ignorance Paradox*. Let us suppose that Socrates maintains that he
knows nothing. To be sure, Socrates presumably said "I know
only that I know nothing [more]" (*Nihil scio praeter hoc, quod
nihil scio*) which is nowise paradoxical. But let us amend reality

somewhat for the sake of an example. Then we confront an aporetic situation which stands somewhat as follows:

(1) Socrates claims to know nothing.

(2) By (1), Socrates makes the claim: "I know nothing."

(3) To claim something is to hold it to be true.

(4) To hold something to be true is effectively to claim to know that it is so, and so to claim to know something.

(5) Sensible people do not make inconsistent claims.

(6) Socrates is a sensible person.

(7) By (5) and (6), Socrates does not make inconsistent claims.

(8) By (1) and (4), Socrates makes inconsistent claims.

(9) (8) contradicts (7).

Here {(1), (3), (4), (5), (6)} constitutes an inconsistent quintet. Now (1) and (6) are putative facts that constitute part of the stagesetting of the problem: their position is secure. And (3) and (5) are plausible principles of rational process, as is (4) albeit at a lower level of plausibility. We thus arrive at the plausibility ranking [(1), (6)] > [(3), (5)] > (4), with the result that the circle of inconsistency should be broken at (4). The rationale for so proceeding is that even conscientious people can stake claims at the level of probable or plausible conjecture or supposition rather than at the level of outright knowledge. ✓

Here we have available the five R/A-alternatives, of abandoning exactly one of the theses (1), (3), (4), (5), (6). These R/A-alternatives have the retention profiles $\{\frac{1}{2}, 1, 1\}$, $\{\frac{1}{2}, \frac{1}{2}, 1\}$, $(1, 1, \frac{1}{2})$, $\{1, \frac{1}{2}, 1\}$ and $\{\frac{1}{2}, 1, 1\}$, respectively. (As indicated above, these numbers indicate the *proportion* of retentions in the three categories at issue.) The *optimal* profile is that which stands *last* in a lexicographic ordering, and it is this which indicates the optimal R/A-alternative that is available in the circumstances. It is clear that the third of these offers the best option, and the sacrifice of (4) results.

2.3 Disjunctive Resolutions: Conflicting Report Paradoxes

To be sure, the preceding rules will fail to decide matters when several retention/abandonment alternatives have the same retention profile. We then come to the end of our preferential tether without reaching a unique result. When this occurs and further preferential elimination is impracticable, we must fall back on a *disjunctive* resolution: For then all that we can then say is that one or another of those equally eligible alternatives must obtain. This sort of thing is rare among the familiar paradoxes but can of course happen.

The journey into paradox sometimes proceeds by way of dilemma. A dilemma-engendered paradox takes the following generic form:

(1) If C, then P. A given.

(2) If not-C, then Q. A given.

(3) Either P or Q. From (1), (2).

(4) Not-P. (P is by hypothesis unacceptable).

(5) Not-Q. (Q is by hypothesis unacceptable).

(6) (3) contradicts (4)–(5).

Here an unavoidable disjunction (Either C or not-C) leads to an unacceptable result (Either P or Q).

Thus consider the following as an illustration of a *Dilemmatic Paradox*: Suppose you borrowed $10 from Tom and $10 from Bob. On your way to repaying them you are robbed of everything but the $10 you had hidden in your shirt pocket. By no fault of your own, you now face the following paradoxical dilemma:

(1) You are obligated to repay Tom and Bob.

(2) If you pay Tom you cannot repay Bob.

(3) If you repay Bob you cannot repay Tom.

(4) You cannot honor all your obligations: in the circumstances this is impossible for you. (By (1)–(3).)

(5) You are (morally) required to honor all your obligations.

(6) You are not (morally) required to do something you cannot possibly do (*ultra posse nemo obligatur*).

Here {(1), (2), (3), (5), (6)} form an inconsistent cluster. (1), (2), and (3) are supposedly fixed facts of the case. Both (5) and (6) are—or seem to be—basic general principles of morality. The resulting plausibility ranking is [(1), (2), (3)] > [(5), (6)]. The conclusion is the one of (5) and (6)—or both—must be abandoned. We here have an instance of the objective situation contemplated above.

To be sure, instead of outright rejection we could endeavor to save them in some duly qualified form, perhaps somewhat as follows:

(5') You are morally required to honor all your obligations— albeit only insofar as the circumstances of the case permit (provided those circumstances are not of your own making).

(6') You are not (morally) required to do something you cannot possibly do (provided the impossibility at issue is not of your own making).

Subject to such qualifications the paradox can be overcome through premiss abandonment along the by now familiar lines.

Other examples of disjunctive solutions are forthcoming in the case of *Conflicting Report Paradoxes*. Thus suppose that three equally reliable contemporaneous polls report the following paradoxical result regarding how people stand on a certain issue of public policy:

	(1)	(2)	(3)
For	30%	55%	30%
Against	30%	30%	55%
Unwilling to respond	40%	15%	15%

Here polls (2) and (3) are incompatible: there is no way to redistribute the nonrespondents of these polls so as to bring them into

accord. We must thus choose between (1), (2)/(3) and (1),
(3)/(2) whose condition in point of retention/priority is identi-
cal. A disjunctive result, along the lines of (1) & [(2) v (3)] now
ensues, suggesting the inconclusive conclusion: For 30–70%,
Against 30–70%. As far as our polling information goes, the situa-
tion is simply a tie—even though this was perhaps not clearly
apparent on first view. And this resolution is the best that we can
achieve here, since we are caught up in a tie in point of retention
priorities. (If we had reason to discount poll (2) or poll (3), the
result would be quite different.)

A further example is also instructive. Suppose a 3 × 3 tic-tac-
toe configuration and suppose that three sources (A, B, and C)
give us reports about this to the following effect:

(1) There are two X's in row 1.

(2) There are three X's in row 2.

(3) There are two X's in row 3.

(4) No column has three X's.

These four claims are clearly incompatible: given (1)–(3), there is
no way in which (4) can be realized. We have a paradox on our
hands.

In view of the collective incompatibility of (1)–(4) we must
break the chain of inconsistency. Now let it be that (1) and (3)
stem from source A, (4) from source B, and (2) from source C.
And let it be that sources A and C are equally reliable while
source B is somewhat less so. Given the envisioned difference in
source reliability, (4) abandonment offers the best prospect
here. Theses (1), (2), and (3) will thus be retained and (4) jetti-
soned, so that we arrive at (1), (2), (3)/(4) as the optimal R/A-
alternative.

However, if we are sensible we will not simply reject B's evi-
dence altogether. Conceding it some modicum of plausibility, we
would at least try to minimize the number of columns that have
three X's. And this leads to the conclusion that just one single
column has only three X's, thereby going beyond the information
conveyed by (1), (2), (3) alone.

Plausible claims, frail thought they are, still count for something. In endeavoring to accommodate insofar as possible even those theses that we abandon—and not simply throwing them on the trash-heap of rejected falsehoods—we position ourselves to profit from the information they provide. *To abandon a plausible proposition in the context of resolving a paradox is not to dismiss it as false and thereby pervasively and context-indifferently useless.* Abandonment is accordingly not something absolute but rather contextual. And it does not abolish completely the cognitive utility that a proposition can have by virtue of its inherent plausibility.

2.4 Compound Paradoxes

A fundamental fact of paradox theory—of *aporetics*—is that every paradox is resolvable in principle by abandoning commitments. For if we dismiss (and thus withhold endorsement from) sufficiently many of the theses that constitute the aporetic cluster at issue there will no longer be an inconsistency among our actual commitments. However, even the best available resolution may well be an indecisive one that leaves us confronting a disjunctive plurality of alternatives no particular one of which can be preferentially justified in the circumstances.

If we abandon a thesis in the context of one paradox, must we not also reject it in the context of another? Not necessarily. Consider an inconsistent cluster compound of two inconsistent triads {(1), (2), (3)} and {(3), (4), (5)} where (1) > (2) > (3) > (4) > (5), Looking to the second triad we will retain (3) and abandon (5). But when we take the first triad also into view, we realize that it is (3) that must be abandoned. When concerned for coherence overall, we must (obviously enough) take a broad, inclusive view of the relevant paradoxes. (Nevertheless, here—as elsewhere—taking *everything* into account may prove to be somewhere between impracticable and impossible.[8])

8. On this theme the words of Nicholas of Cusa still ring true: "A finite intellect, therefore, cannot by means of comparison reach the absolute truth of things. Being by nature indivisible, truth excludes 'more' or 'less,' so that nothing but [the whole] truth itself can be the exact measure of truth. . . . The relationship of our intellect to the truth is like that of a polygon to a circle; the resemblance to the circle grows with the multiplication of the

The illustration of the preceding paragraph yields an example of a <u>compound paradox</u> constituted by an aporetic cluster that has more than one cycle of inconsistency. For when we group all of the relevant propositions together and contemplate the inconsistent cluster {(1), (2), (3), (4), (5)} we find that this gives rise to the two aforementioned inconsistent triads.

A concrete example of such a compound paradox is as follows. Suppose the following four collectively inconsistent reports:

(1) There are no males in the room.

(2) There is only 1 person in the room.

(3) Tom Smith is in the room.

(4) Jack Jones is in the room.

This aporetic cluster consists of three cycles of inconsistency: {(1), (3)}, {(1), (4)}, {(2), (3), (4)}. Thus consistency-restoration overall could be effected by the following R/A-alternatives: (1), (2)/(3), (4) and (2), (3)/(1), (4) and (3), (4)/(1), (2) and (2), (4)/(1), (3). Thus if we had reason to see report (1) as more reliable than the rest we would be led to the resolution (1), (2)/(3), (4) which alone enables us to restore consistency everywhere while still retaining the only top-priority thesis at hand. We would then arrive at the definitive result that there is just one female in the room.

Suppose however that we had a compound paradox consisting of three cycles of inconsistency (*A, B, C*) constituted as follows by three interlocking inconsistent quartets as shown on p. 39.

Note that we could break all three chains of inconsistency at issue here by dismissing premiss (5). But whether or not this would be the appropriate solution would depend entirely on the priority-status of the propositions involved. Suppose, for example, that the priority situation were:

(5) > [(2), (4), (6)] > [(1), (3), (7)]

angles of the polygon; but apart from its being reduced to identity with the circle, no multiplication, even if it were infinite, of its angles will make the polygon equal to the circle The more profoundly we learn this lesson of ignorance, the closer we draw to truth itself." Nicholas of Cusa, *On Learned Ignorance* I, iii; translated by Germain Heron (New Haven: Yale University Press, 1954.)

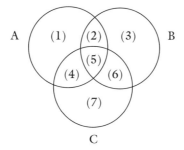

Then we would (and should) unhesitatingly abandon the trio (1), (3), (7), even notwithstanding the fact that dismissing (5) alone would restore consistency across the board.

Though interesting from a theoretical point of view, compound paradox is an uncommon phenomenon. None of the standard paradoxes encountered in the extensive literature of the subject involves more than a single cycle of inconsistency—that is, they all relate to inconsistent *n*-ads.

Paradoxes Considered in Chapter 3

- Moore's Paradox

- Optical Illusion Paradoxes

- The Lottery Paradox

Plausibility as a Guide
to Prioritization

3.1 Theses of Lowest Priority: The Meaningless and the False

The simplest way to eliminate an aporetic paradox is to determine that one or another of its essential premisses is flat-out untenable by way of being either meaningless or false. Here falsity is simple enough but meaninglessness is rather more complicated because there are significantly different routes to this destination. The *hermeneutically* meaningless is literal nonsense, unintelligible gibberish; the *informatively* meaningless is absurd and conveys no usable information, and the *semantically* meaningless is devoid of any stable truth status, so that here there can be no fact of the matter one way or the other. "Yellow weighs wooden tentacles" is hermeneutically meaningless: one can make no sense of it. "He drew a square circle" is informatively meaningless: it anomalously takes away with one word ("circle") what it gives us with another ("square"); we understand—sort of—what is being said but deem it absurd. Finally, "This sentence is false" is semantically meaningless: neither truth nor falsity can be ascribed to it.[1]

In principle, various different avenues can lead to meaningless statements: grammatical anomaly, definition conflict, category confusion, presupposition violation, and referential vacuity. The

1. The distinctions at issue here go back to Husserl's distinction between the hermeneutically and the informatively meaningless, between non-sense (*Unsinn*) and contra-sense (*Widersinn*). The former is radically meaningless; the latter simply confused and self-conflicted. See Edmund Husserl, *Logische Untersuchungen* (Halle: Niemeyer, 1891), Vol. I, pp. 110–16, translated by J.N. Findlay (London: Routledge; New York: Humanities Press, 1970).

43

first two generally produce hermeneutic meaninglessness, the next two generally engender informative meaninglessness, and referential vacuity generally leads to semantic meaninglessness.

While meaninglessness is perhaps the gravest flaw a paradoxical premiss can have, mere falsity is yet another, somewhat less grave failing. In this light, consider the example afforded by <u>Moore's Paradox</u> which centers on the paradoxical nature of locutions of the form "*P* but I do not believe it." [2] This contention conveys the useful lesson of a complexity of "acceptance." The problem here turns on the fact that we may be "of two minds" about some things: that there are some facts that we acknowledge as such with one side of our minds but nevertheless find them somewhere between hard and impossible to accept. ("I find it incredible that some Confederate generals should eventually become generals in the U.S. army," or " I find it incredible that a President of the U.S. should survive in office despite a widely publicized affair with a White House intern".) Moore thus emphasized the paradoxical nature of sentences of the form "*P* but I do not believe that *P*" ("The entire physical universe was once smaller than the head of a pin but I do not really believe it"). To be sure, there is, in general, no anomaly to the assertion "*P* but *X* does not believe it". <u>The difficulty arises only in one's own personal case.</u> And, as Moore sees it, the difficulty roots in the conflict between what the speaker *implies* by his assertions, and what he *states* therein, ✓ between what is implicit and what is explicit.

To formulate the paradox that arises here, let *S* be a statement of the form "*P* but I do not believe that *P*." And now consider:

2. The paradox was discussed by G.E. Moore in his book *Ethics* (Oxford: Clarendon, 1912) and also in P. Schilpp (ed.), *The Philosophy of G.E. Moore* (La Salle: Open Court, 1942), pp. 430–33, and in P. Schilpp (ed.), *The Philosophy of Bertrand Russell* (La Salle: Open Court, 1944), p. 204. (The former of these books contains an article on Moore's Paradox by Morris Lazerowitz [pp. 371–393].) The paradox was already known in medieval times. Albert of Saxony discussed the paradoxical nature of propositions of the form "Socrates believes himself deceived in believing a certain proposition *A*," seeing that in believing *A* Socrates maintains it as true and in believing himself deceived he rejects it as false. (See Kretzmann and Stump 1988, p. 361.) On this basis, Albert developed a complex argument to the effect that it is impossible for Socrates (that is, anyone) to know that he is mistaken about a concrete matter of fact (*ibid*, pp. 363–64). And analogously, William of Heytesbury (ca. 1310–ca. 1370) argued in his *Regulae solvendi sophismata* (ca. 1335) that a person cannot doubt something he knows. (See Boh 1993, pp. 48 and 67–68.) *Nihil scire potest nisi verum* became an accepted dictum.

(1) *S* makes a meaningful statement that conveys coherent information. (A plausible supposition.)

(2) In making an assertion of the form "*P* but also *Q*" a speaker indicates by implication his acceptance of *P*. (A logico-linguistic fact.)

(3) In making an assertion of the form "*P* but I don't believe that *P*" a speaker overtly states his rejection of *P* (i.e., his nonacceptance thereof). (A logico-linguistic fact.)

(4) It follows from (2) and (3) that in making a statement of the form "*P* but I don't accept that *P*" a speaker contradicts himself by indicating both that he accepts *P* and that he rejects it.

(5) (4) is incompatible with (1).

In the circumstances, we have little alternative but to abandon (1). Assertions of the form "*P* but I don't believe that *P*" are accordingly untenable in contexts of rational communication on grounds of self-contradiction.[3]

The paradox contemplated by Moore is thus dissolved, because one of its crucial premises—namely (1)—is simply untenable. For while paradoxical statements of the form *S* are perfectly intelligible (*hermeneutically* meaningful) and people doubtless do say that sort of thing, they are nevertheless not *informatively* meaningful—there is no usable information that we can manage to draw from them. (Perhaps a more generous reaction would be to say that people do say "*P* but I do not believe it" are simply adopting a somewhat incautious shortcut to saying something like "Though I know full well that *p*, I nevertheless still find it difficult to accept its being so," which is a perfectly meaningful and unproblematic assertion.)

However, not every paradox can be written off so conveniently by rejecting some key premise as false or, worse yet, meaningless. For various paradoxes resist dissolution by this strategy. Sometimes we need to invoke considerations of comparative plausibility.

3. Think of Spinoza's scornful dismissal of "one who says that he has a true idea and yet doubts whether it may not be false" (*Ethics*, bk. I, prop. 8, sect. 2).

3.2 Comparative Plausibility and Prioritization

Comparatively low plausibility is yet another serious deficiency of paradoxical premisses. The priority status of propositions is often crucial to the question of conflict resolution. Thus consider:

(1) All *A*'s are *B*'s.

(2) This *A* is not a *B*.

If (1) is seen as a law of nature and (2) as a mere guess, then we must of course jettison (2) as circumstantially untenable. On the other hand if (1) is seen as a mere theory—a *candidate* law of nature, as it were—while (2) reports the discovery of a patent fact of observation (for instance, the Australian black swan that counterinstances the thesis that "All swans are white"), then it is (1) that must be abandoned. Its priority rating is thus a matter not of what a proposition *says*, but of the epistemic status that it has in the larger scheme of things.

Assessments of precedence and priority accordingly do not relate to the declarative *content* of a proposition; a more probable or plausible proposition does not somehow *say* "I am more probable/plausible." Its precedence and priority ranking bears upon the systemic standing or status that we take a claim to occupy in the cognitive situation at hand. (Think here of the analogy of an axiom in mathematics or formal logic. Axiomaticity is not a matter of what the proposition *says* but rather of its cognitive *status* or *standing* in the system of propositions at issue.)

A thesis is minimally plausible when it is *compatible* with what we know. Beyond that, plausibility depends on the extent to which we are committed to it through evidence and the centrality of its position within our overall body of cognitive commitments. We would and should be reluctant to see as plausible a claim that did not qualify as probable in the epistemic circumstances at issue.

Consider an example of how plausible contentions can engender paradoxes. Optical illusions always engender mini-paradoxes. Take for example, the illusion created by the stick which looks bent when held at an angle under water. Here we have two reports:

(1) The stick is bent. (As attested by sight.)

(2) The stick is straight. (As attested by touch.)

The two reports are clearly incompatible. To resolve the incompatibility at issue with such *Optical Illusion Paradoxes* we must, as usual, assess the *comparative* plausibility of the propositions involved. Thus since touch is more reliable than sight in matters regarding the shape of smallish things we resolve the apory by making (1) give way to (2).

Again, consider the optical illusion created when oppositely oriented arrowheads are put at the end of equal line segments.

(A) \longleftrightarrow

(B) $\rangle\!\!\!-\!\!\!-\!\!\!\langle$

Here we have

(1) Line segment (A) is shorter than (B). (As reported by sight.)

(2) Line segment (A) and (B) are equally long. (As reported by measurement.)

Since measurement is generally more reliable in such matters than sight, we can straightforwardly resolve this apory in favor of (2).

In this way, all optical illusions give rise to aporetic situations that can be resolved through preferential prioritization on the basis of larger background considerations regarding the plausibility of claims.

3.3 Issues of Plausibility: Routes to Plausibility Assessment and Priority Determination

The propositions we endorse have two dimensions. There is the *hermeneutic or internally content-oriented* dimension of what the proposition affirms—its meaning. And there is the *epistemic or*

externally status-oriented dimension of the epistemic standing or status of those theses within the wider framework of our commitments.

o The former (hermeneutic) dimension is a matter of what the proposition affirms—of the range of questions it answers. The second (epistemic) dimension relates to questions that can or should be answered about it: Is it axiomatic or derivative? Is it seen as certain or probable or merely plausible? Is its standing that of a mere hypothesis or supposition or is it an established fact? Now as the examples we have been considering show, the prime requisite for the resolution of paradoxes and antinomies is often not some logical mechanism for more elaborately elucidating the *inner assertoric content* of the propositions involved, but a device for assessing the *external status* of a proposition by way of a priority rating that reflects its contextual tenability. What matters here is the availability of principles of precedence or priority for deciding which propositions should be made to give way to rivals in the conflicting circumstances at hand. ✔

It is a crucial fact of paradox management that paradoxes can be resolved by abandoning their low-priority premisses. And there are two main routes to determining the propositional priorities required for paradox resolution, namely fiat and inquiry—or, equivalently, stipulation and investigation. As regards the former, one distinction is very important for present purposes: the difference between a *stipulation* (or *stipulative* hypothesis) and a *supposition* (or *fictive* hypothesis). As this terminology will be used here, a "stipulation" is a postulate which, by conventionalized fiat, lays down the conditions of a problem. Stipulations accordingly can and should be viewed as fixed facts even though custom allows it to be said that such stipulations are true "by hypothesis" [*ex hypothesi*]. Full-fledged hypotheses by contrast are assumptions made "for the sake of discussion." They do not qualify as truths; we are simply invited to go along with them, indulging them for the time being with a "suspension of disbelief." Thus consider the piece of reasoning:

> (1) Suppose that three men are all sitting in a room which is otherwise unoccupied. (2) Let one of them be called "Henry." Now if (3) the other two are also called "Henry," then (4) everyone in the room will have the same first name.

Here (1) and (2) represent stipulations—truths by fiat so to speak. By contrast, (3) is a mere hypothesis. In this context of discussion, we are committed to (1) and (2), while (3) is no more than a provisional supposition. And (4), as a consequence that is contingent upon (3), is also of a provisional and "merely hypothetical" status. The second pair of statements has a standing very different from that of the first pair.

In case of an aporetic conflict, problem-definitive stipulations will of course enjoy the right of way short of their being logically inconsistent.[4] By issue-definitive fiat they—and their ramifications by way of implication and presupposition—are something we have to be prepared to accept. In adopting the issue-definitive stipulation *H* we *ipso facto* thereby render its denial not-*H* untenable in the context of discussion at issue. And whatever conflicts with the natural consequences of *H* in the presence of other high-priority claims must now also be abandoned. For example, the lawful ramifications of hypotheses dominate over the lawful ramifications of mere facts. Thus if this lead bar (which does not conduct electricity since lead does not conduct electricity) were instead made of copper, then it would conduct electricity (since copper conducts electricity). ✔

Stipulations apart, however, priority ranking is a matter of plausibility—of how firmly the contentions at issue are rooted in the cognitive scheme of things. And this is not just a matter of evidence but of the overall systematization of one's beliefs. Thus if I know but little about elephants it seems plausible to think they would have a longer lifespan than gorillas once I know that as a rule large mammals live longer than small ones. But the rule that larger animals eat more than smaller ones is firmer, and so that elephants *eat* more than gorillas is substantially more plausible.

In contexts of factual inquiry a contention is plausible to the extent that there are good grounds for thinking it to be true (good grounds for maintaining it, cogent evidential or probative reasons for it). Indeed this is a feature that is characteristic of "contexts of inquiry" as such. There are, to be sure, other sorts of contexts where other sorts of considerations can come into play in matters of plausibility and cognitive priority. And in due course

4. For complications introduced by logical inconsistency see Chapter 12 below.

we shall see how priorities that are not plausible come into play
and what sorts of ground-rules are operative there. The basis for
these matters is in the end pragmatic and rests on the particular
purposes that are at issue in the various contexts of deliberation.
 Overall we arrive at the following priority ordering in contexts
of inquiry. Issue-definitive stipulations come first. These have right
of way come what may. But from there on in it is a matter of plau-
sibility. And here the order of decreasing priority stands as follows:

- Definitions and acknowledged conceptually necessary
 truths. (Linguistic conventions, mathematical relationships
 and principles of logic included.)[5]

- General principles of rational procedure in matters of
 inquiry (inductive science) and world outlook.

- Patent observational or experiential "facts of life" regarding
 the world's concrete contingent arrangements.

- General laws and well-confirmed generalizations.

- Highly probable contentions regarding matters of contin-
 gent fact.

- Reasonably warranted suppositions.

- Merely provisional assumptions and tentative conjectures.

- Speculative suppositions.

The middle range of this register is occupied by the sorts of
propositions that Aristotle called *endoxa* in the opening chapter of
his *Topics*—that is to say, generally acknowledged beliefs and
widely accepted opinions. (This linkage reinforces the idea that it
need not be specifically *truths* that are at issue.)
 Certain general principles of precedence implement the pre-
ceding ordering through prioritizing

— the comparatively more basic and fundamental.

— the comparatively more factual or less conjectural.

5. That stipulations can predominate even over these will become clear in the discus-
sion of *per impossibile* reasoning in section 12.6.

— the comparatively more probable or more reliable.

— the comparatively better-evidentiated

— the comparatively more commonplace or less far-fetched.

Precedence and priority in point of plausibility are thus largely determined by the criteria and principles inherent in the teleological goal structure of factual inquiry, namely to aid us in doing the best we can to secure viable answers to our questions about how matters actually stand.

Plausibility is one of our principal guides to paradox resolution. But in deliberation, as in life, damage control is generally not to be realized free of charge. When the propositions that we abandon are meaningless or false, their abandonment is effectively cost-free. But not so with plausible propositions. Clearly the more plausible a thesis is, the greater the price of its abandonment. In foregoing a plausible thesis we always lose something we would (ideally) like to have. And when this must be done for want of a cost-free alternative, we have to view the loss we sustain as the price of the best-available bargain.

3.4 Against Semantic Absolutism

When the premises of a paradox represent known facts (and their denials accordingly known falsehoods) there is then no arguing with them: we have to take them in our stride. But when they are mere plausibilities rather than known truths they will not be gift horses into whose mouths we dare not look.

The presently contemplated treatment of aporetic situations is thus radically different from the traditional approach, whose only recourse is to dismiss some of the conflict-generating theses as false when without recourse to plausibility. When acceptance-as-true is the only available mode of endorsement, conflict resolution demands the identification of falsehoods. However if acceptance is envisioned more broadly to include also acceptance-as-merely-plausible, then thesis-rejection need not be categorical (as flat-out false). Dismissal is accordingly not something final and absolute, but merely a matter of abandonment *in a context* on grounds of here being the weakest link. Being the weakest link in

(1) Some integer in the range 1–1,000,000 will be drawn. (A defining condition of the problem-situation.)

(2) The particular integer *i* will not be drawn. (A very plausible, because so highly probable, proposition.)

(3) Theses (2) holds for *any*—and therefore *every*—particular value of *i* in the range 1–1,000,000. (A consequence of (2) and the defining conditions of the problem.)

(4) By (2), (3), no integer in the range 1–1,000,000 will be drawn.

(5) (4) contradicts (1).

Here {(1), (2), (3)} form an inconsistent triad. In view of the indicated considerations, the priority situation is (1) > [(2), (3)]. In view of this we have to abandon the idea that a particular integer will not be drawn—though of course we are left totally in the dark about how this will happen. All that we can say is that some (otherwise unspecifiable) integer in the range 1–1,000,000 will be drawn. (Pp. 222–24 below will return to this paradox.)

Accordingly, a semantic absolutism that says "abandon only those theses whose falsity you can specifically establish" would plunge us into difficulty. Sometimes we can only establish that one of a group of theses must be false but cannot carry this through to the specificity of saying which one is false.[6] And here lies the advantage of dealing in variable plausibility rather than truth/falsity alone. For this enables us to resolve paradoxes through dismissing comparatively implausible prepositions rather than having to find propositions that are identifiably false (as it may well prove impracticable to do). In paradox resolution we face a dilemma of choice: in the interests of consistency-maintenance some of the pertinent claims must be abandoned—some item made to give way to others. We cannot have it all and must settle for minimizing the loss. And in this matter of damage-assessment plausibility suffices to do the job. ✔

6. The *Sorites Paradox* discussed in section 5.1 affords another good example of this.

Paradoxes Considered in Chapter 4

- Zeno's Racetrack Paradox

- Aristotle's Justification Paradox

- Cosmic Explanation Paradox

- Sancho Panza's Hanging Paradox

- The Nasty Crocodile Paradox

- The Contract of Protagoras Paradox

- The Paradox of Existence

- The Russell-Gettier Paradox

- The Bizet-Verdi Paradox

Levels of Paradoxicality

4.1 Four Modes of Paradox Solution

Solving a paradox by eliminating the inconsistency of an aporetic cluster calls for abandoning some of the contradiction-engendering premises involved. But there are importantly different bases for doing this, as follows—

1. An independent determination that some of the premises essential to the aporetic contradiction at issue are either meaningless or flat-out false and can therefore be dismissed altogether—with the effect of restoring consistency. (In the former [meaninglessness] case the paradox is *interpretatively dissolved*; in the latter (falsity) case it is *probatively dissolved* on grounds of the untenability at issue.)

2. A determination that some of the premises essential to the contradiction at issue are so interrelated that in every case the interpretative or applicative circumstances under which some of them are tenable are such that some others are untenable (that is, false or meaningless), so that there is no possible way in which all of these essential premises can be uniformly true together. (In such cases of interpretive dissonance the paradox is *lexically dissolved* on ground of ambiguity or equivocation.)

3. A determination that some of the premises essential to the contradiction are comparatively so implausible in relation to the others that they can be rejected in the context at issue.

57

And moreover—

3a. The consistency-restoring dismissal of minimally plausible theses can be achieved in one single way. (In this case the paradox is *decisively resolved by plausibility considerations*.) Or—

3b. The consistency-restoring dismissal of minimally plausible theses can be achieved in several different but equally eligible ways. (In this case the paradox is *indecisively resolved* through a mere disjunction of alternative possibilities.)

In line with item 1 of the initial list, it must be recalled that there are two distinct routes to the meaninglessness of aporetic premisses. For it is important to distinguish between *hermeneutical* and *semantical* meaninglessness. Hermeneutical meaninglessness obtains when there is no way of making informatively interpretive sense of the proposition at issue: it is more or less uninterpretable nonsense. Semantical meaninglessness, by contrast, arises when there is no possible way of assigning a stable truth status to the proposition at issue as either definitively true or definitively false.

• We thus arrive at three levels of paradoxicality according as the paradox in question admits of dissolution, of decisive resolution, or merely of an indecisively disjunctive resolution. Moreover, in the first case, we will no longer see that supposed paradox as a really serious problem because we now view it as actually the product of an error of some sort—to wit one that rests on the mistake of accepting theses that are meaningless or false or not co-tenable.

It must be noted that the *difficulty* of a paradox is something quite different from its level of paradoxicality. For this is a matter of how complicated it is to make the determinations of viability and comparative priority needed for arriving at a solution. This is a matter of the conceptual and epistemic hurdles one has to overcome to provide a validating rationale for the particular acceptability determinations and priority assessments that provide the basis for paradox resolution.

4.2 Dissolvable Paradoxes

Zeno of Elea, who was born around 495 B.C., was one of the most celebrated and influential pre-Socratic philosophers of Greek antiquity.[1] Aristotle regarded him as the inventor of philosophical dialectic. His famous paradoxes of motion were the subject of innumerable treatises and discussions. Among these arguments designed to show the impossibility of motion was his classic *Racetrack Paradox*, which is represented in the following account:

> A runner is to race from the starting point to the goal. But to reach the goal he must first reach the halfway point. And to reach *this* point he must first reach the halfway point to *it*. And so on ad infinitum. So the runner can never make a start at all—he is immobilized.

The paradox at issue here roots in the following aporetic cluster:

(1) To reach any destination whatever, a runner must first reach the halfway point en route.

(2) By repetition of this principle at issue in (1) reaching the ultimate goal requires an infinite (unending) series of prior goal-reachings that must be achieved in advance.

(3) Since the runner moves at a finite speed, every goal-reaching he manages to achieve requires a finite amount of time.

(4) So in virtue of (2) and (3) reaching the goal requires an infinite amount of time, <u>since an infinite number of finite quantities cannot yield a finite total.</u> *False: see Cauchy 1943 Zeno to Einstein*

(5) Thus the runner can never reach the goal at all. (By (4).)

(6) But since this argument is general and holds for any goal whatsoever—and thereby for any point different from the starting point—the runner is immobilized.

(7) Yet as we know full well, runners are not immobilized: he can and will reach the goal.

(8) (7) contradicts (6).

In searching out the fly in this ointment—the weak link in the chain of inconsistency—suspicion comes to focus on the contention of thesis (4) that an infinity of finite quantities cannot yield a finite total. For in simply deploying the finite-infinite contrast this contention neglects the matter of the *size* of the finite *amounts* at issue. And the fact of the matter is that an infinite number of increasingly diminishing quantities can indeed make up a finite total—as modern mathematics shows in such cases as:

$$\tfrac{1}{2} + \tfrac{1}{4} + \tfrac{1}{8} + \ldots = 1$$

So here the dismissal of premiss (4) as false eliminates the inconsistency and thereby dissolves the paradox. But this is something that is not obvious on the surface because here the rationale for falsity-rejection calls for recourse to the mathematics of infinite series.

Zeno's Racetrack paradox thus illustrates the aforementioned difference between levels of paradoxicality and levels of difficulty. Its paradoxicality level is low, since it is unproblematically dissolvable through rejection of a pivotal premiss. On the other hand, establishing the untenability at issue through a broader rationale for what it is that makes these flawed premisses untenable is an issue of substantial subtlety and difficulty. Making a decisive resolution of a paradox stick can be a complex business.

Again, consider the following *Justification Paradox* that figured prominently in Aristotle's thought:

(1) A rational belief must be based on a rationale of justifying considerations.

(2) The rationale of a belief cannot include the belief itself since this will produce a vicious circle. No belief can figure in its own appropriate justification. The rationale of a belief must therefore always involve further, different beliefs.

(3) Since this leads to an infinite regress, there can be no such things as a rational belief.

(4) We know full well that many beliefs are rationally justified.

Aristotle's resolution of this apory was two-sided. In the case of *necessary* beliefs he rejected (2), holding that these beliefs are effectively self-certifying, so that the justifactory regress here ends with self-evidence. (He insisted that such self-substantiation is not vicious or vitiating in the case of necessary truths but simply makes manifest the nature of their necessity.) And in the case of *contingent* factual beliefs he rejected (1), maintaining that their validation need not be mediated discursively by further beliefs but can be based upon the course of immediate experience.

4.3 Decisively Resolvable Paradoxes

Consider the following *Cosmic Explanation Paradox*:

(1) Every feature of nature has a natural explanation.

(2) *Therefore*: nature-as-a-whole, the universe, has a satisfactory natural explanation.

(3) Natural explanations explain some feature of nature in terms of others.

(4) But in explaining nature-as-a-whole causally we cannot involve its parts or features, since this would make for a vitiating circularity.

(5) *Therefore*: we cannot give a satisfactory natural explanation of nature-as-a-whole.

(6) (5) contradicts (2).

However, (1) is ambiguous. It can mean "every *partial* feature of nature" in which case it is true but does not yield (2). Or it can means "every feature of nature—*holistic* ones included" in which case it yields (2) but is problematic and—in the present context— question-begging. And so the problematic nature of (1) renders the paradox decisively resolvable.

A historic example of a sophisticated paradox is afforded by the <u>Sancho Panza Hanging Paradox</u> of Cervantes's novel *Don Quixote* (Book II, Chapter 51). Here Sancho Panza is made governor of an island where he must uphold a curious law that stipulates that on arrival visitors are to be questioned about their plans and to be hanged if they answer falsely. One day Sancho had to resolve the problem posed by a visitor who, when asked what he would be doing on the island, responded "<u>I am here to be hanged</u>." <u>Now if he is hanged, the answer will be true and the penalty inappropriate, while if he is not hanged, the answer will be false and the law would require his hanging.</u>[2]

el love this!!

The situation that results answers to the following summary:

The traveler is	The traveler speaks	The law therefore requires
Hanged	Truly	Not hanged
Not hanged	Falsely	Hanged

In no case can the traveler's fate be brought into agreement with ✔ the law's requirements.

This situation gives rise to the following aporetic cluster:

(1) The law should always be obeyed. Lawful requirements should always be met. People ought (always) to do as the laws require.

(2) "Cannot" implies "need not": what people cannot possibly do is never actually obligatory for them. (*Ultra posse nemo obligatur* as the Roman legal maxim maintained.)

(3) Ought implies can: what people legally *should* do must be possible for them. From (2) by contraposition.

2. This classic paradox also has the ancient variant of the *Nasty Crocodile Paradox* mentioned twice by Diogenes Laertius (*Lives of the Philosophers*, 44 and 82). Having snatched a baby the nasty crocodile turned to the father: "Answer carefully," he said, "for your baby's life depends on your truthfulness: will I eat your baby?" After thinking for a moment the cagey father replied: "Yes, I do believe you will." For this paradox see Prantl, *Geschichte*, Vol. I, p. 493. (Ashworth 1974, p. 103, discusses the variant *Bridgekeeper Paradox* featuring the functionary who threw liars into the water.)

(4) In some circumstances—such as those indicated by the example of "The Gallows" story—people cannot possibly do what the laws require.

(5) In some circumstances people need not do as the laws require. (From [3] and [4].)

(6) (5) contradicts (1).

Here {(1), (2), (4)} constitute an inconsistent triad. Now (1) specifies a plausible legal ideal, while (2) is a basic axiom of juridico-ethical rationality. And (4) is an aspect of the defining hypothesis of the situation. The overall rating of priorities is thus: ✔

$$(4) > (2) > (1)$$

And in consequence (2), (4)/(1) is the appropriate resolution for the paradox. No other R/A-alternative can match its acceptability profile of {1, 1, 0} utilizing the prospects of retained theses in the three minority categories. One must turn a blind eye to that law, presumably arguing (1) is false because occasionally "the law is an ass" and sometimes requires absurd things. ✔

Sancho's sagacious response took exactly the line "Whichever way I decide, the law is going to be disobeyed, so I might as well be merciful and let this wretch go free." And this makes perfectly good sense. In the circumstances the tacit premiss of the situation "The law is to be obeyed: what is done should be in accordance with the law" needs to be abandoned in the case at hand precisely because this case is so constructed that there just is no possible way for the law to be obeyed. The paradox is thus dissolved by noting that it rests on the mistaken presupposition that the legal-code's stipulation is a meaningful law that can and should always be obeyed.

Another juridical example of a decisively resolvable paradox is afforded by the ancient story of the paradox of *The Contract of Protagoras*. This paradox, widely disseminated in classical antiquity, arises from the following story:

The Greek sophist and teacher Protagoras contracted with some students for a tuition fee to be paid if, but only if, they won their first case. One of these, the clever Euathlos, sued in

court for free tuition with the argument: "If I win this case then by the court's judgment I will owe nothing. And if I lose, then I will owe nothing thanks to the contract, since this is my first case." Protagoras, being no less clever, of course argued exactly the reverse.[3]

The paradox that emerges here inheres in the following aporetic pair:

(1) The court's finding should be in accord with what the contract stipulates. However—

(2) In the specified circumstances, that contract and the court's ruling are bound to disagree on the following basis:

The Court's Finding	Winner of the Case	The contract Specifies
A fee is due	P	No fee is due
No fee is due	E	A fee is due

Thus in no case can the court's finding be brought into line with the contract's specification.

Now since thesis (2) represents the defining hypothesis of the problem, there is no arguing with it. The only available option is to make (1) give way, invoking the legal axiom that an absurd contract is no contract because it invalidates itself (*conventum absurdum non est conventum*). To be sure, the general considerations of aporetics indicating that (1) should be abandoned do not tell us what—if anything—should be put on its place. This requires a closer look at the substantive detail of the particular paradoxical situation that is before us. And on this basis, the court's only sensible option is to *make* a ruling and to prioritize it over what the contract specifies in the circumstances (thereby abandoning (1)). Now here the salient feature of this case is that

3. On ancient discussions of this paradox see Prantl, *Geschichte*, Vol. I, pp. 493–94.

the situation between the contending parties is entirely symmetric, exactly as the response of Protagoras indicates. Thus by deploying the basic principle of justice "Treat like cases alike" the Court's sensible ruling would be to divide the amount in contention (the student's fee) equally between the parties, awarding just half of the agreed amount to Protagoras. To be sure, this requires the explicit—and deliberate—sacrifice of thesis (1), but this is entirely appropriate in the circumstances. ✓

In any event, however, this paradox is decisively resolvable since it is clear *which* aporetic premiss must be abandoned. The only real problem here is that of *why*—that is, of establishing just exactly how the justifying grounds for this abandonment are to be articulated. And it deserves stress that this sort of thing is often the most challenging and difficult aspect of paradox management.

In comparing the Sancho Panza Paradox and the Contract of Protagoras Paradox one observes that they have exactly the same generic structure, as manifested in those alternative-detailing tabulations. (And this is also the case with the Liar Paradox to be discussed in 10.2 below.) On this basis the Stoic paradoxologists of classical antiquity characterized such paradoxes as based on "table-turning" (*antistrophê*),[4] seeing a fundamental symmetry obtains so that whatever can be said on one side can be answered by an equivalent counterpart on the other. That is, we have the situation that not just equally cogent but in fact structurally identical arguments can be given both for a thesis P and for its negation not-P. ✓

4.4 Indecisively Resolvable Paradoxes

Some paradoxes do not admit of a decisive resolution. For example consider the following *Paradox of Existence*:

(1) The real is rational: for every actual state of affairs there is a reason why (that is, why it is so rather than otherwise). [This is the "Principle of Sufficient Reason".]

4. See Prantl, *Geschichte*, Vol. I, pp. 493–94.

(2) *Therefore*: there is a reason for the world's existence—and indeed for its existing as it is.

(3) The satisfactory explanation of a mundane (world-appertaining) fact requires a mundane rationale. (For an extramundane explanation would run afoul of reason's proscription of explaining *obscurum per obscurior*.)

(4) *Therefore*: the real has an explanation in terms of mundane facts.

(5) Any mundane (world-appertaining) fact is either partial or global: it must either relate to some part or aspect of nature or to some feature of it.

(6) But the world's satisfactory explanation cannot be partitive: the whole cannot be satisfactorily accounted for through some part or aspect of itself.

(7) Nor can the world's satisfactory explanation be of the intra-mundane sort, for then it would be circular, seeing that it would account for reality-as-a-whole in terms of itself.

(8) *Therefore*: there is no rationally satisfactory explanation of the existence of the-world-as-a-whole.

(9) (8) contradicts (2).

It is clear that {(1), (3), (5), (6), (7)} constitutes an aporetic cluster. Here (3), stipulates a fundamental principle regarding the sovereignty and *modus operandi* of reason, and (5) is an inevitable principle of logic. (1), (6), and (7), by contrast, are no more than plausible principles. We thus arrive at the following priority ranking: (5) > (3) > [(1), (6), (7)]. It emerges on this basis that the paradox has three viable resolutions based on the preferentially optimal R/A-alternatives (3), (5), (6), (7)/(1); (1), (3), (5), (7)/(6); and (1), (3), (5), (6)/(7). Three distinct pathways to resolution are thus available:

(1)-rejection. Abandoning the idea of the explicability of the real.

(6)-rejection. Reliance on cosmic evolution. This envisions a naturalism that sees the world's entire nature and the

world's laws as evolving emergently over the course of time for some proto-status of physical existence.

(7) - rejection. Rejecting the idea that self-explanation is always vicious. Accepting a circularity of sorts and distinguishing between vicious and virtuous circles.

A trio of options confronts us, none of which prevails over its rivals by considerations of general principle. A disjunctive resolution is the best we can achieve here. ✔

Another paradox that has been extensively discussed in the recent epistemological literature was initially posed by Bertrand Russell in *Human Knowledge*,[5] and amplified in a widely discussed paper by Edmund Gettier.[6] This *Russell-Gettier Paradox* stands as follows:

(1) *X* believes (accepts) *p* v *q*.

(2) *X* believes this only because he justifiedly believes *p*; he disbelieves *q*.

(3) In actual fact, however, *q* is true, and *p* is false—even though all the evidence at *X*'s disposal points in its direction.

(4) *X*'s belief in *p* v *q* is (subjectively) justified (because this follows deductively from something that he reasonably believes).

(5) *X*'s belief in *p* v *q* is actually true. (From (3) because *q* is true).

(6) When a belief is both subjectively justified and objectively true then it constitutes knowledge. Thus *X* knows *p* v *q*.

(7) Nevertheless we cannot and would not credit *X* with *knowledge* of *p* v *q* because his basis for its acceptance is altogether erroneous and inappropriate.

(8) (7) contradicts (6).

5. Bertrand Russell, *Human Knowledge: Its Scope and Limits* (New York: Simon and Schuster, 1948), pp. 154–55.

6. Edmund Gettier, "Is Justified True Belief Knowledge?" *Analysis*, vol. 23 (1963), pp. 122–23.

Given this problem situation we must examine the epistemic status of the theses at issue. Now (1)–(3) are facts fixed by the defining stipulations of the problem. (5) follows from (3). (4) and (6) are plausible epistemic principles, albeit not as clearly plausible and appropriate as (7). We thus obtain the following priorities with regard to the premises of the aporetic cluster {(1), (2), (3), (4), (6), (7)} that stands before us:

$$[(1), (2), (3)] > (7) > [(4), (6)] \quad \checkmark$$

In the circumstances we have two optimal R/A-alternatives, namely those that reject only (4) and only (6) respectively. Both have the same optimal available retention profile $\{1, 1, \frac{1}{2}\}$. We are thus driven to abandoning either (4) or (6). Here too straightforward plausibility considerations again do not constrain one particular outcome. We again achieve only a disjunctive resolution.

It is not that in such indecisive cases we cannot see the way clear about how the paradox can be resolved on the basis of plausibility considerations. Rather, the situation here affords us with a plurality of options—an embarrassment of riches, so to speak. Now sometimes these will be reason to prefer one alternative over the others. But sometimes there is no prospect of this because consistency can be restored in several equally eligible ways. The *Bizet-Verdi Paradox* affords a good example.[7]

Consider the question: "What if Bizet and Verdi were fellow countrymen?" This confronts us with the counterfactual situation of the conditional:

If Bizet and Verdi were fellow countrymen, then Bizet would be (French? Italian?) and Verdi would be (French? Italian?).

The context of the issue is set by the following items of accepted knowledge:

(1) Bizet was of French nationality.

(2) Verdi was of Italian nationality.

7. For the paradox see Rescher 1961.

(3) Fellow countrymen are persons who have the same nationality.

(4) Bizet and Verdi were not fellow countrymen.

The hypothesis of the conditional instructs us to jettison (4) and replace it with

(4') Bizet and Verdi were fellow countrymen.

However, the resulting group {(1), (2), (3), (4')} is still an inconsistent quartet. If we are to maintain the hypothesis (4') and the meaning-explanation built into (3), then we only have two ways to resolve consistency: (A) to drop (1) and make Bizet an Italian, or (B) to drop (2) and make Verdi a Frenchman. We thus confront two maximal consistent subjects of our aporetic cluster, namely {(1), (3), (4')} and {(2), (3). (4')}.

Since (4') is a defining hypothesis of the pattern and (3) a conceptual truth, we arrive at the overall priority ordering:

$$(4') > (3) > [(1), (2)]$$

Here the alternatives of (1)-abandonment and (2)-abandonment are tied in point of acceptability considerations. In view of this alternatives (A) and (B) are on exactly the same plane: there is no reason to give one precedence over the other, and the only safe course is to disjoin them, so as to arrive at the conditional:

If Bizet and Verdi were fellow countrymen then either both would be French or both would be Italian. ✓

This noncommittal "either-or" conditional is the best we can achieve in this case. Here we have to settle for disjunctive solution: in the circumstances any more definite conclusion would be entirely unjustified.[8]

8. For more detail on paradoxes engendered by these "counterfactual conditionals" see Chapter 12 below.

It is clear, however, that "undecidable" paradoxes of such a sort—where no *particular* resolution can be privileged on the basis of general principles—are distinctly more deeply paradoxical than their simpler compeers where a decisive resolution can be achieved.

4.5 The Classification of Paradoxes

Like pretty much anything else, paradoxes can be classified according to various different principles. The prime prospects here are: subject matter *content*, *etiology* in term of what it is that goes wrong so as to give rise to the paradox, mode of resolution, and *complexity* with reference to the extent to which elaborate analyti- cal machinery is required to address the paradox.

Classification by content is the most familiar of these processes. Its results are indicated in Display 4.1 on pp. 72–73. Content is a function of the subject matter at issue in the paradox. It turns on the sort of vocabulary being used. Thus logico-semantical para- doxes would deal with issues of affirmation and denial, predica- tion and relation, designation and reference, and so forth. Mathematical paradoxes would deal with sets and their member- ship, or again with quantitative or geometric relationships. Epistemic paradoxes deal with belief, knowledge, inquiry, or igno- rance; ethical paradoxes with conflicts of duty and obligation. And so on.

Apart from content, the three salient issues regarding a para- dox are: how it arises, how it should be resolved, and how much effort its resolution requires. The key parameters are thus: con- tent, etiology, treatment, and difficulty. For present purposes, eti- ology will serve as the primary classificatory principle, and the subsequent discussion will focus primarily upon how it is that the paradox arises—the root cause of the perplexity at issue. And this approach proceeds in the footsteps of Aristotle's own practice in his *Sophistical Refutations*, where he treated sophism according to the sort of error or fallacy that he took to be at issue, and thereby according to the sort of resolution he saw as appropriate.

Now in general, paradox roots in cognitive overextension—it arises through our accepting too much. And so, what is required throughout paradox management is premiss abandonment. But

this is something that can be validated by different rationales. There are thus different modes of paradoxicality. All paradoxes go wrong, but different paradoxes can go to this common destination along different routes:

- *meaninglessness*;

- *falsity*;

- *vagueness*: mistaken assumption of a clarity of meaning or definition;

- *ambiguity and equivocation*: mistaken assumption of conformity of meaning;

- *implausibility* (insufficient evidentiation or improbability, flawed induction);

- *unwarranted presupposition*;

- *truth-status misattribution*: inappropriate truth-status imputations;

- *untenable hypotheses*; assumptions at odds with the cognitive environment;

- *value conflicts*: perplexing choices.

These seven nagativities represent the major deficiencies through ✓which paradoxes come into being. When one asks "What has gone wrong?" in the case of paradoxes it is in these directions that one must principally look.

Still, the pathways to paradox, though plural, represent a limited plurality. When we clarify paradoxes in line with "how things go wrong" we arrive at smallish list—pretty much as indicated ✓ above.

Note, however, that the resultant classification need not yield mutually exclusive taxa, since several things might go wrong at ✓once in sufficiently awkward cases. Nor will a taxonomy in terms of modes of resolution do so. For if the paradox is so paradoxical that several different things go wrong—and that in consequence each of several different processes would suffice to effect a resolution, then this one selfsame paradox will fit into several different categories even within the same classification. ✓

DISPLAY 4.1

CLASSIFICATION OF PARADOXES
BY SUBJECT MATTER

SEMANTICAL PARADOXES
(essentially involving the ideas of truth,
falsity, and reference)

— *truth-oriented paradoxes*

— *reference-oriented paradoxes*

MATHEMATICAL PARADOXES

— *set theoretic paradoxes* (essentially involving the ideas of sets
and set membership)

- Russell's Paradox

— *numerical paradoxes* (additionally involving the idea of
counting and ordering)

- Cantor's Paradox

- Berry's Paradox

- Richard's Paradox

- Burali-Forti's Paradox

— *geometrical paradoxes*

— *probabilistic paradoxes*

PHYSICAL PARADOXES

- Zeno's Paradoxes of Motion

EPISTEMIC PARADOXES
(essentially involving the ideas of
knowledge and belief)

- Discrepant Information Paradoxes

- Optical Illusion Paradoxes

- Moore's Paradox

- The Socratic Ignorance Paradox

- Aristotle's Justification Paradox

- The Lottery Paradox

PHILOSOPHICAL PARADOXES

— *moral paradoxes*

- Mill's Happiness Paradox

— *metaphysical paradoxes*

- The Paradox of Existence

— *paradoxes of philosophical theology*

- The Paradox of Evil

Unquestionably, disagreement will often arise among paradox analysts. One of them may think that the problem lies with one of the aporetic theses (say due to equivocation) while another thinks that something else (say a problematic presupposition) is at fault. And it is, of course, perfectly possible that *both* may be right because there are multiple flaws within the aporetic group at issue.

Fortunately, however, this sort of thing does not usually happen and paradox classification in terms of "what goes wrong" is often a straightforward matter. Thus of paradoxes those considered in Chapter 1, discrepant report paradoxes and sense-illusion paradoxes both belong to the category of problematic inductions, seeing that evidential dissonance is involved. The who-is-the-engineer paradox involves the unwarranted presupposition that the person-description at issue—which is actually self-contradictory—succeeds in identifying someone. Philosophical paradoxes frequently trade on an ambiguity or equivocation that needs to be removed by using distinctions.

The ensuing chapters will examine a wide range of paradoxes in line with the those above-indicated etiological groupings. And the discussion will endeavor to show that despite substantial variation as regards the source and nature of the paradoxes at issue, the single uniform approach to resolution described in these initial chapters can be used throughout the entire course of paradox management. Paradox resolution, in sum, is a matter of pursuing a unified strategy by means of diversified tactics.

Paradoxes Considered in Chapter 5

- The Heap Paradox or Sorites (Eubulides)
- The Bald Man Paradox or Phalakros (Eubulides)
- The Millet Seed Paradox (Zeno)
- The Color Continuum Paradox
- The Paradox of Sir John Cutler's Stockings
- The Ship of Theseus Paradox
- The Hermeneutic Circle Paradox

Paradoxes of Vagueness

5.1 The Paradox of the Heap

Vagueness in the application of terms is a major source of para-dox. Vague terms will generally have a more-or-less well-defined central core of application surrounded by a large penumbra of indefiniteness and uncertainty. And so when a term T is vague, non-T will automatically also be so. There will accordingly be a fuzzy region of ambivalent overlap between T-situations and non-T situations where our plausibilistic inclination is to see the issue both ways. The aporetic inconsistency of paradox then becomes a tempting possibility.

The eristic (from *hê eristikê* as wrangling or dialectic) that the Megarian school of Greek antiquity took over from the Sophists in the fourth century B.C. was an early version of dialectic—or of *spurious* dialectic according to Aristotle,[1] its principal opponent, who dealt with the matter extensively in his *Sophistical Refutations*.[2] It was thematically oriented towards puzzles, para-doxes, and sophisms. Aporetics is the descendant of this enterprise as it continued through the mediation of the medieval study of sophisms and insolubilia.

Eubulides of Miletus (born ca. 400 B.C.) was the most promi-nent and influential member of the Megarian school of dialecti-cians as whose head he succeeded its founder, Euclid of Megara, a

1. Aristotle, *Soph. Elen.*, II, 6.
2. On the Megarians in general see Zeller, *Philosophie der Griechen*, Vol. II/1, pp. 244–275. For Eubulides see Diogenes Laertius, *Lives of the Philosophers*, II x 108–110; Prantl, *Geschichte*, Vol. I, pp. 21, 50–58; Aristotle, *Soph. Elen.*, 179a32ff.

pupil of Socrates.[3] The Megarians derived this concern from the ancient Sophists who reveled in reason-baffling paradoxes because they brought grist to the mill of their teaching that reason is inadequate for enabling us to grasp the reality of things. (How—they asked—can there be a point in rational inquiry if one must *already* know what is true in order to recognize it when one finds it?[4]) Like the Sceptics later on, the Sophists were not concerned with paradoxes for their own sake but because they saw them as ✓making manifest a fundamental aspect of the human condition.

The Megarians took the view that what was pivotal for dialectic was not so much *logic*, the theory of correct inference, as *eristics* the theory of error avoidance.[5] As they saw it, conflict is the — avenue to health. Knowing how to deal with sophisms—how to manage thought in situations of conflict and competition—is as important for tuning the mind as sporting competition is for tuning the body.

Eubulides did more to promote concern for paradoxes than any other single thinker in the history of the subject, with the exception of Zeno of Elea. He is credited with seven important paradoxes: *The Liar* (*pseudomenos*), *The Overlooked Man* (*dialanthanôn*), *Electra and her Brother*, *The Masked Man* (*egkekalummenos*), *The Heap* (*sôritês*), *The Horns* (*keratinês*), and *The Bald Man* (*phalakros*). At present only The Heap and The Bald Man will concern us; the other paradoxes of Eubulides will be considered in due course.

The "Paradox of the Heap"—the *Sorites Paradox* (from the Greek *sôros* = heap)—is posed in the following account:

A single grain of sand is certainly not a heap. Nor is the addition of a single grain of sand enough to transform a non-heap into a heap: when we have a collection of grains of sand that is not a heap, then adding but one single grain will not create a heap. And so by adding successive grains, moving from 1 to 2 to 3 and so on, we will *never* arrive at a heap. And yet we

3. Pretty well all that is known about Eubulides derives from Diogenes Laertius, *Lives of the Philosophers*, bk. II, sect. 106–120. See Zeller, *Philosophie der Griechen*, Vol. II/1, pp. 246.
4. Zeller, *Philosophie der Griechen*, Vol. I/2, p. 1380. On the Sophists in general see the larger context of this passage on pp. 1371–84.
5. On this aspect of the Megarian teaching, see Prantl, *Geschichte*, Vol. I, pp. 41–58.

know full well that a collection of 1,000,000 grains of sand is a heap, even if not an enormous one.[6]

To achieve a more perspicuous formalization of the argument, it is helpful to use some abbreviate symbolism. Let g_i represent a collection of i grains of sand and let us adopt $H(g)$ to abbreviate the statement: "The group g of sand-grains is a heap." We then have:

(1) $\sim H(g_1)$ — an observable fact

(2) $H(g_{1,000,000})$ — an observable fact

(3) $(\forall i)[\sim H(g_i) \rightarrow \sim H(g_{i+1})]$ — a seemingly evident general principle

(4) $\sim H(g_{1,000,000})$ — from (1), (3) by iteration

(5) (4) contradicts (2)

Here (1) and (3) together logically entail (4). And (4) yields (5) which contradicts (2). The triad {(1), (2), (3)} accordingly constitutes an aporetic cluster and one of its members must be abandoned if the paradox is to be resolved. ✓

But what of the acceptability-status of these propositions? What sorts of considerations of priority and precedence are operative here?

As the above indications make clear, (1) and (2) are observable facts relative to our understanding of what a "heap" is. On the other hand, thesis (3) is cast at a high level of abstract generality and is really no more (though also no less) than an eminently plausible generalization—a theory. The theses of our inconsistent triad accordingly have the following priority ranking:

$$[(1), (2)] > (3).$$

6. On this paradox and its ramifications see Chapter 2 of R.M. Sainsbury, *Paradoxes* (2nd ed., Cambridge: Cambridge University Press, 1995), pp. 23–51. Originally the paradox also had a somewhat different form, as follows: Clearly 1 is a small number. And if n is a small number so is $n + 1$. But this leads straightway to having to say that an obviously large number (say a zillion billion) is a small number. (See Prantl, *Geschichte*, Vol. I, p. 54.)

We have three retention/abandonment alternatives here, whose retention profiles stand as indicated:

(1), (2)/(3) with retention profile $<1, 0>$

(1), (3)/(2) with retention profile $<\frac{1}{2}, 1>$

(2), (3)/(1) with retention profile $<\frac{1}{2}, 1>$

The first alternative alone enables us to retain *all* of the top priority theses and the optimal option here is accordingly to abandon (3). Plausible though it may seem, this thesis is less so than its rivals: it is the weakest link in this chain of inconsistency.

And this is perfectly reasonable. For (3) is actually rather problematic. When dealing with such vague concepts that have a slippery slope, as it were, it is clear that we are in a more confidence-inspiring situation with particular claims like (1) and (2) and (5) than we are with an unrestricted generalization like (3). (After all "we know a *heap* when we see one.") With factual issues of this sort we stand on firmer ground with particular and concrete matters than we do with matters of abstract generality.

And yet despite the comparative frailty of (3) we would not (and should not) simply reject it as flat-out false. For its negation entails $(\exists i)[\sim H(\mathcal{g}_i) \ \& \ H(\mathcal{g}_{i+1})]$, and we would find it very difficult indeed to conceive of such an i. But we do not (and need not) set up (3)'s negation as true; instead, we have the option of seeing (3) as plausible even though we propose to abandon it *pro tem* as "contextually untenable" in the present context.

The course of traditional paradox resolution via the dismissal of premises as false is here made impracticable by disassembling premiss (3) into the following multitude:

(3.1) $\sim H(\mathcal{g}_1) \rightarrow \sim H(\mathcal{g}_2)$

(3.2) $\sim H(\mathcal{g}_2) \rightarrow \sim H(\mathcal{g}_3)$

———

———

———

(3.999999) $\sim H(\mathcal{g}_{999,999}) \rightarrow \sim H(\mathcal{g}_{1,000,000})$

The paradox at hand means that we must abandon some of these as unacceptable, but we would be hard-pressed to identify any one specific culprit. Yet in seeing (3) as merely plausible rather than flat-out true—we can avert the difficulty which otherwise arises here. The Sorites Paradox is thus particularly important because it shows that the doctrinal resource of paradox resolution represented by the strategy of dismissing premises as false has its difficulties. But plausibility is something else again. Clearly, propositions of the format "If $C(g)$, then g is not a heap" grow increasingly implausible with an increase in the size of g, irrespective of the substance of condition C. ✓

The Greek philosopher Chrysippus (ca. 280–208 B.C.), was one of the most prolific authors of the Stoic school and its ablest logician. His extensive writings did much to bring Stoicism into prominence. Chrysippus saw the analysis of sophism as a cardinal training-ground for dialectics.[7] The Stoics offered an extensive treatment of the entire range of the paradoxes known in antiquity (in particular those of Zeno, the Sophists, and the Megarians).[8] Already Zeno of Citium in Cyprus (born ca. 320 B.C.), the founder of the Stoic school, made the study of paradoxical sophisms a key element of his teaching on dialectics.[9] He discussed all of the Megarean paradoxes.[10] And Chrysippus, his principal follower, devoted entire tracts to several of the most important paradoxes—five of them dealt with the *Liar Paradox* alone.[11] Somewhat in the spirit of the present book, the Stoics taught that the paradoxes did not involve formal fallacies of reasoning, but rooted in the substantive untenability of essential premisses. With the Liar in particular, Chrysippus offered the resolution (characterized as *cassatio*, that is, "null and void," by the medievals) that the proposition at issue is simply meaning-

7. On Chrysippus see Zeller, *Philosophie der Griechen*, III/1, pp. 40–44 and 111–18. His discussions of sophism are detailed in Prantl, *Geschichte*, Vol. I, pp. 487–496.

8. See Prantl, *Geschichte*, Vol. I, 485–496 (esp. p. 490).

9. On Zeno see Diogenes Laertius, *Lives of the Philosophers*, VII, 1–160. See also Zeller, *Philosophie der Griechen*, Vol. III/1, pp. 28–34.

10. Ibid. 43–44 and 82. See also Zeller, *Philosophie der Griechen*, Vol. III/1, p. 116.

11. Zeller, *Philosophie der Griechen*. Vol. III/1, p. 116. For this paradox see Chapter 10 below.

less.[12] However, with only the triochotomy of true/false/mean-
ingless in hand—in contrast to the presently contemplated mecha-
nism of comparative plausibility—this led the Stoics into difficulty
with the analysis of *The Heap Paradox* where this machinery is
✓clearly insufficient. Thus it is greatly to his credit that Chrysippus
made the important point that the Heap Paradox (Sorites) cannot
be resolved on the basis of classing the premises as true or false
or meaningless but requires a total suspension of judgment as to
✓truth status.[13]

What makes this Heap perplexity a "paradox of vagueness" is
that the imprecision of what a "heap" is undermines the accept-
ability of a generalized principle like $\forall i [\sim H(g_i) \rightarrow \sim H(g_{i+1})]$
which rides roughshod over the fact that a slippery slope is at
issue here. This sort of generalization rests on the mistaken
impression that the concept at issue is more sharply defined than
is the case. This can be seen graphically by looking at the situation
from a variant angle. Thus consider the (overly brief) series:

$$\bar{H}\,\bar{H}\,\bar{H}\;?\;?\;?\;H\,H\,H$$

Note here that the insertion of a group of indeterminate (neither
H nor \bar{H}) cases between the \bar{H}'s and the H's enables us to retain
the rule:

Whenever g_i is a non-heap, then g_{i+1} is not a heap that is, a
non-heap is never succeeded by a heap.

This thesis is, of course, subject to the interpretation that there
are now *two* ways of failing to be a heap, namely to be non-heap
✓(\bar{H}) or to be an indecisive or borderline heap (as indicated by ?).
It is now clear that (1) a single step forward from \bar{H} will never
carry us over to H, while nevertheless (2) a sequence of steps
along the series will *eventually* carry us from \bar{H}'s to H's.✓

The equally notorious *Phalakros (or Bald Man) Paradox* (from
the Greek *phalakros*—a bald man) is closely related since it simply

12. See Rüstow 1908, p. 115: *Cassantes autem dicunt, quod dicens se dicere falsum
nihil dicit,* or again *non est verum nec falsum, quia nullam tale est propositio.* See also
Prantl, *Geschichte,* Vol. IV, p. 41.
13. See Prantl I, 489. Sextus Empiricus, *Adv. Math,* VII, 416. Cicero, *Academica,* II,
29 and 93. See Zeller, *Philosophie der Griechen,* Vol. III/1, p. 116.

moves in the direction opposite from the Heap Paradox while otherwise being strictly analogous.

> A man with a full head of hair is obviously not bald. Now the removal of a single hair will not turn a non-bald man into a bald one. And yet it is obvious that a sufficient continuation of that process must eventually result in baldness.

The treatment of this paradox parallels that of the Heap Paradox. And here too those slippery slope iterations just do not work smoothly with vague concepts such as "being a heap"—or for that matter being tall or rich or bald. After all, the key to paradox resolution is the search for the weak spots—those chinks in the armor of paradox where its defenses are the weakest. And with the Bald Man Paradox this will once more be the iteration thesis which lays down that general rule: "loss of a single hair does not a bald man make."[14]

The *Millet Seed Paradox* of Zeno of Elea is an ancestor to these paradoxes. It too roots in the effect of unnoticeably small ("subliminal") differences, arising from the question of how it is that while dropping a single millet seed makes no sound, dropping a bushel of them makes a loud thud.[15] Leibniz used this example as a case in point for his theory of "minute," unnoticeably small, perceptions beneath the threshold of consciousness. In any case, in this instance also that iteration rule akin to mathematical induction becomes the weakest link in the plausibilistic chain.

5.2 The Color-Continuum Paradox

Consider the following situation which characterizes what might be called the *Color-Continuum Paradox*. We lay out a long row of color patches: say 100 of them. Any two adjacent ones are color-

14. Again, breaking up the general rule into a large series of particulars will make this paradox more baffling. For now while we can identify the region in which the remedy of premiss rejection must fall, we cannot pinpoint the exact location at which this must be effected.

15. The paradox also took a variant form in antiquity: a single drop of water effects no change on the form of a stone, while a long-continued succession of drops wears a hole in it. (See Aristotle, *Physics*, 253b14.)

wise indistinguishable to the unaided eye. But gradually and glacially we shift over to quite a different color by the time we get to the end of the series. We thus arrive at the aporetic cluster represented by the following four theses:

(1) Patches that are colorwise visually indistinguishable (to a normal observer in normal circumstances) have the same color.

(2) Patches [1] and [2] are colorwise visually indistinguishable, as are [2] and [3]. And so on up to patches [99] and [100].

(3) Hence—all these patches have the same color (by (1)).

(4) Nevertheless, patches [1] and [100] are visually distinguishable as having quite different colors.

Here {(1), (2), (4)} constitute an inconsistent triad. And since (2) and (4) are straightforward facts, it is the more suppositional (1) that must be abandoned. Color identity is something more complex than what can be settled by visual means alone.

However, we would again presumably not wish to abandon (1) outright—and there is no need to do so. But we would have to demote it from the realm of the flat-out true to that of the merely plausible. This would provide for its continued availability in other deliberations despite its contextual untenability in the present case.

5.3 Sir John Cutler's Stockings

The *Paradox of Sir John Cutler's Stockings* is based on a story that goes as follows:

Sir John Cutler had a favorite pair of stockings to which he was greatly attached. But over the years they wore out. Still he would not be parted from them. Bit by bit and piece by piece the stockings were repaired and rewoven over the years, with one successive repair superimposed on its predecessor until at last nothing of the original material remained. The puzzle

arises whether what remains at the end is still the same pair of stockings.

This story leads to the following paradox:

(1) When a smallish repair is effected on a stocking what results is still the same stocking. (Yet carried on sufficiently this can result in a total replacement of that stocking's fabric.)

(2) The final stocking results from the initial one through a succession of smallish repairs.

(3) Ergo (by (1) and (2)) the final stocking is the same as the original.

(4) When an ongoingly "repaired" material object like a stocking (or a car or a piece of furniture) no longer has a single bit of material in common with what was there initially it cannot count as the same object.

(5) Ergo (by (2) and (4)) the final pair of stockings is no longer identical with the original pair—contrary to (3).

The group {(1), (2), (4)} obviously constitutes an inconsistent triad, (3) and (5) being derivative claims. Now (2) is an observable fact. And (1) and (4) are general principles which, though both eminently plausible, are nevertheless such that (1) enjoys some advantage in point of its plausibility. (This advantage roots in the fact that (4) is the more ambitious in its range and generality.) We thus arrive at the priority ranking:

$$(2) > (1) > (4)$$

In seeking to break the chain of inconsistency at its weakest link we note that it is (4) that affords this point of greatest vulnerability. We thus arrive at the result that the R/A-alternative (2), (1)/(4) that is optimal, seeing that its retention profile {1, 1, 0} wins out over the available alternatives. To feel comfortable about this resolution we would certainly like to have a well-articulated rationale for (4)-dismissal—a fuller account of just why it should

be that it deserves to be relegated to the bottom of the plausibility ranking. And this demand can presumably be met by noting that familiarity with automobile repair and with the gradual replacement of the cellular material of a human body inure us to the prospect of identity despite replacement.

This paradox also takes the version of the *Ship of Theseus Paradox*, which is repaired plank by plank and spar by spar until not a bit of the original ship remains. Plutarch tells us that on Theseus's return journey to Athens from slaying the Minotaur, his men preserved the ship by replacing its rotten timbers with new ones.[16]

The following paradox is at issue here:

(1) Whenever only a single part is interchanged, the resulting ship remains the same, as was.

(2) When the totality of parts is interchanged the ships are interchanged.

(3) By (1) the initial and final ships in the possession of each of the parties are unchanged at the end of the operation.

(4) By (2) the initial and final ships in the possession of each of the parties have been interchanged.

(5) (4) contradicts (3).

Here (1) and (2) are inconsistent. And seeing that (2) seems more plausible than (1), the best plan would be to abandon (1) in its full generality, viewing it as a principle of limited flexibility that "can be stretched only so far." To be sure, it is somewhere between difficult and impossible to be precise about the limits of this flexibility since where a limit is not precise one cannot indicate it precisely. And it is this circumstance that marks the paradox as one of vagueness.

16. Plutarch's *Lives*, "Life of Theseus," 22–23. Clearly when only one or two planks are replaced it is still the same ship. But as the process continues, how long does this situation persist. Is it still the same ship when all of its fabric has been replaced?

5.4 The Hermeneutic Circle

Matters of degree often engender paradoxes of vagueness. Thus consider the *Hermeneutic Circle Paradox* encapsulated in the following theses:[17]

(1) We can get a firm grip on the meaning of verbal texts.

(2) One cannot firmly determine the meaning of a word without a firm grip on the meaning of its sentential (or even larger) context.

(3) One cannot firmly determine the meaning of a semantical (or even larger) context without a firm grip on the meaning of its component words.

(4) In view of (2) and (3), it is not possible to get a firm grip on the meaning of a verbal text(contrary to (1).

Here (1)–(3) present an inconsistent triad. And since (2)–(3) stand on essentially the same plausibility footing we effectively have to choose between abandoning (1) and abandoning the pair (2)–(3).

The pathway to resolution here lies in the consideration that the idea of a "firm grip on meaning" is not an on-off dichotomy but is actually a matter of degree, of more or less. And on this basis we can enter into a cyclic feedback alternation between word and context interpretation that enables us to achieve a stepwise escalation that provides an increasingly firm grip on the meaning ✓ of word and context alike.

An instructive lesson results from the sorts of examples that ⌐ have been surveyed here. For they show that the conception of

17. The idea (and terminology) of a hermeneutic circle is due to Wilhelm Dilthey (1833–1911), who saw this conception of a reciprocal interpretative dependency of part and whole as recurring at many levels, not just sentence/paragraph, but paragraph/book, book/genre, genre/cultural tradition. Dilthey regarded this phenomenon as characteristic of interpretation in the human sciences in general, not just at the textual level, but in plastic arts, cultural mores, ways of thinking, and other reactions of the human sciences. On the hermeneutic circle see D.C. Hoy, *The Critical Circle: Literature and History in Contemporary Hermeneutics* (Berkeley: University of California Press, 1978), and Paul Ricoeur, *Hermeneutics and the Human Sciences* (Cambridge: Cambridge University Press, 1981).

comparative plausibility is a serviceable instrumentality which enables us to have our cake and eat it too, as it were. In contexts where plausible propositions are unproblematic we can make use of them in pursuing our question-resolving inquiries. And where they prove to be contextually untenable we can abandon them *in this context* without necessarily incurring a total loss that must carry over to other contexts as well. The crucial point here lies in the previously stressed difference between acceptance *as plausible* and acceptance *as true*.

Paradoxes Considered in Chapter 6

- Aristotle's Paradox of Change
- The Teacher as Assassin Paradox
- The Plausibility Paradox
- Zeno's Paradox of Differentiation
- Zeno's Space Paradoxes
- Zeno's Achilles Paradox
- Zeno's Arrow Paradox
- Zeno's Moving Bodies Paradox
- Relation Riddles of Eubulides
- The Masked Man Paradox (Eubulides)
- Electra and Orestes (Eubulides)
- The Overlooked Man Paradox (Eubulides)
- The Reiteration Paradox
- The Garbage Truck Paradox
- The Master Argument Paradox
- The Mind-Body Paradox
- Frege's Morning Star Paradox
- The Categorization Paradox
- The Surprise Examination (or Execution) Paradox

Paradoxes of Ambiguity
and Equivocation
(Insufficient Distinctions)

6.1 Equivocation as a Road to Paradox

Nicholas of Cusa (1401–64), who propounded a doctrine of the coincidence of opposites (*coincidentia oppositorum*), maintained the paradox that all being is, as it were, nothing. But distinctions must be drawn in this regard since closer scrutiny indicates that what he had in view is that the maximum of being (God) is the minimum of comprehensibility because "nothing has no properties" (nihil sunt nullae proprietates) and we cannot ascribe properties to God since none of the properties of which we mere mortals can form an adequate conception can be attributed to God.[1] His words took on rather unaccustomed senses, however, and his minimum-maximum paradox is resolved by the fact that ✓different things are being measured. And this illustrates a more general situation.

One of the most common routes to paradox is through the mistakenly uniform use of a term or concept that actually has a plurality of senses and applications. Already Aristotle regarded such equivocation and ambiguity as a pathway to fallacy and paradox,[2] and his own example, "I saw him being beaten with my

1. Nicholas of Cusa, *Of Learned Ignorance* (translated by Fr. Germaine Heron (New Haven: Yale University Press, 1954); see pp. 17 and 39. True learning, Nicholas held, lies in grasping the inevitability of our ignorance: "The relationship of the intellect to the truth is like that of a [regular] polygon to a circle; the resemblance of the polygon to the circle grows with the multiplication on its angles, . . . but no multiplication of its angles—even if it were infinite—will make the polygon equal to the circle."
2. Aristotle, *Soph. Elen.*, 165b25ff and 177a40ff.

own eyes," affords a vivid illustration of the phenomenon.[3] This sort of statement is all too often a mere sleight of hand (or, rather, pen!) of this general sort.

In considering property-attribution claims of the usual format, *Fx*, the ancients noted that ordinary properties admit of qualification. Smith is young for a senator, but old for a carpenter's apprentice. Jones is heavy for a jockey but light for a Sumo wrestler. And to avert the logical conflict of the paradoxical claim that *x* is both *F* and not-*F*, Aristotle stressed that we have to construe that property attribution as something that is relativized ✓both as to time and as to respect. This led him to a version of the Principle of Contradiction that nothing can be both *F* and not-*F* at the same time and in the same respect. Distinctions of time and of respect here come into play as crucial paradox-averters.

Aristotle analogously contemplated what might be called the *Paradox of Change* which runs somewhat as follows:[4] "The young Socrates is clearly not old. But Socrates is always one and the same person. Hence the old Socrates is not old." The paradox here runs as follows:

(1) Socrates is always the same person.

(2) By (1), Young Socrates is Old Socrates.

(3) Old Socrates is old.

(4) Young Socrates is not old.

(5) By (2), (4) Old Socrates is not old.

(6) (5) contradicts (3).

Aristotle's analysis of the inconsistent triad represented by {(1), (3), (4)} is that paradox results from ignoring the factor of time. The verb "is" is equivocal. It can represent a timeless or time-

indexical

3. Aristotle, *Soph. Elen.*, 177b10–12. Another example he offered was: "This dog is a father. This dog is yours. Therefore, this dog is your father" (ibid. 179b14-15; but the example occurs already in Plato's *Euthydemus* 298D-E). Or again: "One can only give what one has. But one can give somebody a kick. And yet a kick is not the sort of thing one can have" (ibid, 171a5.)
4. Aristotle, *Metaphysics*, Book IV, Chapters 3–4, and compare *Categories*, Chapter 5.

indifferent relationship like that of the "is" of identity in (2), or a temporalized is-at-the-time relationship as in (3) or (4), now with "Old Socrates is old" to be construed as "Old Socrates is old at the time when he is Old Socrates." In the former (timeless) sense of "is" (1) is true but (3)–(4) false, while in the temporalized sense of "is" (1) is false (3)–(4) are conjointly true. And so the premisses of the perplex are never all-true-at-once. A failure to implement distinctions in point of time is, as Aristotle maintained, a fertile source of paradox as a failure to heed differences in respect. His Principle of Contradiction comes to the fore here. It is indeed true that "Something cannot both be and not be thus-and-so"; but one has to add "at the same time and in the same respect."

Consider in this light the Sophistical *Teacher as Assassin Paradox* of Plato's *Euthydemus* (283D) which runs: "Education is little better than murder, for to bring into being Alpha as he would like him to be (educated) is to do away with Alpha as he is (ignorant)." Here we must, of course, distinguish between the person as such—the individual Alpha as he is from birth to death—and his various temporal and descriptive stages in the course of change as per young/old or ignorant/learned. To change Alpha is certainly not to do away with him.

The scholastics of the middle ages, John Buridan preeminent among them, reveled in sophisms (*sophismata*) such as "Water has five letters; one can drink water; therefore, one can drink letters," a paradox that cries out for dissolution via a distinction that removes the equivocation as between the word "water" and the substance it stands for. Or again, the ancient paradox "Man belongs to the animal kingdom, so the animals possess man," obviously two senses of "belongs to," namely "is part of" and "is owned by."

Consider what might be called *The Plausibility Paradox* engendered by the following inconsistent triad:

(1) Plausible propositions can be accepted: they can appropriately be endorsed.

(2) Plausible propositions can engender apories: they can form inconsistent clusters of collectively incompatible propositions.

(3) It is never appropriate to accept (all of) a group of incon-
sistent propositions.

The exit from paradox in the face of this inconsistent triad lies in
noting the equivocation of the term "accept" as between (i) the
stronger sense of "accept as true" and (ii) the weaker sense of
"accept as credible/plausible" or "accept as a promising truth-
candidate" or the like. In sense (i), thesis (3) is correct but (1) is
false, while in sense (ii) thesis (1) is correct but (3) is false. (And
different things are at issue here: *provisional* acceptance as true is
no more actual acceptance as true than a bronze owl is an actual
owl.) Thus in neither case will all of those incompatible proposi-
tions obtain together, and the paradox is thus resolved. Any piece
of well-articulated reasoning is subject to the (usually tacit) pre-
supposition that *identical terms are being used in a uniform sense*:
that where different senses or uses of a term are at issue this will
be made explicit by some appropriate terminological complica-
tion. Equivocal premises become disconnected from one another.
In this sort of way, the identification of equivocal, ambiguous, or
vague terms can often unravel an apparent paradox.

Equivocation paradoxes can accordingly be seen as involving a
failure to satisfy a requisite communicative presupposition.

Working our way out of a distinction-neglecting paradox
requires close attention to the use of words in order to overcome
the verbal miscalculations that can arise. It is, after all, clear that
one principal avenue to paradox proceeds by running together
things that should be separated.

6.2 Zeno's Paradox of Differentiation

Zeno of Elea, born around 490 B.C., devised some of the most
celebrated paradoxes of all time—widely discussed and debated
already in classical antiquity.[5] Eight of these have come down to

5. On Zeno see Zeller, *Philosophie der Griechen*, Vol. I/I, pp. 746–765, as well as
Gregory Vlastos, "Zeno of Elea" in P. Edwards (ed.), *The Encyclopedia of Philosophy*, Vol. 8
(New York: Macmillan, 1967), pp. 368–379, and also G.E.L. Owen, "Zeno and the
Mathematicians," *Proceedings of the Aristotelian Society*, Vol. 58 (1957–58), pp. 199–222.
An informative collection of discussions of Zeno's paradoxes is Wesley C. Salmon (ed.),
Zeno's Paradoxes (Indianapolis: Bobbs Merrill, 1970), which also offers a bibliography of
some 140 entries.

us. One is the Millet Seed Paradox already considered on p. 83, and another the Racetrack Paradox discussed on pp. 59–60. Additionally, there are three directed against space and three against motion—all to be considered later in the present chapter—as well as the *Paradox of Differentiation* to which we now turn.

Zeno sought to support the doctrine of his teacher Parmenides that plurality must be denied and that at bottom all is one. According to Plato, "the first hypothesis of the first argument of Zeno's book" runs as follows:

> If existences are many, they must be both alike and unlike—alike in differing from all others, and unlike since they are not one and the same. But this is impossible, since unlike things cannot be like, nor like things unlike. Therefore, existences are not many.[6]

The paradox at issue here runs as follows:

(1) As we look about us, we see by the evidence of our own senses that existence is plural—that it is heterogeneous in that there are many different kinds of existents, and thus many existences.

(2) Let it then be supposed that existences—the kinds of existents that there are—are many.

(3) Then all existents have the common factor of differing from all the other kinds of things, of all the other existences. They are thus all alike in fundamental regard of differing from others and "being themselves," so to speak.

(4) But if existents thus have a fundamental feature in common they are all of the same kind, homogenous. So there is only one king of existent, only one existence.

(5) Since this consequence (4) contradicts (2) we have established not-(2) by a reductio ad absurdum. Thus existences are not many.

(6) But (5) contradicts (1).

6. See Plato, *Parmenides*, 127D.

Zeno saw this attribution to the same things of likeness and unlikeness as a violation of the idea later encapsulated in Aristotle's principle of contradiction. For him it threw doubt upon the extent to which reality honors logic. But as Aristotle himself (rightly) saw it, the problem here is one of equivocation: the matter is not one of being the same or different pure and simple but of being the same or different in one or another particular respect. On this basis, Zeno's Paradox of Differentiation paved the way towards the Principle of Contradiction.

6.3 Zeno's Space Paradoxes

Zeno also proposed a series of paradoxes designed to invalidate the entire idea of plurality of punctiform places in an extended space. He offered three arguments against an extended space composed of a plurality of places (or points) which run as follows:

I. "If there are many (spatial units) they must be both so small as to have no magnitude at all, and so large as to be infinite." If, as is said, spatial units have no magnitude, no extension, they will be nothing at all. So they must have magnitude if they are to exist and compose space. But now since they have extension, then they will have parts and their parts (e.g., their top half) would also have extension. And this in turn would also require extension, and so an ad infinitum. So spatial units would be infinite: they would not be parts of the spatial whole, but the whole of it.

II. Spatial units are said to be something. But if one is added to another then this other is (ex hypothesi) enlarged (that is, increased by what was added. But this, it is said, is not the case with spatial units: their addition does not enlarge, nor their subtraction diminish. Hence they are nothing.

III. Spatial units are said to be the constituents of larger (finite) wholes. But these larger wholes must then have

some fixed number of units (neither more nor less. But between any two distinct units there is yet another. So there cannot be any fixed number of them: they must be infinite in number.[7]

These perplexes are all paradoxes of equivocation: ✓

No. I involves two problems. First is the equivocation of "spatial unit" as between a single point and a small (atomic) region which leads to in the questionable supposition that no extension implies "no existence" rather than simply "no measurable size." Second is the mistaken idea that having "infinitely many extended constituents" implies "infinite in extent." As with Zeno's Achilles paradox this overlooks the fact that an infinity of (ever-diminishing) extensions can nevertheless run up to a finite total as per $\frac{1}{2} + \frac{1}{4} + \frac{1}{8} + \ldots = 1$.

No. II pivots on the idea that the addition of spatial units implies an increase in measurable size. If these "spatial units" are genuinely punctiform then this need not be so. (The interval from 0 to 1 is just as long in the way of measurement whether or not one includes the endpoint.)

No. III comes to grief on the fact that finite wholes can have infinitely many constituents (e.g., through successively taking away half of what is left). Moreover, with infinite numbers— unlike finite ones—the addition of more units need not lead to a different (larger) whole. When N is infinite we can (supposedly) achieve $N + 1 = N$. (Thus the series 1, 2, 3, 4, 5, . . . and 2, 3, 4, 5, 6, . . . have equally many members—as can be seen by pairing the first of each with that of the other, and then the second, and then the third, etc.)

To be sure, any adequate resolution of Zeno's spatial paradoxes calls for raising the level of mathematical sophistication beyond

7. This statement of the paradoxes is paraphrased from the texts given in John Burnet, *Early Greek Philosophy*, 4th ed. (London: Macmillan, 1930), pp. 315–16.

the level of ideas current in his time. For these paradoxes all pivot
on the erroneous supposition that what is infinitely divisible must
✓ be infinitely great. This would indeed be a telling argument
against the atomist if they were to hold that spatial units admit of
infinite divisibility—which it was the very reason for being of their
theory to deny. But it certainly does not hold against the geome-
ters—once they developed their theory of space to a level of suffi-
cient sophistication.

6.4 Zeno's Achilles and the Tortoise Paradox

Zeno of Elea also devised a series of ingenious arguments
designed to show the impossibility of motion. One of these was
the *Paradox of Achilles and the Tortoise*, based on the following
narrative:

> Notoriously fleet-footed Achilles has a race with a proverbially
> slow tortoise. Naturally enough, the tortoise demands a head
> start. But now by the time that Achilles reaches the tortoise's
> starting point the tortoise will have moved on and will be
> somewhat ahead. And when Achilles reaches *that* position the
> tortoise will have moved on and will still be ahead a bit. And
> so on. Thus Achilles will never catch up with the tortoise.[8]

The paradox at issue here goes as follows:

(1) At no stage of the endless sequence of positional catch-
 ups, will Achilles have succeeded in reaching the tortoise.
 Therefore—

(2) Achilles will never pass the tortoise.

(3) But—as we know full well—Achilles will soon pass the
 tortoise.

8. Kirk, Raven, Schofield, *The Presocratic Philosophers*, 2nd ed. (Cambridge:
Cambridge University Press, 1983), p. 272.

Here theses (1) and (3) are perfectly in order. But the chain of inconsistency is broken at (2) which actually does not follow from (1) at all because the move from "at no stage of the sequence" to "never" is simply inappropriate.

The fact of it is that a deep underlying equivocation is at work in the paradox as between "the sequence of catch-ups is *unending* (limitless) *in steps*" and "the sequence of catch-ups is *unending* (limitless) *in time*." The two expressions have a different sense. For the catch-up sequence just does not cover the whole of the future, seeing that it converges to a final limit even as $\frac{1}{2} + \frac{1}{4} + \frac{1}{8} +$. . . converges to 1. Thus the steps of that sequence, even in endless totality, will only cover a finite timespan.

Zeno's Achilles paradox is thus decisively resolvable through the recognition that an equivocation unravels the aporetic inconsistency through which it arises. (Whoever thinks that this unfavorable series does not sum up to one but always falls short of it just does not understand the function that those three little dots are serving here: they stand for *et cetera*, meaning and *all* the rest.)

Along these same lines, there is a cognate paradox already discussed by Aristotle (*Physics*, 239b 9–14). It runs essentially as follows:

> Suppose you wish to move from point *A* to point *B*. Before you can accomplish this motion, you must first reach point *C*, the halfway point between *A* and *B*. But before you can reach point *C*, you must first reach point *D*, the halfway point between *A* and *C*. And so on. Thus before you can accomplish any motion you must first accomplish an infinity of prior motions, which means that you can never accomplish any motion at all.

The situation here is, of course, identical with that of Zeno's Racetrack Paradox. And the road to resolution is thus the same in both cases. One is also reminded of Achilles and the Tortoise. There we had it that a limitless series of steps do not require a limitless amount of time; here we have it that a limitless series of steps do not require a limitless amount of space.

6.5 Zeno's Paradox of the Arrow

Another of Zeno's paradoxes of motion is that of *The Arrow*.[9]
What is at issue here is an aporetic collision among the following
theses:

(1) At any given instant the arrow does not move. (A clear
fact: instants are too short to allow movement.)

(2) A span of time consists of (nothing but) instants.
(A salient aspect of our understanding of time as a one-
dimensionally linear manifold.)

(3) The arrow is immobile: it never moves in any given span
of time. (From (1) and (2).)

(4) Arrows can and do move. (A fact of observation.)

Since we know (4) as a fact, it is clear that (3) must give way to it.
Accordingly, there is something seriously amiss within the pair
constituted by (1) and (2) from which (3) supposedly derives.
And yet both of these seem undeniably true, so that the paradox
is a really troublesome one.

The problem here actually roots in the first premiss because a
vitiating equivocation is at work. The fact that an arrow *does not
move DURING* an instant (an instant, being of its very nature,
too brief to allow the accomplishment of a movement) does not
mean that an arrow *is not in motion AT this instant*. And once this
distinction is drawn we come to realize that premiss (1) is equivo-
cal as between:

(1.1) At any given instant an arrow does not accomplish a
movement.

(1.2) At any given instant an arrow is not in motion.

Here premiss (1.1) is true but does not join with (2) to yield the
paradoxical (3). (The fact that arrow-motion does not accomplish
a movement *at* an instant does not mean that it is not accom-
plished over a great array of them—any more than the fact that a

9. Kirk, Raven, Schofield, *op. cit.*, pp. 272–73.

single letter conveys no information means that a text inducing a ✓great many of them cannot do so.) On the other hand, premiss (1.2), which does actually yield (3), is simply false. So neither way ⌐will an actual paradox result. The distinction between *being in motion* and *accomplishing a movement* is crucial for resolving this paradox because the former is actually compatible with instanteneity whereas the latter is not.

Zeno's Arrow paradox is geared to time. Its challenge is "But *just when* is the arrow moving? There is really no instant of time at which it moves." The Megarian Diodorus Cronus reformulated this paradox with respect to space, configuring it as a dilemma:

That which moves must either move where it is or where it is not. But it cannot move where it is, because that is a fixed location. And it cannot do anything—let alone move—where it is not. Hence it cannot move at all.[10]

The problem with this dilemmatic *Motion Paradox of Diodorus* ⌐is again one of equivocation. A distinction once more saves the day. The fact that an arrow does not move *at* its fixed, now-determinate position (but is only *in* motion there) does not mean that it does not move *from* this fixed, now-determinate position to another (exactly by virtue of being in motion). ✓

6.6 Zeno's Paradox of Moving Bodies

Zeno's *Paradox of Moving Bodies* runs as follows:[11]

Suppose we have three bodies, each of the same unit size. Initially they are in alignment. Then two are set into motion. While one of them (A) remains stationary, the second (B) passes it from left to right, and the third (C) passes it from right to left. The two moving bodies move at the same speed, say one unit per minute. Then after one minute *B* will have traveled one unit of distance since it will have passed by all of

10. See Zeller, *Philosophie der Griechen*, Vol. II/1, p. 266.
11. Kirk, Raven, Schofield, *op. cit.*, pp. 274–76.

A. On the other hand, *B* will have traveled two units of distance since it will not only have passed all of *C*, but have traveled one unit beyond it.

Initial After 1 Minute

Thus we have the contradiction both that *B* travels at 1 unit per minute and that *B* travels at 2 units per minute.

The resolution here lies in noting the equivocation of the idea of *speed* between an unrelativized and a relativized mode. Thus *B*'s velocity *relative to A* is 1 unit per minute, and *B*'s velocity *relative to C* is 2 units per minute. There is no contradiction in this when that essential relativization is heeded. We must simply avert the equivocation as between speed relative *to a fixed frame of reference* and *speed relative to the position of other particular objects*.

6.7 The Relation Riddles of Eubulides

Let us now turn from Zeno to the later Eubulides who flourished around 400 B.C. and taught at Megara, near Athens, conducting a prolonged controversy with Aristotle about the value of sophisms and paradoxes. Three of his paradoxes turn on the same issue, and can all be represented in the form of riddles: [12]

> *The Masked Man* (*egkekalummenos*): "Do you know this masked man?" "No." "But he is your father. So—do you not know your own father?"

Electra and Orestes. Electra saw that a man was approaching her. The man was her brother, Orestes. So—Did Electra see that Orestes was approaching her?

The Overlooked Man (*dialanthanôn*): Alpha ignored the man approaching him and treated him as a stranger. The man was his father. So—did Alpha ignore his own father and treated him as a stranger?

The same equivocation is at work throughout these *Relation Riddles of Eubulides*. In each case, there is, firstly, the individual *as the protagonist of the narrative takes him to be*, and, secondly, the individual *as the narrator takes him to be* (or as he actually is). In this regard, the paradoxes at issue are typified by that of the Masked Man, which in its elaborated forum runs somewhat as follows:

(1) You know who your father is.

(2) You do not know who the masked man is.

(3) The masked man is your father.

(4) By (2), (3), you do not know who you father is.

(5) (4) contradicts (1).

The problem here is that the "knowing who" of premiss (2) is equivocal and admits of a variety of modes. In mode No. 1 (subject's perspective) you do "know" who the veiled man is: he is that person over there. That is, under that description "the man in the mask standing over there" you do indeed know the masked man. And so premiss (2) is false. However, in mode No. 2 (narrator's perspective) you do not know who the masked man is, namely, you do not know that he is your father—and, consequently, you do not know your father's identity with the masked man. In mode No. 2, premiss (2) is thus true, but premiss (1) is now false. In this manner, all three of these riddles present typical paradoxes of equivocation. The point is that what a person knows can be stated both from the subject's and from the reporter's perspective. When I say that Caesar knew intimately the men who were to slay him, it is—clearly—the reporter's, and not the sub-

ject's perspective that is at issue. (Caesar would never have thought of Brutus as "my good friend and assassin.")

Eubulides was an opponent and critic of Aristotle. For Aristotle dismissed such sophisms of equivocation as mere errors, and careless mistakes of a sort. Eubulides, on the other hand, seems to have thought that a deep point is at issue, namely that we do not know things pure and simple but only in a relativized way, only under a certain description or from the vantage point of a particular cognitive perspective. And in this regard it would seem that Eubulides was entirely on the right track. Their insistence that things can only be grasped from the vantage point of a conceptual standpoint led to the Megarians being characterized as "friends of ideas (*tôn eidôn philous*)."[13]

6.8 Further Riddles

Consider the riddle: "Tom and John both had (different) cars. John said that he had the fastest car in town and Tom said the same thing. Did Tom agree with John?" A paradox arises here which might be called *The Reiteration Paradox*:

(1) John said that he had the fastest car in town.

(2) Tom said so too: that is, Tom said that John has the fastest car in town.

(3) Tom said so too: that is, Tom said that he (himself) had the fastest car in town.

(4) By (1) and (2) Tom and John are in agreement.

(5) By (1) and (3) Tom and John are in disagreement.

(6) (4) contradicts (5).

As (2) and (3) make transparently clear, this paradox roots in equivocation. For the expression "the same thing" as used in stating the riddle can mean either *the same contention or statement* (viz., "John has the fastest car in town") or the *same sentence or*

13. Prantl, *Geschichte*, Vol. I, pp. 37–38.

✓*form of words* (viz. "I myself have the fastest car in town"). Here the paradox is resolved by noting that one cannot have it both ways, and that with either alternative one member of the pair (5)-(4) becomes untenable so that the paradox is dissolved. ✓

And this sort of mismatch is generally the case with such riddles. Thus consider the classic riddle:

Q: What has four sets of wheels and flies?

A: A garbage truck.

This riddle is supposed to baffle us because things that fly just do not have four sets of wheels. And so the following *Garbage Truck Paradox* looms up before us:

(1) The object at issue has four sets of wheels and flies.

(2) Natural objects that fly (such as birds) do not have wheels.

(3) Artifacts that fly (such as airplanes) do not have four sets of wheels—they have two.

(4) The object at issue is either natural or artificial.

(5) Therefore: the object at issue just cannot both have "sets of wheels" and also fly, contrary to (1).

Escape from this riddle paradox lies in remarking the ambiguity of "flies." The riddle creates the expectation that "flies" is a verb here. But of course this could also be a noun, with "has flies" = possess or is accompanied by flies. Thus (1) and (5) are disconnected by the fact that (1) sees "fly" as an insect-indicative word ✓while (5) sees it as a transport-indicative verb. Again, that crucial (if tacit) supposition of a uniformity of meaning is violated. And once the appropriate distinctions are introduced, the premisses of this *Garbage Truck Paradox* are disconnected with the result that the paradox dissolves. As Aristotle stressed, the drawing of distinctions affords an effective device for the management of equivocation paradoxes.[14] ✓

14. See *Soph. Elen.*, 175b27–38.

The sophists of pre-Socratic Greek antiquity relished something/nothing puzzles.[15] They deliberated over such questions as "If nothing ever comes from nothing, how can anything come to be?" And they were drawn to such riddles as:

Q: What is that which isn't?
A: Nothing!

or in a somewhat more elaborate formulation:

Q: How can anything be something that is not something?
A: By being nothing.[16]

Plato's dialogue *The Sophist* is full of reflections on this sort of <u>Something/Nothing Paradox</u>, whose formal structure is roughly the following:

(1) Everything is self-identical: anything whatsoever is whatever it is.

(2) Therefore: Nothing is nothing. (From (1).)

(3) To say that X is Y is to say that X is something-or-other.

(4) Nothing is something or other. From (2), (3).

(5) Whatever is something-or-other is not nothing.

(6) Nothing is not nothing. From (4), (5).

(7) (6) contradicts (2).

Here {(1), (3), (5)} constitutes an inconsistent triad. And (3) is the Achilles Heel of this aporetic situation. For it confuses the *is* of predication (as per X *is* Y, "Fiction is unreal") with the *is* of being (with *is* as *exists*, that is, as being something-or-other in the realm of reality).

15. Gorgias even entitled his treatise "On Nature or That Which Is Not."
16. Lewis Carrol's *Alice in Wonderland* offers the following variant: "I see nobody on the road," said Alice. "I only wish *I* had such eyes," The king remarked in a fretful tone. "To be able to see Nobody! And at that distance too! Why, it's as much as *I* can do to see real people, by this light!"

The fact of it is that nothingness as an abstract condition exists in the same way that any other abstraction does—self-identity or complexity or the like. But *nothing* is just that, utter vacuity, the total absence of things, and not the presence of some peculiar sort of thing, a "nothing." To say "Nothing has the feature *F*" is to say that "no existing thing has this feature," symbolically ~∃xFx or equivalently ∀x~Fx. It is not to say that there is some strange sort of existing or quasi-existing thing, a non-thing or *Unding*, called Nothing, that possesses this feature (symbolically ∃x(x = n & Fn).)

Plato's puzzle question how can we can regard "nothing" as total vacuity when it is clearly something, to wit nothingness, the object of theoretical concern, consideration and discussion—can be resolved on this basis. What we are talking about is indeed something—viz. nothingness, the condition of utter vacuity. But this does not mean that by saying (for example) that nothing lacks all properties (*nihil sunt nullae proprietates*) we are denying properties to a certain sort of thing—a particularly negative object called "nothing." All of those something/nothing paradoxes are based on an equivocation in "nothing" that leads to a confusion between the absence of any objects designated by the term to the inevitably present *sense* or *meaning* of the term itself.

As such examples indicate, riddles will often engender a paradoxical situation that we can avert by unmasking an equivocation. Such riddles pivot on conceptual (rather than optical) illusions.

All of the preceding examples are instances of what might be called the *dilemmatic equivocation collapse* of a paradox. This occurs when the paradox in question has premisses so interconnected by a common equivocal term that in every case the sense which makes a given premiss true renders some of the others false, so that in trying to make the premisses true one is caught in a defeating dilemma.

6.9 The Master Argument of Diodorus (Kyrieuôn)

Perhaps the most important ancient continuator of Zeno's assault on motion was Diodorus Cronus (born ca. 350 B.C.)[17] He devel-

17. See Zeller, *Philosophie der Griechen*, Vol. II/1, pp. 247–48 and 266–271.

oped four arguments against motion that were, in effect, varia-
tions on the theme of Zeno. However, the most famous paradox
proposed by Diodorus Cronus is the following Master Argument
Paradox:[18]

(1) There is contingency in nature, that is, there are actual
 states of affairs that are not necessary but merely contingent
 (in that their non-realization is, theoretically, possible).

(2) The possible cannot engender the impossible: no possible
 state of affairs can produce a consequent one that is
 impossible.

(3) Once a state of affairs is realized it is impossible to change
 it: whatever is actual thereby becomes necessary. And so
 after the fact the nonoccurrence of anything actual is
 impossible.

(4) By (2) and (3) no possible state of affairs can result in the
 nonoccurrence of anything actual. For the nonoccurrence
 of anything actual is (ultimately) impossible by (3) and the
 possible cannot engender the impossible (by 2). In conse-
 quence, anything actual is necessary.

(5) (4) contradicts (1).

What we have here is a paradox of equivocation. We must distin-
guish between what is necessary or impossible *after the fact* and
what is so even *in prospect*.

Thus (2) is problematic and can obtain only if suitably con-
strued. For what is possible before the fact can indeed engender
something that is impossible after the fact on grounds of being
incompatible with it.✓

6.10 Sameness amidst Change: Mind-Body
 Equivocation

Paradoxes of equivocation often arise in philosophical contexts.
Consider, for example, a hypothetical situation of the sort illus-
trated by the following *Mind-Body Paradox:*

18. For the Master Argument and its literature see the author's "A Version of the
'Master Argument' of Diodorus," *The Journal of Philosophy*, vol. 63 (1966), pp. 438–445.

X and Υ were hooked up to a thought-transfer machine. And as a result all of their thoughts—knowledge and memories, likings and tastes—were interchanged. As a result the bodies of these people continued unchanged. It was just their minds that were interchanged—the entire content thereof. Which one is X and which one is Υ?

The issue turns on whether it is bodily continuity that is pivotal ✓for personal identity or continuity of thought and personality. And the following paradox arises:

(1) After the transfer process, the possessor of X's body is also the possessor of Υ's mind, and conversely.

(2) Bodily continuity is the definitive factor that is crucial for personal identity.

(3) Ergo—the post-operation possessor of X's body is X, and the same for Υ.

(4) Mental continuity is the definitive factor that is crucial for personal identity.

(5) Ergo—the post-operation possessor of X's mind is X, and the same for Υ.

(6) Two different individuals are at issue. No one can be *both* X and Υ.

Here {(1), (2), (4), (6)} constitute an inconsistent quartet. But (1) is fixed by the defining hypotheses of the problem, and (6) is an incontrovertible fact. So we have the priority ranking:

$$(1) > (6) > [(2), (4)]$$

On this basis, we will have to abandon at least one of (2) and (4). However, since in the existing circumstances these two contentions are to all visible intents and purposes "in exactly the same boat," we have little option but to abandon both of them, plausi- ✓ ble though they seem.

And the justification for doing so could plausibly run as follows: Both (2) and (4) rest on the "definitive factor" supposition that "personal identity" is a clearly defined, precisely articulated

concept whose application rests on a single determinative factor (bodily continuity in the one case and mental continuity in the other). But if we regard this supposition as false and view the concept of "the same person" at issue in personal identity as a complex concept that involves an admixture of bodily and mental considerations—a mix whose nature is not altogether clear and definitive—then the props are pulled out from under theses (2) ✓and (4). The paradox can thus serve as a roadway towards an instructive lesson: personal continuity is something complex and many-sided—no one single factor should be seen as decisive here✓ Perhaps the lesson is even that personal sameness is an equivocal idea and that—at least in theory—one should distinguish between physical and mental sameness. ✓

6.11 Frege's Morning Star Paradox

Along these lines consider the *Morning Star Paradox* due (in essence) to the German mathematician Gottlob Frege:

(1) The Morning Star is not the same as the Evening Star.

(2) The Morning Star is the same as the planet Venus.

(3) The Evening Star is the same as the planet Venus.

(4) The Morning Star is the same as the Evening Star. (From (2) and (3)—contrary to (1).)

Here again there is a paradox of equivocation. The expression "the Morning Star" and "the Evening Star" refer to the same object by different characterizations associated with different ✓identificatory-descriptive properties. Hence (1) is appropriate because distinctly different *modes of identification* are at issue. But the *objects of reference*—the things being referred to—are one and the same, and both (2) and (3) are appropriate on this basis. The items at issue with "the Morning Star" and "the Evening Star" are different *identificationally* but identical *referentially*, and we must correspondingly distinguish between the *sense* of the identificatory expression at issue and its objective *reference*. With "is the

same as" construed *identificationally* (2) and (3) are false but (1) is true; with "is the same as" construed *referentially* (1) is false but (2) and (3) are true. Accordingly, this distinction dissolves the paradox since the sense of the relevant terms needed to render certain of its premises true will falsify others. ✔

The situation is substantially the same as that of the Relation Riddles of Eubulides. We have to do with one and the same thing under different identifying characterizations. ✔

6.12 The Categorization Paradox

Again, consider what might be called the Categorization Paradox. Some items can be categorized as defining a certain collection or group: rivers crossed by George Washington, for example, or things that have been transported by train. Others we cannot categorize—or indeed even form a conception of them, much as Caesar could not form a conception of electrical appliances. Yet is not the idea of things we cannot collect together in a categorization group a contradiction in terms? For in speaking and thinking of them in this sort of way, have we not already categorized them, namely as Uncategorizable? To all appearances there is a paradox here, due to the fact that the uncategorizable ipso facto becomes categorizable in just exactly that way. ✓

On this basis we appear to be trapped within the aporetic duo:

(1) There are uncategorizable things.

(2) Anything uncategorizable can be categorized.

The resolution of this paradox lies in the fact that there is an equivocation at work here. We have to distinguish between the initial category-impoverished situation and the subsequent category-enriched situation that ensues upon introducing the pseudo-category of what is Uncharacterizable in terms of those initially envisioned categories. With respect to pre-categorizability thesis (1) is true but (2) is false, while with respect to post-categorizability (1) is false but (2) is true. Neither way will both premisses crucial to the paradox be co-tenable. A distinction has again saved the day.

6.13 The Surprise Examination (or Execution)

What has become known as *The Surprise Examination Paradox*[19]
further illuminates the role of equivocation as a source of para-
dox. It arises in the prosaic-sounding situation of the following
narrative:

> There is a schoolteacher who announces: "Class, you had best
> do a lot of reviewing this week-end. For there will be an exam-
> ination on the topic next week. However, I am not going to
> tell you on what day the exam will come; its timing will be a
> surprise—the exam will not be foreseeable in advance." Now
> in the class there is one over-clever student who reasons as fol-
> lows: "The teacher has promised us a surprise examination.
> But the exam cannot be on Friday, the last school day of the
> week. For it is supposed to be a surprise, and if it has not taken
> place by Thursday, then its coming on Friday, the last possible
> day, would no longer be surprising. It will become foreseeable
> after school on Thursday. So Friday is out. But if Friday is out,
> then so is Thursday. For if the exam has not taken place by
> Wednesday, then (since Friday is out) it would have to be on
> Thursday. And so its falling on Thursday would also conflict
> with its stipulated surprisingness. And the further steps along
> this road are now easy. For if Thursday and Friday are both
> out, then—by parity of reasoning—the exam cannot come on
> Wednesday either. And then similarly with Tuesday and with
> Monday. In consequence, the whole idea of a surprise exami-
> nation is an impossibility and we have nothing to worry
> about." So reasons the over-clever student, who accordingly
> predicts that there will be no examination at all, taking the
> teacher to have promised surprise and concluding that in the
> circumstance this rules the examination out.

19. The Surprise Examination Paradox was initially presented as a surprise *hanging*
paradox and eventually also recast into other guises (such as a surprise military inspection
or a surprise wartime blackout). Its original version was presented in a paper by W.V.
Quine circulated in the early 1940s but not published until a decade later as "On a So-
Called Paradox" (*Mind*, vol. 62 [1953], pp. 65–67; reprinted in Quine 1966). In the
meantime, it was discussed by D.J. O'Connor (1948), L.J. Cohen 1950, M. Scriven 1951,
P. Weiss 1952, and others. For a survey of proposed solutions see Avishai Margalit and
Maya Bar-Hillel, "Expecting the Unexpected," *Philosophia*, vol. 13 (1983), pp. 263–288.

What is one to make of this predictive puzzle, which some writers present in terms of a surprise execution with a judge taking the place of the teacher?

The aporetic situation at issue can be represented by means of the following theses:

(1) The examination will occur next week.

(2) The examination may occur on any day of the next week, bar none.

(3) When it occurs, the examination will be a surprise to the students up to the very day that it is given.

Here (2) implies that the examination may occur on Friday. But (1) and (3) imply that the examination cannot occur on Friday (since it will then obviously be predictable when it has not yet occurred by Thursday).

How is this chain of inconsistency to be broken? Let us examine the possibilities. As regards plausibility, we have it that (1) and (2) state fixed facts that are parts of the defining condition of the problem. What is at issue here lies (by hypothesis) entirely within the teacher's power. Thus (3) is the weakest link in the chain and we have it that the plausibility situation is [(1), (2)] > (3), with (1), (2)/(3) as the appropriate resolution thanks to its optimal retention profile of {1, 0}.

There is in fact good reason to see (3) as problematic. Its vulnerability roots in the fact that it suffers from a vitiating equivocation by *failing to fix the temporal as-of-when specification of the impredictability or surprise at issue.* (After all, no event is surprising after the fact.) Now on Friday, on the morning of the school-week's last day, one can no longer see as surprising the threatened examination that has not occurred up to that time. That is, the timing of the examination can no longer be surprising *as of then.* But *at the time of the announcement* prior to the week at issue—or indeed on the Monday of that week itself—the fact of the exam's falling on Friday would assuredly be a surprise since it certainly could not *then* be predicted on the basis of evidence in hand. To be sure, as of the end of school on Thursday the surprise will be gone. But the choice of Friday would certainly be a surprise during the week before. And the same with any other day of the

week. And so, if the day of the examination is kept concealed at the time of announcement, then we have a surprise examination alright (rather than a pre-scheduled one)—though of course the surprise inevitably vanishes with the passage of time. The long and short of it is that inability to pinpoint occurrence times is nothing absolute but is itself a matter of timing. One must acknowledge both (*i*) that there cannot (in the logical nature of things) be an examination that is surprising at or after the fact, and (*ii*) that there cannot be a day-deadlined examination that is surprising up to the day of administration, even after the next-to-the last day has passed. The fact, however, remains that an examination whose timing is a surprise sufficiently early on thanks to its impredictability *at that earlier time* is an unproblematic possibility.

And so the crux of this supposed paradox is that one must give due heed to the temporal reference-point relative to which the timing of the "surprise examination" is indeed surprising. All that the teacher has promised is that the day of the examination will be an unpredictable surprise *at the time of the announcement,* and not necessarily at various later junctures (which, as the paradox shows, is in some cases impossible). Owing to the equivocation of that pivotal aporetic thesis, there is no actual *paradox* of prediction here, only the vitiating flaw of equivocation inherent in neglecting the time as of which surprise obtains—that is, a failure to grasp the norms of surprise. And so, that over-clever student who pits himself against the instructor via the prediction "There will be no examination at all" is thereby in reality setting himself up for an all the more assured surprise when the examination actually occurs—*whatever* the day may be.

The value of paradoxes as an instrument of inquiry is strikingly exhibited by these paradoxes of ambiguity and equivocation. For the discovery and validation of the distinctions needed to eliminate inconsistency is and ever has been a powerful instrument for fostering clarity of thought and perceptiveness of understanding.

Paradoxes Considered in Chapter 7

- "Third Man" Paradox

- Aristotle's Sea Battle Paradox

- Kierkegaard's God Paradox

- The Existential Paradox

- The Time Travel Paradox

- The Divine Foreknowledge Paradox

- The Paradox of Explanation

- The Freedom/Causality Paradox

- The Promise-Breaking Paradox

- The Form/Matter Paradox of the Presocratics

- The Socratic Paradox of Ethics

- The Divine Omnipotence Paradox

- The Self-Advantage Paradox

Philosophical Paradoxes

7.1 Philosophical Paradoxes

Paradoxes arise in philosophy principally because of discord within the wider community of philosophers. Conflicting doctrines find their advocates. One philosopher or school builds up a case for one contention and another philosopher or school builds up a case for an rival contention incompatible with the first. If (or, rather since) the plausibility of a philosophical contentions must be understood on the liberal democratic basis of having *some* philosophers on its side (rather than approval of one authoritative philosopher or school), it's little wonder that plausible con-tentions can come into aporetic conflict in this domain.

Opponents of Plato's Theory of Ideas, deployed the notorious "*Third Man*" *Paradox* which stands effectively as follows:[1]

(1) What makes distinct objects into items of the same type is assimilation to an Idea. Individual men are alike as men because they all participate in similarity-kinship to the ideal and eternal archetype of Man. (This, in essence, it the core of Plato's theory.)

(2) But if this is so in general, then what assimilates this or that individual man to the Man-idea must be their com-mon participation in yet another super-idea, Man No. 2, that assimilates a man and the Man-idea to one another. ✔

1. The Third Man argument was launched against the Theory of Ideas by Parmenides in Plato's dialogue of that name. It was emphatically endorsed by Aristotle in *Metaphysics*, 990b15–23 and 1031b19–1032a7. See Prantl, *Geschichte*, Vol. I, pp. 18–19.

(3) And this process will continue *ad infinitum*: We now need Man No. 3 to liken Man No. 2 to the first-order Man-idea(and so on.

(4) A viable doctrine cannot involve itself in an infinite regress. Thus—contrary to (1)—Plato's Theory of Ideas is not viable.

Why not 4?.

As Plato's critics saw it, the sensible way out of this paradox is to jettison (1) thereby abandoning Plato's Theory of Ideas. (To be sure, a defender of Plato's theory would doubtless abandon (2) and see the participation relationship between individuals and ideas in terms other than type-similarity.)

Consider next the following *Sea Battle Paradox* put on the agenda of philosophical deliberation by Aristotle:

(1) Truth is timeless. If a (fully definite) statement is ever true, then it is true always and everywhere, and is as true the day after tomorrow as it is today.

(2) If a statement about what happens tomorrow is already true today, then what it claims will be inevitable, an accomplished fact, as it were, that is effectively fated and predestined.

(3) One of the two statements "A sea battle will take place in the bay on [tomorrow's date]" and "A sea battle will not take place in the bay on [tomorrow's date]" will be true on the day after tomorrow.

(4) It is already fixed, certain, and inevitable that the sea battle is or is not going to occur. (From (2), (3).)

(5) But since free will exists and the battle arrangements and place are not as yet fixed and decided, that putative sea battle tomorrow is not something that is already fixed, certain, and inevitable—contrary to (4).

These statements clearly constitute an aporetic circle of inconsistency that will have to be broken. And—naturally enough—the philosophers who have wrestled with the pattern have disagreed about the plausibilities of the case.

Aristotle himself saw (1) as the culprit—the weak link in the chain. And the reason—as some interpreters see it—is that propositions like "A sea battle occurs on [tomorrow's date]" are not true timelessly but become true as of the date of the events in question and then remain so. (Earlier on they are in a truth limbo.)

The Megarian theorists of classical antiquity opted to reject thesis (5). They were determinists who sought to exclude chance and contingency from the world.

By contrast, modern theorists often opt for rejecting thesis (2). The truth of temporalized statements is, they would argue, solely and exclusively dependent on what happens *at the* time talked about in the statement. And on this basis truth is wholly and entirely detached from matters of determinism, inevitability, and predetermination.✓

However, what is perhaps the most sensible approach is as follows. Clearly {(1), (2), (3), (5)} constitutes an aporetic quartet. Now here (1) and (3) are fundamental principles of the theory of truth. However (2) and (5) are more problematic and speculative theses about fate, inevitability, and predestination. So we arrive at the priority ordering [(1), (3)] > [(2), (5)], with the result that the R/A-resolutions (1), (2), (3)/(5) and (1), (3), (5)/(2) are tied for optimality with a retention profile of {1, $\frac{1}{2}$} We have, in effect, a standoff between two possible exits from inconsistency: abandoning (2) with its idea that preset truth entails future inevitability, and abandoning (5) thereby accepting the idea of predeterminative inevitability and predestination. The resolution of *this* choice lies beyond the reach of general principles and calls for the deployment of a substantive philosophical doctrine. ✓

Philosophical theology provides a further illustration of the sort of complexities involved. According to Søren Kierkegaard it is a paradox of Judeo-Christian philosophical theology that humans cannot conceive of God as he really is. *Kierkegaard's God Paradox* envisions the following inconsistent triad:

(1) It is rationally appropriate to worship God.

(2) A rational being will not—cannot—worship something he does not properly understand.

(3) Man cannot understand God properly.

Seeing (1) as rendered problematic through its linkage of religion to rationality, while accepting (2) and (3) as evident facts of life, Kierkegaard envisioned the priority ranking: [(2), (3)] > (1). Accordingly he maintained (1) must be rejected. As he saw it, the demand for a rational comprehension in matters of religion is ✓untenable and inappropriate. Thus Kierkegaard did not take the atheist's easy route to (1)-rejection. Instead, with St. Paul and Pascal, he viewed religious faith as something above and beyond reason—something that, with Tertullian, might have to be acknowledged in the face of its inherent contradictions. ✓

To be sure, a prioritization of commitments can provide a way of resolving a dilemma. (In thinking *about* religion—as contrasted with thinking *within* religion—Kierkegaard would like us to maintain consistency.) However, as the example indicates, the priorities cannot always be seen as clear-cut, and theorists operating with different priorities might be perfectly content to abandon (2) or (3).[2]

Philosophers of the "existentialist" school are drawn to the *The Existential Paradox*, which turns on the idea that birth (the entry into life) is automatically the start of an unavoidable transit towards death (the exit from life).[3] Formally elaborated, the paradox runs somewhat as follows:

(1) The processes of organic nature are all geared to the realization and amplification of life.

(2) Life is indissolubly linked to death: every living organism is on an inescapable journey towards death. Nature is characterized by the death tropism of its organic beings.

(3) (2) is incompatible with (1).

Here (1) is clearly the more speculative and problematic contention, seeing that (2) is effectively a "fact of life." But (1)'s abandonment would presumably be coordinated with a distinc-

2. On theological paradoxes see H. Schröer, *Die Denkform der Paradoxalität als theologisches Problem* (Göttingen: Vandenhoeck and Ruprecht, 1960). See also Gale 1991.
3. On this paradox and its theological and psychological ramifications see Howard A. Slaatte, *The Persistence of Paradox* (New York: Humanities Press, 1968).

tion between life at the level of individuals and life at the level of species. Thus thesis (1) would be accepted with regard to large-scale aggregates of individuals but not with regard to particular individuals. Indeed, the mortality of individuals could/would be represented as a means to foster the well-being of the mass. Here, as so often, distinctions provide a means towards salvaging something in the wake of thesis abandonment.

The *Time Travel Paradox* is a science fiction fixture:[4]

(1) Time travel is theoretically possible.

(2) By going into the past, the time traveler can encounter his own ancestors.

(3) The time traveler can interact with the people he meets, and—in particular—can kill them.

(4) In view of (3), the time traveler can prevent his own birth by killing one of his antecedents.

(5) Contrary to (1), time travel is impossible since it involves the absurd prospect of preventing one's own birth.

The possible modes of resolution are readily surveyed:

(1)-abandonment. Rejecting the possibility of time travel altogether.

(2)-abandonment. Rejecting the possibility of time-travel access to certain spatial sectors of the temporal past.

(3)-abandonment. Enjoining the time traveler to causal impotence in at least some domains.

(4)-abandonment. Precluding the time traveller from certain kinds of self-interference.

4. On time travel and its philosophical ramifications see John Earman, "Recent Work on Time Travel," in S. Savitt, ed., *Time's Arrow Today* (Cambridge: Cambridge University Press, 1995).

In view of the highly conjectural nature of the issue, the solutions
✓ of the paradox must be highly conjectural as well. But as the pre-
ceding indications show, the speculative philosophy of science
offers various doctrinal possibilities for resolving the time-travel
paradox. Again, the assessment of comparative plausibilities
‑ requires taking a stance on the substantive issues at stake.

The conceptual complexity of philosophical issues is such that
it is easy to be caught up in problems of terminology. For this rea-
son the philosophical paradoxes are a fertile source of examples of
‑paradoxes of equivocation. Thus consider the classic *Divine
Foreknowledge Paradox* from philosophical theology based on the
following inconsistent quartet:[5]

(1) Man is a free agent.

(2) Being omniscient, God must know—even "in advance,"
so to speak—how human decisions will eventuate.

(3) But if human decisions are foreknown they are thereby
temporally predetermined. Given that what one does is
foreknown to God, one cannot do otherwise.

(4) Accordingly, man is not a free agent, since the capacity to
decide and to act differently is the crux of freedom.

The resolution of this paradox depends on one's basic views of
God, man, and their relation. Theological determinists see (1) as
the weakest link and opt for a position of deterministic predesti-
nation. Other theorists abandon (3) and propose a more sophisti-
cated theory according to which divine foreknowledge does not
entail predetermination and is compatible with the freedom of
man's will. Still others reject (4) and see freedom as residing not
as a capacity to act differently but rather in the accord between
one's actions and one's deliberative decisions, foreknowledge of
which would therefore not impede freedom. Still others dismiss
(2), arguing that foreknowledge must be abandoned because
omniscience is a matter of knowing not literally everything but

5. For ramifications of this paradox and many related paradoxical issues see Gale
1991.

only everything that can be known—which is not the case with yet unresolved free human decisions.

As this plethora of possibilities indicates the topic is fodder for dispute and John Milton's frustrated devils were constrained to debate in vain this issue of "Fixt Fate, Free Will, foreknowledge absolute/And found no end, in wand'ring mazes lost" (*Paradise Lost*, II, 559–560). All their endeavors were fruitless, since alone among God's rational creatures those devils were themselves subject to a "fixt Fate"; losing their free will after its inappropriate exercise led to their expulsion from heaven. ✔

7.2 Philosophical Apories Tie Issues Together

In philosophical epistemology the need arises to come to grips with the following *Paradox of Explanation*:

(1) *Principle of Sufficient Reason*: Every fact needs and (in principle) has a satisfactory explanation.

(2) *Principle of Noncircularity*: No fact is self-explanatory. And none can appropriately figure in its own explanatory regress.

3) *Principle of Comprehensiveness*: No explanation of a fact is satisfactory so long as (any of) its explanatory materials themselves go unexplained.

(4) But then since the facts at issue at any stage of the explanation must be explained, and this explanation itself requires something new and yet unexplained (by (4)), it follows that no fact can ever be explained satisfactorily.

(5) (4) contradicts (1).

Here (1)–(3) constitute an inconsistent triad. At least one of the plausible principles of this aporetic cluster has to be abandoned in its unqualified generality. There are three exits from this situation:

(1) - rejection. The acceptance of surds, of brute facts that must be accepted without themselves having or needing explanation.

(2) - rejection. Allowing some facts to play a role in their own explanation—perhaps by adopting a nonlinear ("coherentist") model of explanation that distinguishes between vicious and virtuous explanatory circles. ✔

(3) - rejection. Accepting an explanation as satisfactory once it reaches a point where the materials at issue are substantially clearer and more perspicuous then the fact being explained—a point where sufficient explaining has been done that we are entitled to call it a day.

Three very different philosophical positions are involved here: surdism, coherentism, and explanatory pragmatism. And it is clear that the apory at issue interlocks them into a coordinated interrelationship.

Consider the *Freedom/Causality Paradox* of the following aporetic cluster, which sets the stage for controversy about freedom of the will:

(1) All human acts are causally determined.

(2) Humans can and do act freely on occasion.

(3) A genuinely free act cannot be causally determined—for if it were so determined then the act is not free by virtue of this very fact.

These theses represent an inconsistent triad in which consistency can be restored by any of three distinct approaches:

(1) - rejection: "Voluntarism"—the exemption of free acts of the will from causal determination (Descartes).

(2) - rejection: "Determinism" of the will by causal constraints (Spinoza).

(3) - rejection: "Compatibilism" of free action and causal determination—for example, via a theory that distinguishes between inner and outer causal determination and sees the former sort of determination as compatible with freedom (Leibniz).

Again we have a variety of philosophical positions interlocked through their common role in an aporetic situation. And in this case the issues can be addressed by disentangling our knotted terminology through suitable distinctions.

7.3 Philosophical Plausibility

In point of strategy, the way to resolve a paradox in philosophy is the same that we must adopt anywhere else, to wit: thesis abandonment, hopefully accompanied by some partially salvaging distinction. And, of course, the more plausible we deem the thesis—the better we deem the case for its retention to be—the harder we have to "bite the bullet" when faced with its loss.

The problem with philosophical paradoxes is that the crucial business of determining the comparative priority and precedence of theses is seldom altogether straightforward in this domain. It is something that depends on assessments and evaluations that are likely to be sensitive to the specific ideological sensibilities of the problem solver.

But how to proceed? What is our standard of priority to be? With philosophy, our guidance for making these curtailments lies in the factor of overall systematicity. The operative principle at work here is that of achieving the optimum alignment with experience—the best overall balance of informativeness (answering questions and resolving problems) with plausibility (keeping to claims which on the basis of our relevant experience there is good reason to regard as true). We want answers to our questions but we want these answers to make up a coherent systematic whole. It is neither just answers we want (regardless of their substantiation) nor just safe claims (regardless of their lack of informativeness) but a reasonable mix of the two—a judicious balance that systematizes our commitments in a functionally effective way.[6] And this goes for paradoxes as well. Here too it is not just locally but globally adequate solutions that one would ideally want.

6. The aporetic nature of philosophy and its implications are explored in detail in Nicholas Rescher, *The Strife of Systems* (Pittsburgh: University of Pittsburgh Press, 1985). The book is also available in Spanish, Italian, and German translations.

7.4 The Role of Distinctions

Whenever the resolutions of philosophical paradoxes requires the *abandonment* of some of the theses involved in the conflict there just is no easy way out that is altogether cost-free. The issue is always one of a choice among alternatives where, no matter how we turn, we find ourselves having to abandon something which on the surface seems to be plausible. And at this point distinctions serve another important function. For whenever one of the premisses of a paradox has to be abandoned in the interest of a consistency-restoring solution, damage-content efforts can be made to salvage some element of that non-abandoned premiss by introducing a distinction to divide it into an untenable and a tenable part.[7]

Consider an example. *The Promise-Breaking Paradox* has played a significant role in ethical theory. It runs as follows:

(1) Promise breaking is morally wrong.

(2) It is never morally wrong to do what we cannot possibly help doing.

(3) In some circumstances one cannot help breaking a promise: promise breaking is circumstantially unavailable.

One way of proceeding here is to distinguish between *voluntary* and *involuntary* promise breaking. In the voluntary sense of the term "promise breaking" (1) is true but (3) false, while in the involuntary sense of the term (3) is true but (1) false. The paradox suffers a dilemmatic collapse on grounds of equivocation. But we could now salvage something from the wreckage. Retaining (2) and (3) one could then still salvage something of (1)'s contention that promise breaking is always morally wrong by restricting such condemnation to the special case of *voluntary* promise breaking. ✓

And this strategy of damage containment by means of distinctions has a wide applicability. Since each thesis of an aporetic cluster is individually attractive, unqualified rejection lets the case for

7. See Rescher, *The Strife of Systems* (op. cit.), especially Chapter 3, pp. 64–77.

a rejected thesis go unacknowledged. By merely modifying rather than outright rejecting a problematic thesis we may be enabled to give proper recognition to the full range of considerations that initially led us into contradiction. ✓

Distinctions accordingly enable the philosopher to remove inconsistency not just by the brute negativism of thesis *abandonment* but by the more subtle and constructive device of thesis *qualification*. The crux of a distinction is not mere negation or denial, but the amendment of an untenable thesis into something positive that does the job better. Thus consider an inconsistent triad having the following structure:

— All *A*'s are *B*'s.

— All *B*'s are *C*'s.

— Some *A*'s are not *C*'s.

Note that these are incompatible only if the connecting terms that link these theses together, *A, B, C*, are used in precisely the same sense in each occurrence. If careful scrutiny manifests the least deviation—if, say, the *A* of one of those theses is A_1 and that of the other is A_2—then the inconsistency is removed and the problem abolished. Distinctions are thus a crucial tool for philosophical problem solving; they are the natural means for eliminating inconsistency.

Let us examine the workings of this process more closely.

Consider the *Form/Matter Paradox* based on the following four contentions, all of which were viewed with favor by various Presocratic philosophers:

(1) Reality is one: real existence is homogeneous.

(2) Matter is real (self-subsistent).

(3) Form—considered geometrically—is real (self-subsistent).

(4) Matter and form are distinct (heterogeneous).

Here (2)–(4) entail that reality is heterogeneous, thereby contradicting (1). The whole of the group (1)–(4) accordingly represents an aporetic cluster that reflects a cognitive overcommitment. ✓

And this situation is typical: the problem context of philosophical issues standardly arises from a clash among individually tempting but collectively incompatible overcommitments. The issues standardly center about an aporetic cluster of this sort—a family of plausible theses that is assertorically *overdeterminative* in claiming so much as to lead into inconsistency.

In such situations, whatever favorable disposition there may be toward these plausible theses, they cannot be maintained in the aggregate. Something has to give. In particular, we can proceed:

- To reason from (2)–(4) to the denial of (1),
- To reason from (1), (3), (4) to the denial of (2),
- To reason from (1), (2), (4) to the denial of (3),
- To reason from (1)–(3) to the denial of (4).

Accordingly, the ancient Greek philosophers confronted the following range of possibilities:

(1)-denial: Pluralism (Anaxagoras) or form/matter dualism (Aristotle)

(2)-denial: Idealism (the Eleatics, Plato)

(3)-denial: Materialism (atomism)

(4)-denial: Dual-aspect theory (Pythagoreanism)

As this aporetic analysis indicates, the doctrines of these various major schools of Greek metaphysics are locked into a coordinated unity by the paradox at issue.

Of course, each alternative has its own problems as well as its own opportunities. Consider, for example, the situation that arises with rejecting thesis (2). It is instructive to note that this could be accomplished by not simply *abandoning* it altogether but rather by *replacing* it—on the idealistic precedent of Zeno and Plato—with something along the following lines:

(2') Matter is not real as an independent mode of existence; rather it is merely quasi-real, a mere *phenomenon*, an appearance somehow grounded in immaterial reality.

The new quartet (1), (2'), (3), (4) is cotenable. ⌐

In adopting this resolution, one again resorts to a distinction, namely that between:

(i) strict reality as self-sufficiently independent existence

and

ii) derivative or attenuated reality as a (merely phenomenal) product of the operation of the unqualifiedly real.

Use of such a distinction enables us to resolve an aporetic cluster—yet not by simply *abandoning* one of those paradox-engendering theses but rather by *qualifying* it. (Note, however, that once we follow Zeno and Plato in replacing (2) by (2')—and accordingly reinterpret matter as representing a "mere phenomenon"—the substance of thesis (4) is profoundly altered; the old contention can still be maintained, but it now gains a new significance in the light of new distinctions.)

What is sometimes called the <u>*Socratic Paradox*</u> in ethical theory turns on Socrates's thesis that "nobody does wrong willingly."[8] This leads to the following line of argumentation:

(1) Rational and well-informed people often act wrongly— and willingly so.

(2) A rational person will only do willingly that which he believe will—in the circumstances—yield a greater balance of positive as against negative results.

(3) To choose the wrong deliberately damages the psyche of the agent to an extent that is automatically greater than whatever benefits that wrong action may otherwise yield him.

(4) By (2) it is only through mistakenly believing that—contrary to (3)—a wrong action yields a positive balance of benefit that a rational person will do wrong willingly.

8. See Plato, *Protagoras*, 352.

5) A rational and properly informed person will never act wrongly. By (3)–(4).

(6) (4) contradicts (1).

Here {(1), (2), (3)} constitute an inconsistent triad. Prioritizing (2) and (3), Socrates himself therefore rejected (1), and was thus led to his "paradoxical" teaching that "Nobody [who is rational and properly informed] does wrong willingly." The result, for Socrates, is that wrongdoing (moral transgression) is ultimately a failure of the intellect (of rationality and its proper application) rather than a failure of the will.

On this basis, it emerges that, on Socrates's own analysis, the paradox is essentially one of equivocation. We must distinguish between *actual* choice and action and *rational* choice and action. With rational action (1) is false and (2) true; whereas with actual action (1) is true and (2) false.

Again consider the classic conundrum of medieval philosophical theology: can God, an omnipotent being, reduplicate himself? This question engenders a dilemmatic paradox. For if God cannot do so, then how can one say that he is omnipotent, seeing that there is something he cannot do? But if he can do so, then how can he qualify as omnipotent, seeing that there is, or could be, another no less powerful being who can check his actions?

This puzzle gives rise to the *Divine Omnipotence Paradox* which roots in the following aporetically inconsistent collection of theses:

(1) There is an all-powerful, omnipotent being, God. (By assumption.)

(2) An omnipotent being is one who can do literally anything. (This is, supposedly, the definition of "omnipotence.")

(3) God can do literally anything. (From (1) and (2).)

(4) God can reduplicate himself. (From (3).)

(5) A reduplicated God would be equipowerful with the original. (By the definition of "reduplication.")

(6) The action of any being can be counteracted—and thus negated—by the action of an equipowerful one. (By the definition of "equipowerful.")

(7) A being whose actions can be counteracted by another is not all-powerful (omnipotent). (From (2).)

(8) God is not omnipotent—contrary to (1). (From (5)–(7).)

The clash between (8) and the starting point (1) indicates that the overall set is aporetic—that is, collectively inconsistent. Again we have a paradox. [9]

Since various theses of this apory are derivative in that they can be obtained by logical inference from others, we can trace the conflict at issue back to the inconsistent quartet {(1), (2), (5), (6). Because these four theses are the only nonderivative ones (whose justification is not in terms of "from,") they alone carry the burden of contradiction here.

And so in these circumstances we are driven to a forced sacrifice of one of the four theses at issue. Once again, we have to probe for the weakest link in the chain of inconsistency.

Let us look at our problematic foursome more closely. Here (1) is a fundamental dogma of monotheistic theology and (5) and (6) issue from comparatively unproblematic definitions. However, the purported definition at issue in (2) is in fact highly problematic because we have to ask ourselves whether omnipotence is the ability to do literally anything rather than anything that is logically possible. On this basis, the priority ranking at issue is

$$(1) > [(5), (6)] > (2). \checkmark$$

Here we have just three priority levels. The appropriate resolution is accordingly (1), (5), (6)/(2) with its here optimal retention profile. [10]

And there is in fact good reason for concern about (2). For the paradox at issue could be seen to be based on a questionable con-

9. For this paradox and related issues in philosophical theology see Gale 1991.

10. There are, of course, more radical possibilities such as the atheist's all-out rejection of the very possibility of God.

struction of omnipotence. And just this was the alternative gener-
ally favored among the medieval scholars. As they saw it, it is
omnipotence in the "can do literally anything" sense of the term
✓that is the weak spot here. For "omnipotence" cries out to be
construed as "can do anything that is possible" or "can do any-
thing that a God-like being could reasonably want to do." And if
(2) is abandoned—or, rather, reconstrued in the proposed way—
then the inconsistency is resolved.

This example conveys an important lesson. The use of distinc-
tions interacts with plausibility considerations. For there is good
reason for the policy of fixing upon the least plausible aporetic
✓premiss and dividing it by a saving distinction. It is, after all, more
than likely that the burden of carrying the "bad" side of the dis-
tinction was the source of the implausibility involved.

To be sure, distinctions are not needed if all that concerns us is
averting inconsistency; simple thesis abandonment, mere refusal
to assert, will suffice to that end. Distinctions are necessary, how-
ever, if we are to maintain informative positions and provide
answers to our questions. We can guard against inconsistency by
refraining from commitment. But that leaves us empty-handed.
Distinctions are the instruments we use in the (never-ending)
work of rescuing our assertoric commitments from inconsistency
✓while yet salvaging what we can.

The history of philosophy is accordingly shot through with the
use of distinctions to avert aporetic difficulties. Already in the dia-
logues of Plato, the first systematic writings in philosophy, we
encounter distinctions at every turn. In Book I of the *Republic*,
for example, Socrates's interlocutor quickly falls into the following
Self-Advantage Paradox:

(1) Rational people always pursue their own best interests.

(2) Nothing that is in a person's best interest can be disadvan-
 tageous to their happiness.

(3) Even rational people will—and must—sometimes do
 things that prove disadvantageous to their happiness.

Here, inconsistency is averted by distinguishing between two
senses of the "happiness" of a person—namely the rational con-
tentment of what agrees with one's true nature and what merely

redounds to one's immediate satisfaction by way of pleasure, in ✓sum, between real and merely affective happiness. With *real* happiness, (2) is true but (3) false, while with merely *affective* happiness, (2) is false, but (3) is true.

For the most part, the Platonic dialogues present a dramatic unfolding of one distinction after another as Socrates and his interlocutors seek to work their way out of a maze of inconsistency. And this use of distinctions as a paradox-buster is pervasively common-place in philosophy because distinctions always make it possible to salvage something from the wreckage. ✓

Paradoxes Considered in Chapter 8

- Absurd Instruction Paradoxes (such as the *Mikado* Paradox)

- The Parent-Beater Paradox

- The Horn Paradox

- Rule/Exception Paradoxes

- The Adult/Child Paradox

- The Barber Paradox

- The Bibliography Paradox

- Illicit Totalization Paradoxes

- Kantian Antinomies

- Predictive Paradoxes (various)

Paradoxes of
Inappropriate Presupposition
(Improper Totalities
in Particular)

8.1 Unwarranted Presupposition

Like other instances of exact reasoning, paradoxes routinely, if only tacitly, involve certain basic formal communicative presuppositions, preeminently including the following two:

- The terms involved in formulating these propositions are meaningful, well-defined, and unequivocal (in other words, uniform in meaning across different premises).

- The propositions at issue are meaningful, and at least plausible if not actually true.

Of course, such presuppositions may possibly fail to be met—in ways that can prove fatal to the viability of the argumentation of the paradoxes at issue.

However, it is not these generic and routinely standard communicative presuppositions that primarily concern us in the present chapter. Rather it is *substantive* and thereby fact-prejudging presuppositions that will be at issue here. The difference is significant. Communicative presuppositions such as the above are *generic prerequisites* for the cogency of the argumentation of a paradox. Substantive presuppositions are *particular material assumptions* whose untenability (let alone erroneousness) would

137

erase some of the premises of the argument. For paradoxes often
rest upon inappropriate and unwarranted *factual* suppositions.
For example, they can result from a suppositional process of con-
struction whose directions are actually impossible to carry out—
be it in principle or in practice. Thus consider the instructions:

1. Take brick No. 1.

2. Take brick No. 2.

3. Place brick No. 1 alongside brick No. 2.

This set of instructions is in general quite unproblematic. But what
if brick No. 1 is to be the same brick as No. 2? Clearly the instruc-
tion "Take a brick and then put it next to itself" is absurd, and
straightaway leads to paradox. The pictures of M.C. Escher vividly
illustrate this phenomenon, for example, his print of a hand draw-
ing itself,[1] which suggests the even stranger possible variant of a
whitewash wielding figure in process of painting itself out. As with
optical illusions, it is not that such vistas themselves are paradoxical
but rather that the statements we take to provide a "natural"
description of what those pictures depict form an inconsistent set.
Paradoxes of this kind rest on the unstable foundation of the mis-
taken supposition or presupposition that a certain hypothetical
construction can be carried out—something which is in fact not
the case because an inherent absurdity is involved through a con-
flict with fundamental facts of physics or of geometry.

Again consider the *Mikado Paradox* based on Gilbert and
Sullivan's operetta of the same name, a paradox which ensues
upon four rules:

• There is to be one execution per month

• Execution is to be by beheading with a sword

• There is to be no departure from a specified ordering of
 prisoners to be executed

1. M.C. Escher, *The Graphic Work of M.C. Escher* (New York: Duell, Sloan, and
Pearce, 1961), p. 47. There's also Steinberg's drawing of the same subject in Saul
Steinberg, *The Passport* (New York: Harper, 1954).

- Only the official Lord High Executor can carry out an execution.

And now a paradox obviously results when the next prisoner to be executed is himself appointed to be Lord High Executioner.

Paradox can thus affect not only contentions and questions but also instructions. The injunction "Never say never" is every bit as paradox-engendering as "All generalizations are false." And the sign posted on the wall that reads "No signs are to be posted here" is in much the same boat as the graffito that says "All statements on this wall are false." Another example of directions that cannot be carried out are "Do not read this sentence"—the request obviously comes too late. A more interesting example is the following resolution reportedly adopted by the Municipal Council of Canton, Mississippi:[2]

1. Resolved, by this Council, that we build a new jail.

2. Resolved, that the new jail be built out of the materials of the old jail.

3. Resolved, that the old jail continue to be used until the new jail is finished.

A nice trick if they can do it!

When we subscribe to an unwarranted presupposition regarding something where "we ought to know better," this all too easily runs into conflict with other things that we know—or think we do. A good instance of this is provided by the old chestnut "Have you stopped beating your father?"[3] This engenders the classic *Parent-Beater Paradox* based on the following contentions:

(1) The respondent must answer the question Yes or No.

2. Patrick Hughes and George Brecht, *Vicious Circles and Infinity* (Garden City: Doubleday, 1975).

3. For this paradox see Diogenes Laertius, *Lives of the Philosophers*, II, 35. The moderns changed the referent here from father to wife, but political correctness calls for reversion to the original form. The American Philosophical Association's "Guidelines for the Non-Sexist Use of Language" (http://apa.udel.edu/apa/publications/texts/nonsexist/html) specifically mentions the wife-beater riddle as an instance of the introduction of sexual stereotypes into philosophical discourse. (I owe this reference to Karen Arnold.)

(2) If he replies Yes, that comes to acknowledging that he used to beat his father.

(3) If he replies No, that comes to acknowledging that he still beats his father.

(4) Either way, it follows that the respondent concedes that he has beaten his father.

(5) But as we know perfectly well, the respondent may never have beaten his father at all.

(6) Consequently, the respondent can fail to speak truly no matter how he replies.

(7) However, some direct reply to a Yes/No question must be true in any circumstance.

(8) (6) and (7) contradict one another.

How can this chain of inconsistency be broken? One promising prospect here relates to thesis (3). For this thesis ignores the fact that a negative reply to the question admits of two distinct constructions and covers two different possibilities. By accepted usage the negative response here covers at least two possibilities: "No, I haven't stopped beating him because I'm still doing it," or "No, I haven't stopped beating him because I never even started." The construction of (3) that supports (4) simply ignores those other possibilities. It rests on the presupposition—totally unwarranted in the circumstances—that the respondent has been beating his father.

The Horn Paradox of Eubulides (probably) is another example of an inappropriate-presumption paradox much favored in classical antiquity: "Have you lost two horns? No! Well, then you must still have them!"[4] Such paradoxes which rest upon an unwarranted and often even erroneous presupposition have always been a commonplace in this field.

4. See p. 12 above. For Eubulides see pp. 102–04 above.

8.2 Paradoxical Questions

The *Parent-Beater Paradox* and the *Horn Paradox* illustrate the larger phenomenon that not only statements but even questions can be paradoxical. The question "Is the answer to this question No?" is an example. For consider the resultant situation:

The answer given is	The answer claimed by the answer that has been given
Yes	No
No	Yes

There is no way of achieving an alignment here. For every direct answer to the question results in a paradoxical statement: "Yes the correct answer to this question is No" and "No the correct answer to this question is Yes." And this state of affairs generalizes. A paradoxical question is one every direct answer to which is paradoxical through being self-consistent. No (direct) answer to such a question is possibly correct. And the crux of all such paradoxes lies in the fact that the question at issue involves a presupposition that fails to obtain.[5]

A standard presumption of meaningful questions is that they can be answered directly and that some direct answers are at least *possibly* correct. Paradoxical questions violate this presupposition.

On the other hand, a question is *crypto-paradoxical* if there is no possible way of giving a direct answer to it that is incorrect. For example: "Is your answer to this question affirmative?" Here there is simply no way for the answer given and the answer that is validated by the given answer to get out of synch.

We may be on paradoxical ground if we assert that "All rules have exceptions" or—as Oliver Wendell Holmes Jr. put it more picturesquely—"No general proposition is worth a damn." But the fact remains that *virtually* all rules admit exceptions and that *virtually* all generalities are subject to qualification, the point at

5. All questions involve some presuppositions—even if only the minimalistic one that they are answerable. On these issues of question epistemology see the author's *Empirical Inquiry* (Totowa: Rowman and Littlefield, 1982).

✓issue being made unparadoxical by that quantification "virtually."
Now as Aristotle noted in his *Sophistical Refutations*,[6] the prim-
rose path to paradox is paved with questions that involve subscrip-
tion to a general rule that actually has exceptions: "Ought one to
do what the law requires?" "Ought one to honor the wishes of
one's parents?" As with the Parent-Beater Paradox, you cannot
win either way with such a question. For if you answer No, the
rule will be against you, and if you answer Yes, then the plausible
exceptions will be cited against you.[7] The mistaken supposition
that a sensible rule is absolutely unexceptionable and *always*
✓ applies is the crux of the problem here.

Consider an example. Frederic, the protagonist of Gilbert and
Sullivan's *Pirates of Penzance*, is in a predicament. For the ques-
tion "How old is Frederic?" poses a puzzle owing to the follow-
ing *Adult/Child Paradox*:

(1) Frederic is an adult of 25 years, having lived for that many
 years.

(2) People are as many years old as they have had birthday
 anniversaries.

(3) Frederic was born in a leap year on February 29th, a leap
 day. He has thus had only five birthdays.

(4) By the birthday reckoning at issue in (2)–(3), Frederic is a
 mere child of only five years.

(5) (4) contradicts (1).

The culprit here is clearly premiss (2). It states a perfectly plausi-
ble rule to which there are only once-in-a-blue-moon exception—
specifically 1 in 1,460. However, in Frederic's case we have to
come to terms with one of these exceptions. Dissonance arises
here because the specifics of the case point one way, the generali-
- ties of the rule another.

6. See Aristotle, *Soph. Elen.*, 176a19–38.
7. See Aristotle, *Soph. Elen.*, 173a19–25 and 174b12–19.

8.3 Negatively Totalitarian Self-Involvement: The Barber Paradox

As noted above, all contexts of rational assertion and deliberation are governed by an at least tacit supposition that not only are the terms being used in the assertions at issue univocally meaningful, but that these assertions themselves are at least plausible if not actually true. Should this presupposition prove to be unwarranted, the chasm of paradox yawns wide-open.

This is illustrated by *The Barber Paradox*,[8] a conundrum that has received much attention. It is based on the following riddle:

> A certain village has a barber whose practice it is to shave all the adult male villagers who do not shave themselves. He himself, of course, is an adult male who lives in the village. Does he or does he not shave himself?

The evident paradox here is that if he is a self-shaver, then (by hypothesis) our barber does not shave himself, while if he is not a self-shaver, then (by hypothesis) he does shave himself. Either way we are in difficulty.

Putting it more formally, our barber B is (by hypothesis) someone such that: *For every x, $Sbx \equiv \sim Sxx$*

For every x, the Barber shaves x iff x did not shave himself.

$$\forall x\, [S(B, x) \text{ iff} \sim S(x, x)]$$

$$(x)(Sbx \equiv \sim Sxx)$$

But when the x at issue is instantiated as B himself, this yields:

$$S(B, B) \text{ iff} \sim S(B, B)$$

This result plunges us into paradox, seeing that we now can maintain neither $S(B, B)$ nor $\sim S(B, B)$. It seems that consistency is beyond our reach here.

The following theses constitute the aporetic cluster that defines the paradox:

8. For this paradox see Russell 1918 and T.S. Champlin, *Reflexive Paradoxes* (London: Routledge, 1988), esp. pp. 172–74. Also called the *Barber of Seville Paradox*, it is an informal variant of Russell's Paradox in set theory (for which see pp. 170–73 below).

(1) There is—or can be—a barber who answers to the specifications of the narrative.

(2) This barber of the narrative (like any other) either does or does not shave himself, but not both.

(3) If the barber shaves himself then, by the narrative's stipulation he is not someone who shaves himself.

(4) If the barber does not shave himself then, by the narrative's stipulation he does shave himself.

(5) Thus either way a contradiction ensues.

The optimal point at which to break the chain of consistency here is clearly at its very start with that hypothetical barber himself. For there is not and cannot be a barber who answers to the specified conditions. The barber paradox thus is vitiated from the very outset, by being predicated on the supposition of a barber who cannot possibly be. That purported introduction of a barber upon the stage of discussion misfires—it fails to introduce.

Again consider the closely related *Bibliography Paradox* arising from the following account:

> There certainly are bibliographies of bibliographies (and lists of lists and registers of registers). And such a bibliography (or list of register) is *complete* if it lists all bibliographies (etc.) But of course most bibliographies will be incomplete when they leave something out. And one bibliography that many of them will leave out is themselves. Such a bibliography may be characterized as self-omitting. But now consider this idea of self-omitting bibliographies. And let us contemplate the idea of a complete bibliography of these—a bibliography that lists all (and only) the self-omitting bibliographies. Will such a bibliography include itself? Clearly this question plunges us into paradox.

What we have here is once more a paradox based on an erroneous and untenable presupposition, namely that there can be such a bibliography (or list or register). There cannot. The very idea of such an item is absurd, as the articulation of the paradox itself makes manifest.

Again, let us suppose the following definition:

T = the conjunction-of-truths that conjoins all (but only) those conjunctions-of-truths that do not include themselves as conjuncts.

Then paradox ensues. For if T includes T as a conjunct, then it does not. And if T does not include T as a conjunct, then it does. The way out here is, of course, to say that, notwithstanding its overt specification as a conjunction, a conjunction of the specified sort simply does not exist. Neither T nor anything else fills the bill. Which is to say that T is no more than an illicit or improper pseudo-specification of an item purportedly at issue. Put differently, that purported "conjunction of truths" does not in fact qualify as something that can be characterized in this way at all. There is not and cannot be such a conjunction and so the issue of what it does or does not include simply does not arise. ✓

8.4 Illicit Totalization Paradoxes

Various paradoxes attest to the impropriety of negation-totalities arising from expressions which might be called the "X of X's" format. Items of some sort are seen as self-inclusive by encompassing themselves. For example:

a set of sets

a list of lists

a picture of pictures

a conjunction of conjunctions

a text of texts

a praiser of praisers

a shaver of shavers

All such self-encompassing item-types are homogeneous in the sense that here an X of X's is itself an X (a set of sets is a set, a list of lists is a list, and so forth).

With such self-encompassment in view we can now project an X-totalization of self-nonencompassing X's:

> the X of *all* those X's that do *not* X-wise encompass themselves (the set of all those sets that do not set-include themselves)

It is clear that such self-exclusive totalization is always paradoxical. Thus consider the container (set) of all containers (sets) that do not contain (set-include) themselves, the list of all lists that do not list themselves, the picture of all pictures that do not depict themselves, etc. The idea here is that if "the x such that, for every y, x encompasses y iff y does not encompass itself." Putting the usual symbolism to work, what we have in view is the following totalization item:

$$(\imath x) \; \forall y \, (x \text{ enc } y \text{ iff } \sim y \text{ enc } y).$$

If (but only if!) such an item exists—let us continue to call it X—then we have:

$$\forall y \, (X \text{ enc } y \text{ iff } \sim y \text{ enc } y).$$

But the modus operandi of X-specification is such that X is supposed itself to be an item of the range of our variable x, y etc. This being so, we can particularize the preceding generalization to X so as to obtain:

$$X \text{ enc } X \text{ iff } \sim X \text{ enc } X.$$

Paradox is now upon us. But so is its resolution. For this contradiction itself straightaway negates our preceding assumption that that initial totalization item does (or can) exist.

The issue is thus straightforward. We confront the question: Does this totalitarian X-item encompass itself X-wise or not? Does that set of sets include itself, that list of lists list itself, that picture of pictures picture itself, and so on? And paradox occurs

immediately because in virtue of its very definition that totality of self-exclusive X's is itself an X that neither can nor cannot encompass itself. The problem, of course, is that the presupposition that such a negatively totalitarian X does or can exist is simply false. The item purported to be an instance of the kind at issue (a set, a list, etc.) just does not exist at all: to *call* it such does not *make* it such. A substantive matter is at issue that cannot be settled by terminological slight of hand. (In the next chapter we shall see that the violation of a very general requirement is at issue, namely the Successful Identification Principle, SIP.)

The preceding difficulties relate to the misidentification of items purporting to be of a type to which they could not possibly belong in view of the way in which that identification is presented. Throughout this range of cases, we have paradox of inappropriate presupposition that incorrectly holds that something is *appropriately identified* by a specification which actually does not and cannot succeed. Any body of reasoning or argumentation presumes, explicitly or tacitly, that its propositions are meaningful and thus that its relevant referring terms succeed in doing so. And when terms become unraveled on the basis of an inappropriate totalitarian self-involvement, this crucial presupposition is falsified and the paradox dissolved. When the charge of illicit totalization can be made to stick, it is a highly effective presupposition-buster.

8.5 Immanuel Kant's Antinomies

The general idea we have been considering, inappropriate totalization, played an important role in the philosophy of Immanuel Kant—although he approached the issue in a positive rather than negative light. As he saw it, the four classic "Antinomies" of *Critique of Pure Reason* exemplify the preceding situation. These *Kantian Antinomies* run as follows:

I. *The totality of physical existence* (= the world or the universe as a whole)

- is limited in the physical manifold of space and time.
- is unlimited in the physical manifold of space and time.

II. *The ultimate simples of nature* (= the absolutely atomic, totally indecomposable constituents of physical substance

- are pervasive throughout all of physical reality.

- are excluded from physical reality (in other words, do not exist as such).

III. *The totality of natural occurrence* (= the aggregate of events in physical realm)

- is of necessity determined by physical law.

- is free from determination by physical law.

IV. *An absolutely necessary, self engendering being* (= a being that itself encompasses the totality of its own cause)

- is physically or causally active in the natural world.

- is physically and causally excluded from the natural world.

In each case what we have at issue is an extra-ordinary, somehow totalitarian (that is ultimate or absolute) object of consideration regarding which some far-reaching physically geared feature is ✓ both flatly affirmed and categorically denied. What is being claimed throughout is (structurally speaking) that a certain putative object (A) both does and does not have a certain physically oriented feature (F). Conflicting predications are thus at issue: "A is F" and "A is not-F." And, so Kant insists, equally good arguments can be constructed either way, so that both the thesis and the antithesis can be rendered plausible.[9]

On this basis, Kant's antinomies were seen by him as engendering a paradox along the following general structural lines:

(1) Item A (for instance, physical-existence-as-a-whole) is a legitimate object of predication. [A supposition.]

(2) There is cogent reason for saying that item A (for instance, physical existence) is F (for example, limited).

9. On Kantian antinomies see N. Hinske, "Kants Begriff der Antinonie und die Etappen seiner Ausarbeitungen," *Kant-Studien*, vol. 56 (1965), pp., 485–496, as well as the several commentaries on the *Critique of Pure Reason*.

[A substantive fact grounded in argumentation that Kant presents in some detail.]

(3) There is cogent reason for saying that item *A* (for example, physical existence) is not *F* (for instance, unlimited). [Also a substantiable fact rooted in presented argumentation.]

(4) (2) and (3) are logically incompatible if (and whenever) *A* exists as a legitimate object of predication. [A fact of logic.]

(5) Therefore, by (2)–(3) item *A* does not exist because it is a fact of logic that no legitimate object of predication can have incompatible predicates.

(6) (5) contradicts (1)

As Kant saw it, the natural place to break this chain of contradiction is at thesis (1) which—so he maintains—is the weak spot of the antinomy. For him the proper lesson to be drawn is that only *identifiable particulars* can exist as proper objects of physically oriented predication whereas *abstract totalities* are vitiatingly problematic in this regard.

The four Kantian antinomies arise from a series of corresponding questions of a common format

Is the ultimate unit of *A* limited or unlimited in point of *B*?

where the four cases stand as follows:

A	B
(1) physical existence	spatio-temporal distribution
(2) physical divisibility	physical presence
(3) natural occurrence	lawful determination
(4) existential self-sufficiency	causal participation in nature

And all of these questions make the common supposition that that ultimate item at issue with *A* actually exists as a legitimate

object of physically oriented predication—something that Kant
emphatically denies.

Kant thus argues that in each and every case, the resolution of
the antinomy consists in rectifying a mistaken presupposition that
the ultimate *A*-unit at issue is a bona fide (physical) existent that is
capable of being a proper bearer of (physically oriented) predicates
such as spatiotemporal extent, physical existence, lawful determina-
tion, or causal efficacy. Such ultimates are communicative devices
to guide the processes of thought and discussion but not items of
natural existence of which physical features can be predicated.
(This is why the second, negative side of the antinomies always
comes closer to the mark.) Kant's position is not so much that of
Nicholas of Cusa that certain totalities are beyond human compre-
hension as that they are not defined as items that can bear the sorts
of predicates at issue in their putative specification.

Kant's position here is certainly discussible. One could, for
example, contend that those supposed "cogent reasons" at issue
in (2)–(3) constitute the Achilles heel of the argument rather than
thesis (1). Or again one could try to dissolve the contradictions
on grounds of equivocation, arguing (for example) that the *sense*
in which the physical world is limited in space-time is different
from the *sense* in which it is not so limited.

All the same, Kant's idea of rejecting certain totalities as inca-
pable of characterization in certain terms of reference is not all
that implausible. No painting of a painting can represent *all* of its
detail. And even so no thought or theory can encompass the
entire reality to which it itself belongs. The hypothetical projec-
tion of such an item envisions a totality that is incapable of cogni-
tive realization—one whose acceptance conflicts with the things
we know about the nature of human knowledge. As Kant saw it,
the synoptic (totalitarian) purview of the claims of classical meta-
physics is simply unavailable to us humans. We have to operate
within the physical world and therefore from a particular (specifi-
cally human) perspective. We have no cognition-external
Archimedean fulcrum outside the realm of our thought from
which to move the entire domain of thought as a whole.

And this Kantian perspective relates to the relationship
between inner and outer. We humans are emplaced *within* nature
and by this very fact are limited in the information we can obtain
about nature. All of our observation-based judgments are partial

and thereby incomplete. As far as actual knowledge goes, absolutistic totalities are off limits—be it the totality of actual experience (the self) or of its objects (the world) or of its rationale (ultimate purpose or God).[10] Such ideas represent useful mind-contrivances for the assessment of actual knowledge but do not—cannot—themselves constitute actual objects of knowledge. For Kant, they are not *entities* at all, but only practical resources, thought instrumentalities useful only for contrasting what we actually have with what we would ideally like. For him, those improperly totalized items simply cannot constitute objects of knowledge. And paradox accordingly results because here the presupposition of existence is not satisfied.

8.6 Predictive Paradoxes

I can confidently make the indefinite prediction *that* some of my best-considered predictions will come false, but of course cannot—without paradox—predict specifically *which* ones. However, I may very well (and quite unparadoxically) predict that *your* predictions will come false—and even specifically identify them.

Inappropriate presumptions about the future are a fertile source of paradox. One of them relates to the very possibility of prediction. Could a predictive machine—call it Pythia—predict *everything*? Could it be so perfected as to provide a tenable answer for *every* predictive question one enough cares to ask? Clearly not. For one thing, there are essentially paradoxical questions on the lines of: "What is a predictive question that you will never-ever have to deal with in answering questions put to you?" Pythia itself must keep silent on this issue—or else confess its imperfection with an honest CAN'T SAY. But the question itself is certainly not meaningless, since we ourselves or some other predictor could in principle answer it correctly.

Again, we could wire our supposedly perfect predictor up to a bomb in such a way that it would be blown to smithereens when next it answers YES. And we now ask it: "Will you continue active and functioning after giving your next answer?" Should it answer

10. See the discussion of these ideas in Kant's *Critique of Pure Reason*, A680–B708 = A689–B717.

YES, it would be blasted to bits and its answer thereby be falsified. Should it answer NO it would (*ex hypothesi*) continue in operation and its answer thereby be falsified.[11]

To say that a predictive question is unresolvable is not, of course, to say that a predictor cannot answer it. We could certainly program a predictive machine to answer every *yes-no* question by "YES," every *name* question by "George Washington," every *when?* question by "in ten minutes," and so on. If it is simply an answer that we want, we can contrive predictors that will oblige us. But the problem, of course, is to have a predictor whose predictions are *probable* or, in the case of a putatively perfect predictor, *correct*, on a basis that is credible in advance of the fact.

Specifically, one of the issues regarding which no predictor can ever function perfectly is its own predictive performance. In the area of prediction, as elsewhere, paradoxes can arise through problems of self-reference. Consider the question: "Is the prediction that you are going to respond negatively to this question going to come true?" The ensuing situation is as follows:

The answer given is	This answer means that the prediction is	This means that the answer is
YES	Correct	False
NO	Incorrect	True

In no case can the given answer manage to correspond to the facts.

Analogously, consider the question: "Will you answer this question—this *very* question—indefinitely, that is, by CAN'T SAY (rather than YES or NO)?" We arrive here at the following situation:

The answer given is	Its truth status is automatically	So the predictor
YES	false	fails (by falsity)
NO	false	fails (by falsity)
CAN'T SAY	immaterial	fails (by indecision)

Inevitably, our predictor cannot function adequately here either. Or again consider a somewhat different example:

The predictor starts in state non-*C*. And it is programmed to shift to state *C* if ever it gives a negative answer. At a moment before time *t* (with only just enough time for processing one single last question before *t*) we ask: "Will you be in state *C* at *t*?"

The answer given is	Its truth status is automatically	So the predictor
YES	false	fails (by falsity)
NO	false	fails (by falsity)
CAN'T SAY	immaterial	fails (by indecision)

In no case can the predictor at issue possibly provide a correct answer to such questions—though we ourselves could in principle ✓do so.

The long and short of it is that no predictor can function perfectly with respect to its own operations and, in particular, none can predict all of its own future predictions.[12] The very most one

12. This point has been argued forcefully in other contexts by K.R. Popper. See his *The Poverty of Historicism* (London: Routledge, 1957), p. vi. But also compare Peter Urbach, "Is Any of Popper's Arguments Against Historicism Valid?" *British Journal for the Philosophy of Science*, 29 (1978) 117–130 (see pp. 127–28). Popper's argumentation has its problems, however. For it pivots on Kurt Gödel's famous Incompleteness Theorem to the effect that no reasoner proceeding on mathematical principles can decide whether a certain sentence *G* is or is not a theorem of arithmetic. Popper now proposes asking the putative predictor the question: "If you are asked at *t* the question 'Is *G* a theorem?' (and we attend until *t'* for an answer) will you or will you not before *t'* respond with 'yes' or

could plausibly ask for might seem to be that *predictors predict correctly everything that is in principle possible for them to predict.* But even here there are problems. Perhaps the most obvious of them is that of deciding just what is "in principle possible" for a predictor by way of genuine prediction. For to determine what is in theory or in principle predictable—and what is not—we have to look to the deliverances of natural science. For science itself tells us that some sorts of predictions are in principle infeasible— for example, the outcome of such noncausal quantum processes as are at issue in the question: "Exactly when will this atom of a transuranic element with halflife 283 years disintegrate?" "Exactly what will be the position and momentum of this particle two minutes from now?" What is needed at this point is a determination of *what is in fact predictable*—and not just an indication of what the science of the day *considers (perhaps mistakenly) to be predictable.* And this is an issue that could only be settled satisfactorily by perfected or completed science, something we do not have now and could not be sure of having even if (*per impossibile*) we did sometime acquire it.

From the vantage point of aporetics, it emerges that those predictive paradoxes issue from problematic questions that inappropriately presuppose themselves to have a viable answer.[13]

8.7 Summary

The overall lesson that emerges from the analysis of these paradoxes of inappropriate presupposition is that these can in general be regarded from a reverse point of view. That is, they can also be construed as *reductio ad absurdum* arguments that establish the untenability of that inappropriate presupposition itself.[14]

'no'?" (See also Popper's "Indeterminism in Classical Physics and in Quantum Physics," *British Journal for the Philosophy of Science*, Vol. 1 (1950) 117–133 and 173–195 (see p. 183).) The problem with this particular example is that the temporality at issue is spurious. For the predictor's incapacity to answer the given question—other than by CAN'T SAY— roots in its incapacity to answer its detemporalized counterpart: "If asked 'Is *G* a theorem?' will you answer 'yes' or 'no'?" Given the speciousness of its temporalization, the question at issue is not genuinely predictive. Its incapacity to answer may render that predictor *cognitively* imperfect, but it is not *predictively* imperfect.

 13. On these issues see the author's *Predicting the Future* (Albany: State University of New York Press, 1998).

 14. For more on such reduction-to-absurdity argumentation see Chapter 12 below.

Of course, spotting that inappropriate presupposition is the easy part. The difficulty generally lies in the subsequent task of diagnosis—detecting just what there is about that problematic thesis that makes for its untenability. Determining a rationale for relegation to inappropriateness is often the most challenging part of paradox analysis.

Paradoxes Considered in Chapter 9

- Hilbert's Hotel Paradox

- Cantor's Paradox

- De Morgan's Paradox

- Illicit Self-Reference Paradoxes

- The Supertruth Paradox

- The Valid Argumentation Paradox

- Russell's Paradox of Sets

- Illicit Totalization Paradoxes

- Curry's Paradox

- Russell's Impredicability Paradox

- Grelling's "Heterological" Paradox

- Russell's Relational Paradox

- Berry's Paradox

- Richard's Paradox

- Burali-Forti's Paradox

Mathematical Paradoxes

9.1 Cantor's Paradox and the Valid Introduction Requirement (VIR)

Mathematics is a purely theoretical enterprise. And so, when things do go wrong here, they will go wrong in a fundamental way. Inconsistency must be taken very seriously in this domain.

Paradoxes have played a major role in the philosophy of mathematics in the twentieth century. Since all of these mathematical paradoxes are, in effect, paradoxes of unwarranted presupposition, this chapter could be seen as a mathematical appendix to its predecessor. For the long and short of it is that the mathematical paradoxes share the common format of pivoting on a presupposition that something-or-other is meaningful and/or true which ✓actually is not so.

The mathematics of infinity is a fertile arena of paradox because it leads to results at odds with the finite point of view. Laurence Sterne's Tristram Shandy, who spent two years in chronicling the first two days of his life, lamented that at that rate he would never be able to finish the job. But a self-perpetuating committee working at the same rate would be able to write up a complete account of its own history. No day's activities would have to be omitted—even though the work would fall ever more deeply into arrears. The resources of the infinite make strange states of affairs realizable.

The so-called "paradoxes of the infinite" arose through the very mistaken supposition that the groundrules for reasoning about finite qualities can be carried over intact to the infinite case. It seems paradoxical, although it actually is not, that a mere part of an infinite set can be every bit as large as the set itself—that

(for example) there are just as many even integers as there are integers all told because every integer can be paired with it double as per:

1, 2, 3, 4, 5, . . .
| | | | |
2, 4, 6, 8, 10, . . .

This yields the rather more picturesque *Hilbert's Hotel Paradox.* With an ordinary (finite) hotel, no more guests can be accommodated once the rooms are filled. Not so with Hilbert's hotel, with its infinity of rooms bearing the numbers of the integers:

1, 2, 3, 4, 5, . . .

Even though every room is filled—Room No. i with guest No. i, for i = 1, 2, 3, . . . —further guests can always be accommodated. When Messrs. A and B check in, the manager simply directs the desk clerk to make some room changes: "Let's put A in No. 1, and B in No. 2, and then shift Guest No. 1 to Room No. 3, and Guest No. 2 to Room No. 4, and so on." Although full, Hilbert's Hotel can always take in more guests. Even an infinity of new quests can be accommodated via the instruction "Let's just move Guest No. i to Room $2i$," for all i. That certainly opens up a lot of rooms. And there is no real paradox here—no actual inconsistency—as long as we do no make the mistaken presumption that the same arithmetical groundrules (such as $N + 1 > N$) that hold on ordinary finite quantities will hold for infinite ones as well.[1]

"How can there possibly be an infinite set—for example, the set of all integers—when such a set must be *complete* (contain *all* integers) and yet represents a collection that can never be completed, since no matter how many integers it already includes there are yet more of them to be added?" But this objection is based on the mistaken idea that a set needs to be specified by

1. On the same basis, somebody with an infinite income (a dollar for every integer) could pay out a like amount in income taxes and still have the initial amount left, dollar for dollar.

some sort of sequential listing of its content and yet cannot admit a complete inventory which is indeed something that can only be done with finite sets. The reality of it is that sets can be specified simply in terms of a condition of membership.

In analyzing mathematical paradoxes we can again map out the possible approaches to resolution in the usual way by identifying the R/A-alternatives. An illuminating starting point here is afforded by Cantor's Paradox of set theory. Georg Cantor (1845–1918), the German mathematician and founder of the theory of sets, proved the important theorem that for any and every set, the set of all of its subsets—its so-called *power set*—has a cardinality (mathematical size) that is greater than that of the original set. This means that there can be no greatest set, and therefore also no set of all sets, since such a supposed total would at once yield a larger one.

This power set business engenders an aporetic situation for the idea of a set of all sets, symbolically $\{x: x \text{ is a set}\}$. For this set leads at once to *Cantor's Paradox* which runs essentially as follows:

(1) For any and every predicate F, there exists the set of all items that have F—symbolically $\{x: Fx\}$ or more fully $(\iota y)\, \forall z\, (Fz \equiv z \in y)$.

(2) The characterization "——— is a set" specifies a predicate.

(3) Hence (by (1) and (2)) the set of all sets exists.

(4) Provably (by Cantor's Theorem): Any set gives rise to a set of larger cardinality than itself (namely its power set—the set of all its subsets).

(5) Hence (by (3) and (4)) the power set of the set of *all* sets must have a larger cardinality then that set itself, since it includes all its subsets.

(6) But a set of cardinality greater than that of the set of *all* sets, is patently impossible.

(7) Hence (by (6)) a set of all sets cannot exist.

✔ (8) (7) contradicts (3).

Here we have an aporetic cluster formed by the theses {(1), (2), (4), (6)}. Now (2) is securely fixed in place: to abandon it would be to abandon set theory. And with (4) and (6) firmly in place as demonstrable mathematical facts, the only remaining alternative is to abandon (1) and thereby to accept placing some suitable restrictive limitation upon the predicates (*F*) that are capable of engendering sets answering to the definition "the set of all items that have *F*."

From this point of view we realize that Cantor's Paradox is a paradox of unwarranted presupposition. For thesis (1) is predicated on the (deeply problematic) idea that meaningful predication is of itself sufficient to determine a well-formed set automatically and without further ado—that no *further* conditions are required for a predicate to define a set.

An auxiliary observation about definite descriptions is crucial here. With a putative item characterized as "the *x* such that the condition *Cx* obtains"—symbolically ($\iota x)Cx$—two sorts of things can go wrong. There can be failures of definition and failures of identification. A failure of definition occurs whenever we do not have *uniqueness*, that is whenever it is not the case that:

$$\exists y \,[\, Cy \,\&\, \forall z \,(Cz \,\rightarrow\, z = y)\,]$$

This means that $(\iota x)Cx$ will be defined only when *C* demonstrably applies to a single existing object.

On this basis, $(\iota x)\ Cx$ is only meaningful in a setting where it is established that one and exactly one *x* is such that *Cx* obtains, so that this remains undefined whenever:

(i) The condition *C* is uninstantiated and applies to nothing at all (*Cx* is always false).

(ii) The condition *C* is multiply instantiated and applies to several distinct objects (*Cx* is true for several values of *x*).

When one of these default conditions obtains, then $(\iota x)Cx$ is undefined, indeed nonexistent: there just is no such thing.

And this means further that an attribution-statement of the format $F[(\iota x)Cx]$ will be:

- *true* if there is exactly one item that satisfies C and this item has the feature F.

- *false* if there is exactly one item that satisfies the condition C and this item does not have the feature F.

- *meaningless* otherwise—(that is, if there is not just exactly one item that satisfies the condition C, so that $(\iota x)Cx$ goes undefined. (It is, of course, the semantical sense of "meaningless" that is at issue here, with its indication of lack of determinate truth status.)

We thus arrive at what might be called the Valid Identification Requirement (VIR):

For something to be appropriately brought upon the stage of discussion by an identificatory specification of the format "the x that satisfies the condition C" the availability of a unique item of this description must be independently pre-established.

For example, in set theory the power theorem shows that this is infeasible in the particular case of "the set that includes all sets." For including all sets is something that a set just cannot do. Accordingly, "the set of all sets" is not a meaningful item. It is a set in name only, something that is *called* a set, but does not actually qualify as such because it does not—cannot—admit of meaningful identification. And this very fact that "the set of all sets" is not intelligibly identified—is a mere pseudo-item—abolishes the perplexity generated by the question of whether or not it is a member of itself.

Thus consider the definition of "the set of all items that possess the property F":

$$\{x\colon Fx\} = (\iota y)\forall x\,(x \in y \leftrightarrow Fx)$$

For an aspiring set-specification of this format to yield a well-defined set we must pre-establish the unique determination of the item supposedly at issue.

What we have in the case of failure in this regard is a *referential* singularity of much the same kind as the *arithmetical* singularity that arises when we attempt to divide by zero. In the former

case the propositional formula $F(\imath x)Cx$ is not defined, while in the latter the arithmetical function $f(y) = \frac{1}{y}$ is not defined. This function has an arithmetical singularity at $y = 0$; Fy has a referential singularity at $y = (\imath x)Cx$ (when C is unsuitable). On this basis, that "set of all sets" is an undefined item even as $\frac{1}{0}$ is an undefined quantity.

When we divide by zero and proceed as though $\frac{x}{0}$ were a well-defined quantity, we fall into paradox. Thus since $2 \times 0 = 0$ and $3 \times 0 = 0$ we have $2 = \frac{0}{0}$ and $3 = \frac{0}{0}$ so that $2 = 3$! And so we fall into paradoxical arguments like Augustus de Morgan's comic demonstration that $1 = 2$, which runs as follows: let $x = 1$. Then $x^2 = x$. Therefore $x^2 - 1 = x - 1$. Dividing both sides of this equation by $x - 1$ we have: $x + 1 = 1$. But since $x = 1$, this means $2 = 1$. The fallacy at the root of *De Morgan's Paradox* of course lies in dividing by $x - 1$, that is, by zero.

And the same thing happens when we proceed in inappropriate cases as though $(\imath y)Cx$ were a well-defined object at a point of the discussion when this simply cannot be claimed.

9.2 The Successful Introduction Principle (SIP)

Besides the *identification* failure at issue in the Valid Identification Requirement (VIR) there is also the prospect of an *introduction* failure. That is, if $(\imath x)Cx$ is to be used to *introduce* an item—to initiate or introduce it as an item upon the stage of discussion—then it must not happen that the condition C is such that it refers to $(\imath x)Cx$ itself—that is, that $(\imath x)Cx$ should occur within the formulation of C. For example, let C be the condition such that Cx iff $x = (\imath y)Cy$. Here of course there is no way of assuring that this condition applies to a unique individual—or for that matter to *any* individual—until we have settled the identity of $(\imath y)Cy$—that is, unless we have *already* accomplished the very thing that we are in process ✓of trying to do. Not only circular *explanations, and circular definitions,* but also circular *introductions* are by nature futile.

The preceding Valid Identification Requirement accordingly has the inferential consequence that: *The identifying condition for an item must not involve a reference—explicit or tacit—to that item itself.* This might be called to the *Successful Introduction Principle* (SIP). The basic idea is that the classic fallacy of "begging the

question" must be avoided not only in argumentation,[2] but also in identification.[3]

Now observe that Cantor's putative "set of all sets" not only violates the Valid Identification Requirement (VIR) because there is no such thing as a totalized set of all sets, but also violates the Successful Introduction Principle (SIP) because the C-condition of the here-operative $(\iota x)Cx$ specification—namely being an all-encompassing set that is also supposed to include $(\iota x)Cx$ itself—is such that the SIP-prohibited reference to $(\iota x)Cx$ occurs in it. That set-totalization mistakenly presupposes that the set at issue is *already* available.

The rationale for SIP stands essentially as follows:

If an item is to be introduced into the agenda of discussion meaningfully, then its introducing specification must not presume that this item is *already* available for consideration. That is, if something is to be *introduced* into the discussion by means of a defining specification that takes the identificatory format of its being "the (one and only) item *x* such that *Cx* obtains," then this identifying specification *C* must not refer to or quantify over that item itself—however indirectly. In other words, identificatory self-reference is prohibited: if *X* is by definition to be $(\iota x)Cx$ then mention of *X* cannot occur within *C*. (Note that what we have here is a propriety of expository procedure that sets a condition for the meaningfulness of the resulting discourse.)

Identification must answer our questions about what it is that is to be at issue; an identification cannot proceed in a circular way that supposes that we already know the answer. It does not help to identify someone by the vacuous specification that he is "the person who is husband to the lady who is his wife."[4]

2. See C.L. Hamblin, *Fallacies*, revised ed. (Newport News: Vale Press, 1993), pp. 32–35 and passim.
3. The ancients already had a good sense of this, in rejecting such circular arguments (*diallēlos logos*) as: Where does Theon live? ["Identify for me the place where Theon lives".]; He lives where Dion lives; And where does Dion live? He lives where Theon lives. (See Prantl, *Geschichte*, Vol. I, p. 492.)
4. Observe that this principle has as a corollary the *Illicit Totalization Principle* (ITP): To be meaningfully and viably introduced into the discussion (that is, adequately specified, identified, defined) a totality (collection or whole) must not be purported *in its introducing definition* to include itself. That is, if *X* is by definition to be $(\iota x)Cx$, the totality of

While violation of the Valid Identification Requirement (VIR) leads to a *failure of reference*, violation of the Successful Introduction Principle (SIP) leads to a *failure of specification*. In the former use there is no such thing; in the latter, no proper identificatory introduction has been effected—irrespective of any questions of existence. In neither event do we "know what we are talking about." When these principles are violated, what we have is not an *inferential* defect, a logical fallacy, but rather a *referential* defect, a semantical error. Referential vacuity is just exactly that— the literal absence of a determinable object of discussion. By analogy, consider the proposition: "The statement in the (adjacent) box is complex." Now there just is no statement in the box!—and

there is nothing for the statement at issue to be about. We have as much reason to say that "it" is false as to say that "it" is true, there simply being no *it* at issue. That supposedly identifying expression "The statement in the box" is vacuous and claims about "it" (that it is true, or false, or complex) are literally meaningless.

This Successful Introduction Principle (SIP) swings a powerful ax that fells a wide range of paradoxes. The basic idea that underlies this principle is already encountered in a tract attributed to William of Occam (1285–1347). This stipulates that in *institutio*, the inauguration of a term into the setting of a discussion (*disputatio*), one must follow the rule *numquam pars potest significare totum* ("part [of an expression] can never signify the whole"). This principle was illustrated via the statement "Every statement is true" (*Omnis propositio est vera*), part of whose formulation ("every statement") brings the whole of itself—the entire statement at issue—within its own range of designation.

objects answering to the condition *C*, then *X* must not itself be one of the items whose status in relation to *C* must be settled enroute to setting the boundaries of $(\iota x)Cx$ itself.

This principle is, in its effect, closely akin to Russell's Vicious Circle Principle (VCP) already discussed in the preceding chapter. It too can serve to sideline various mathematical paradoxes.

The Occamite author then applies this principle to the solution of the paradox engendered by:

(A) *A* is false.

Here the specification of *A* must be rejected (*institutio non est admittenda*) because *A*'s self-invoking specification violates the principle at issue: *A significat hoc totum "A significat falsum"* is an illicit specification (*institutio*). For the idea that *"A* stands for '*A* is false'" leads straightaway into the paradox (*sophisma*) that *A* is true if false and false if true.[5] This Occamite analysis is yet another example of the subtle and original contributions of thirteenth-century logic. Its focus on the introduction of terms rather than the existence of things puts our medieval author's approach ahead of the treatment of cognate ideas in the early twentieth century (as, for example, Bertrand Russell's Vicious Circle Principle which will be discussed shortly).[6]

It should be observed that the rationale of VIR and SIP is not that paradoxes can result from their violation. (That is simply an ex post facto aspect of their nature.) Their justification lies in the fundamental prior considerations of the same qua non condition under which processes like identification and introduction can conceivably accomplish their intended work. What is at issue are fundamental principles of rational procedure and not just ad hoc devices for paradox-elimination.

9.3 Pseudo-Objects

To see how pseudo-objects which violate the principles under consideration can engender paradox let us consider in detail the idea of a <u>supertruth</u> that encompasses all truths.[7] Such a

5. See Prantl, *Geschichte,* Vol. IV, p. 42. The text cited by Prantl deserves closer analysis than it has received to date.

6. Occam was criticized in the fourteenth century on exactly the same point on which Russell was criticized in the twentieth, namely that his strictures ruled out harmless self-reference ("Some propositions are true" or "All propositions can be discussed") along with the paradoxical ones ("All propositions are false"). See Ashworth 1974, p. 105.

7. Note that the infeasibility of such a truth would also make for a negative answer to the question: "Is truth-as-a-whole finitely axiomatizable?"

supertruth would be a truth S such that: $\forall p[Tp \rightarrow (S \vdash p)]$. So the question at hand comes down to the tenability of the thesis:

$$(1)\ \exists q\,[q\ \&\ \forall p\,[p \rightarrow (q \vdash p)]]$$

Adopting the idea of a supertruth implies that we should settle this question via the definition:

$$(2)\ T = (\iota q)[q\ \&\ \forall p\,[p \rightarrow (q \vdash p)]]$$

Now for this definition to satisfy VIR we need to establish both uniqueness and existence. Here uniqueness is no problem. It is readily shown that any two propositions q' and q'' meeting the condition at issue are relevantly identical (i.e., logically equivalent). But this existence claim at issue with (2)'s VIR satisfaction reverts to begging the very question at issue. That is, (2) could only accomplish its intended missions if an affirmative answer to the question of (1)'s tenability were *already* in hand.

Moreover, with (2) we are also plunged into problems in relation to SIP. For note that the formulation of what follows (ιq) in (2) involves a universal quantifier with respect to propositions, viz., $\forall p$. So T itself would here have to qualify as one of the values of the relevant variable. And this means that SIP is also violated.

The principles with which we have been dealing thus rule out the idea of a supertruth on grounds of its illegitimate self-encompassing nature. But is such an embargo actually necessary to avoid paradox? Or are those principles blocking us off from something that is actually unproblematic?

The paradoxical character of the supertruth idea emerges from the apory:

(1) A supertruth entails all truths.

For every truth there is yet another dominator-truth, that is, a truth that entails it but that it does not entail. The following two illustrations demonstrate this fact—in each case the proposition at issue dominates t:

- t is a truth whose implications no one realizes in their full detail

- *t* is a truth of which someone may possibly not be aware.

- *t* is a truth that has consequences which some people would probably deny.

(1) Now this being so, there will also be a dominator-truth for that supposed supertruth *S*.

✓(2) But if a truth is dominated by another it cannot entail *all* truths.

(3) (4) contradicts (1).

The best resolution of this *Supertruth Paradox* lies in seeing it as *a reductio ad absurdum* of the very idea of a supertruth *S*. And the fact of *S*'s violation of the meaningfulness requirements at issue not only authorizes but enjoins this rejection.

It warrants note that the SIP identification principle applies to items of all sorts and not just to objects or to propositions. For example, arguments also come within its purview. Thus consider the argument

(I) Argument (I) is valid

Therefore: Argument (I) is sound

Recall that a valid argument is one whose premises entail its conclusion, and that a sound argument is a valid argument with true premises. But now consider the following *Valid Argumentation Paradox*:

(1) A valid argument cannot have a conclusion that claims more information than is provided by its premises.

(2) By the thesis (1), (I) is not a valid argument.

(3) (I) is a valid argument, for there is no way for its premises to be true and its conclusion false (which is the definition of argument validity).

(4) (3) contradicts (2).

The exit from paradox here lies in noting the argument's failure to distinguish between suppositional (or conditional) truths and categorical truth. Moreover—and this is the presently crucial point—the salient flaw of (1) lies in its blatant violation of the Successful Identification Principle (SIP).

9.4 Russell's Paradox

One of the most notorious paradoxes encountered in twentieth-century logic and mathematics is *Russell's Paradox*, based on the idea of "the set of all sets that do not contain themselves," symbolically $\{x \colon x \notin x\}$. (Here \in is set membership and \notin its denial.) We thus envision a certain set R supposedly defined through the following specification of its membership:

> By definition (of R): R is the set of all non-self-containing sets, so that $S \in R$ iff $S \notin S$

This specification is supposed to provide a contextual definition of R (in the specific context of membership attribution). And perplexity arises here when we ask whether or not R contains itself. For if $R \in R$, then by the definition of R we have $R \notin R$. And if $R \notin R$, then by the definition of R we have $R \in R$. Thus contradiction results either way.

Given these considerations, we confront the following aporetic situation:

(1) R as defined by the preceding specification exists as a well-defined set—that is, one such that any existing item either is or is not a member of it.

(2) $R \in R \rightarrow R \notin R$ by the definition of R

(3) $R \notin R$ from (2) by standard logic

(4) $R \notin R \rightarrow R \in R$ by the definition of R

(5) $R \in R$ from (4) by standard logic

(6) (3) contradicts (5)

The resolution of this paradox is, in a way, straightforward. Since the whole course of argumentation pivots on (1), the only exit from inconsistency has to proceed via its rejection.

When we ask a question like "Does the set *R* include itself or not?" we presuppose that the set *R* exists. But what the argumentation of the Russell paradox actually shows is simply that it does not—that this essential presupposition of the question is not satisfied. There is no alternative to taking the line that the Russell set *R* is simply not a well-defined set. The only real question is *why* this is so—that is, how it comes about that *R*'s seemingly straightforward definition goes awry and is illegitimate. It is not *R*'s demise that is in question, but the result of the autopsy, the question of why it is that *R* cannot survive a proper scrutiny of its meaningfulness.

The difficulty with the Russell set *R* is that it is *introduced* into the arena of discussion by a definition of the form:

- the set that includes all sets of a certain type (viz., non-self-inclusive sets).

We could conceivably use such a formula to *describe* a given set in the range of sets if it indeed existed and answered to that description. But the SIP requirement means that we cannot *introduce* it on this basis. For such an introduction to be appropriate we would need to pre-establish the existence of a (unique) set *x* such that

$$\forall y \, (y \in x \text{ iff } y \notin y).$$

And the argumentation of the Russell Paradox shows that no such set can exist. The fact is that the Russell set is an inappropriate hypostatization (or an identificatory failure), because its introduction on the stage of discussion proceeds by a defining specification that is inappropriate exactly because there can be no such set.

It warrants note that from the formal point of view Russell's paradox of the set that contains all but only sets that are non-self-belongers strictly parallels the paradox of the barber who shaves all but only persons who are non-self-shavers. Both paradoxes rest on pretty much the same mis-presumption of the existence of their pivotal item.

The early Russell adopted an approach quite different from that taken here. He took over from the French mathematician Henri Poincaré a principle he enunciated in 1906 and which Russell following him characterized as the

Vicious Circle Principle (VCP): No collection (whole or totality) can contain members that are defined in terms of itself: specifically, no existing collection can ever be a constitutive ✓ part of itself.[8]

As it stands, this principle is clearly a limitation upon the *constitution* of actual totalities—and a very strong limitation at that. For Russell, saying that such a "collection" "has no total," is to say that it does not exist as a collection. What we have here is a restriction on the sorts of collections that can exist—that is, upon ⟋ how authentic collections can validly be constituted.

The present approach, by contrast, pivots matters on the SIP ⟋ Principle. It takes the line that only when something is properly identified, can it serve as a subject of meaningful discussion. For when we do not know what we are talking about, we do not know what is or what is not to be said about it. With an inappropriately identified pseudo-object z it is every bit as plausible (or, rather, implausible), to claim $F(z)$ as not-$F(z)$. The doorway to

8. See Bertrand Russell and A.N. Whitehead, *Principia Mathematica*, Vol. I (Cambridge: Cambridge University Press, 1910 [re-issued in paperback, 1967]), pp. 31, 37. Elsewhere Russell puts it as follows: "If provided a certain collection has a total, it would have members only definable in terms of that total, then the said collection has no total." *American Journal of Mathematics*, vol. 30 (1908), pp. 222–262 (see p. 240). Russell went on to explain that "When I say that a collection has no total, I mean that statements about all its members are nonsense." (*Ibid.*; see also *Principia Mathematica*, Vol I.) He appears to think, however, that the culprit here is "all" instead of "its"! For he stresses that "Whatever involves *all* of a collection must not itself be one of the collection" ("Mathematical Logic as Based on the Theory of Types" (1908) reprinted. in J. van Heijenoort, *From Frege to Gödel* [Cambridge, MA: Harvard University Press, 1967], pp. 153–182; see p. 155.) Elsewhere, Russell is more cautious "If, provided [we assume] a certain collection has a total, it would have members only definable in terms of the total, then the said collection has no total." (Bertrand Russell, "Mathematical Logic as Based on the Theory of Types," *American Journal of Mathematics*, vol. 30 [1908], pp. 222–262; see p. 227; cf. *Principia Mathematica*, Vol. I, pp. 31, 36.) The phrase "only definable in terms of" helps matters but also introduces problems of its own, since what is to say that something not definable in one way cannot possibly be defined—by hook or crook—in some other way? All of Russell's formulations sound as though he thought that a problematic collection is there all right, but we must avoid making claims about *all* of it. This seems quite wrong-headed. ✓

contradiction and paradox is thrown wide open. Only that which has been identified can be said to have a discernible descriptive identity. Only when we know what the "it" at issue is can we meaningfully attribute any descriptive features to it.

Accordingly, the line of argument contemplated here via the Successful Introduction Principle (SIP) is quite different from Russell's VCP even though it accomplishes much the same work. For it does not address the *ontological* issue of what sorts of sets or collections do or do not exist. Rather, it addresses itself to the *communicative* issue of the conditions that must be met for a purportedly identifying description of an object to succeed in specifying a well-defined referent and thereby presenting a meaningful object of discussion. All in all, SIP affords a more natural, less restrictive and more economical way of sidelining the paradoxes ✓than the Russell-Poincaré Vicious Circle Principle (VCP) puts at our disposal. On this basis, the issue is at bottom not one of the ontology of what does or does not exist, but one of the semantics of what sort of statements can or cannot meaningfully be made.

9.5 Paradoxes Related to Russell's: Curry's and Grelling's

Curry's Paradox is best seen against the background of Russell's Paradox. Instead of contemplating the Russellian "set of all sets that are not members of themselves, $\{x: \sim(x \in x)\}$, Curry contemplates the set of all sets such that *if* they are members of themselves *then* an arbitrary proposition obtains:

$$\{x: (x \in x) \rightarrow p \}$$

This enables Curry to recover Russell's paradoxical result on a negation-free basis when p is self-contradictory. In view of the absurdity of what follows the implication sign, this paradox is an effective variant of Russell's, and is amenable to essentially the same deconstructive analysis.✓

In the original 1903 edition of his *Paradoxes of Mathematics* (Cambridge University Press), Bertrand Russell introduced his *Impredicability Paradox.* This is based on the idea of *impredicable* predicates, namely those which, unlike "abstract" or "intelligi-

ble," cannot be predicated of themselves. And he maintained that the predicate "impredicable" cannot itself be classed as a predicate on the basis of the following argumentation: "Let us assume that 'not-predicable of itself' is a predicate. Then to suppose either that this [supposed] predicate is, or is not, predicable of itself, is self-contradictory. The conclusion in this case seems obvious: 'not predicable of oneself' is not a predicate . . ." (p. 102). To allow it to qualify as such would be to invite a contradiction. Russell's analysis thus successfully averts the paradox.

The "Heterological" Paradox of the German mathematician Kurt Grelling is an in-name-only variant of Russell's Impredicability Paradox.[9] It pivots on the idea of a *heterological* predicate. A predicate (or adjective) is autological if it applies to itself (for example, the predicate "intelligible" is intelligible and the predicate "common" is common). Otherwise, a predicate is heterological; for example, "green" is not green nor is "prehistoric" prehistoric. Thus we have the defining specification: *F* is a *heterological* predicate iff it is not self-applicable:

(Het) For any predicate F: $H(F)$ iff $\sim F(F)$

Now *Grelling's Heterological Paradox* pivots on the question: Is "heterological" heterological or not? Letting the F of the preceding specification be H itself we arrive at

$$H(H) \text{ iff } \sim H(H)$$

We arrive at a paradox. The predicate "heterological" is heterological (and thus self-applicable) iff it is not so.

The scope for resolution here is narrow, since there is nothing to attack save (Het) itself. Our best bet here is to take the line that it rests on an erroneous presupposition, namely the supposition that H as a predicate of predicates is eligible for inclusion within the range of the variable F at issue in the preceding specifi-

9. On Grelling's Paradox see Kurt Grelling and Leonard Nelson, "Bemerkungen zu den Paradoxien von Russell und Burali-Forti," *Abhandlungenden der Fries'schen Schule*, N. S., vol. 2 (1908), pp. 301–334. See also Hermann Weyl, *Das Kontinuum* (Leipzig: Veit, 1918).

✓cations. For SIP precludes that *H* is a something that lies within the range of the universal quantifier ∀ that is at issue when we stipulate: ∀*F* [*H*(*F*) ≡ ~*F*(*F*)]. The point is that in adopting Het we have a "creative" definition that superadds something to a presumably pre-determined range of predicates:

- the predicate of predicates which applies to a given predicate wherever that predicate does not apply to itself.

The flaw here is not self-involvement as such but self-involvement in the context of an initiating-definition or item-specification. For this straightaway leads to a violation of the Successful Introduction Principle (SIP).

It warrants noting that Grelling's Heterological Paradox of the "predicate that applies to all non-self-applicable predicates" is also closely parallel to Russell's Paradox of "the set that contains all non-self-inclusive sets." The former looks at the issue intentionally where the latter sees it extensionally. For consider any specifiable feature *F* of things. We will then obtain {*x*: *Fx*}, the set of all items that have *F*, and also (λ*x*)*Fx*, the property that all *F*-bearing things share in common. The Russell Paradox turns on the set of all sets that are not self-inclusive, {*x*: *x* ∉ *x*}, while Grelling's Heterological Paradox—as indeed Russell's own Impredicable Paradox—turns on predicate applicable to all predicates that are not self-characterizing, (λ*F*) ~*F*(*F*). So the difference is, in effect, merely stylistic. In each case the same pattern obtains. And so, both lend themselves to the same deconstructive analysis to the effect that the paradoxical item at issue (supposedly a well defined set in the one case and a meaningful predicate in the other) does not and cannot qualify as appropriate because the Successful Introduction Principle (SIP) is once again violated. In each case the property *F* at issue is one whose formulation supposes the availability of the very item in question. For in the Russell case it is "the set of all sets, *itself included*, that have the predicate *F*" and in Grelling's case it is "the predicate of all predicates, *itself included*, that have the property *F*."

Grelling's paradox shifts the Russell paradox difficulty from sets to predicates. And Russell himself extended his finding that sets of sets can engender paradoxes to the idea that relations of

relations can also do so.[10] ~~Russell's Relational Paradox~~ projected the idea of a special second-order relation T which obtains between two relations (R and S) wherever it is not the case that R obtains between R and S.

(T) By definition (of T): T is the relation such that for any two relations R and S we have $T(R, S)$ iff $\sim R(R, S)$:

$$T = (\iota V)\forall R \ \forall S \ [\, V(R, S) \leftrightarrow \sim R(R, S)]$$

The question now arises: Given a relation S, does the relation T hold between itself and S? Note that in virtue of definition (T) we will have it that the substitution of T for R yields:

$$T(T, S) \text{ iff } \sim T(T, S)$$

And this is of course paradoxical: it means that $T(T, S)$ can neither obtain nor fail to do so.

There is but one way to resolve the paradox that arises here: We have to abandon the idea that (T) affords the meaningful specification of a relation. This being so, T will not belong to the range of the variables at issue (R and S) and so the substitution of T for R, which engenders the difficulty, becomes unraveled as a meaningful inferential step. And so this paradox—like its predecessors—also falls to the ax of the Successful Introduction Principle (SIP).

9.6 Berry's Paradox and Its Ramifications

An interesting paradox was credited to the Oxford University librarian G.G. Berry by Bertrand Russell, who first published it in 1908.[11] Berry's Paradox emerges from the following narrative:

The integer 1 can be identified (in standard English) by a single word ("one"), whereas the number 10 exp.10 cannot.

10. Bertrand Russell, *The Principles of Mathematics*, revised ed. (New York: Norton, 1938), pp. 102–03, section 102.
11. Russell 1908, reprinted in Hiejenoort 1967.

What then of "the least integer that cannot be identified in fewer than fourteen English words"? This clearly poses an anomaly. For we have just identified it in thirteen words.

The paradox that arises here roots in the following aporetic cluster:

(1) Some number or other is bound to answer to the identifying descriptive expression "the least integer that cannot be identified in less then fourteen English words."

(2) In view of (1), the descriptive expression "the least integer that cannot be identified in less then fourteen English words" identifies this integer.

(3) But—contrary to this contention—the descriptive expression "the least integer that cannot be identified in less then fourteen English words"—which has only thirteen words—successfully identifies the integer.✓

The only practicable exit from inconsistency here lies in insisting that the purportedly identificatory "least integer" expression fails. And it does so because its use in the present paradox rests on a — mistaken existential presupposition.

And this seems plausible enough. For Berry's paradox could be construed as a *reductio ad absurdum* of the idea that there is such a number as "the least integer that cannot be identified in ✓fourteen English words." After all, suppose that there were such an integer. Then let it be printed out in some (conceivably sizable) book to be entitled The Number Tome. Then the expression "the integer printed out in The Number Tome" will identify this number, few though its words be. Only if the allowable ways and means of number specification are specified clearly from the outset will the theses that constitute Berry's Paradox be meaning-—ful—and once this is done the contradiction at issue dissolves.

This way of addressing Berry's Paradox was argued by Alexandre Koyré, who emphasized that there are two very different ways of specifying an integer, first, via a naming-formula of the standardized format for numbers ("five thousand six hundred and ninety-two"), and second, via some identifying condition that

this number alone satisfies (such as "the number of grains of sand in the Sahara desert").[12] The former (naming) would generally require a long expression for number specification, but the latter (identifying) might generally be achievable by compact means. The paradox thus succumbs to a dilemma. With technically standardized number-naming, premisses (3)–(4) are true but (5)–(6) false, while with unformalized number-identification, (5)–(6) would be true but (3)–(4) false.

It is, however, possible to recast Berry's paradox into a more challenging formulation. For consider the following line of thought:

(1) Every finite text that can be presented in an alphabetized natural language such as English is contained in the text-series which first presents in alphabetic order all possible texts of one-letter length, and then all texts of alphabetic length two, and then all texts of alphabetic length three, and so on.

(2) Since any particular (positive) integer can be identified in standard English by a finite text, it follows that any and every particular integer will eventually be identified by some text in this series.

(3) The number of integers that *can* be identified by texts of length less than n is always finite because the number of such texts is finite. This means that the (infinite) set Z_n of all integers that *cannot* be identified by a text of length less than n will always exist.

(4) Like any other set of integers, finite or infinite, such a set Z_n will always have a smallest member z_n^*. In the circumstances this will be the smallest integer that *cannot* be identified in standard English by a text of alphabetic length n or less.

12. Koyré 1946. However, instead of the present line that *any* integer can be identified very briefly in the second mode, Koyré's resolution takes a different line: "La question: 'peut-on ou ne peut-on pas "nommer" un nombre donné en tent de syllables?'—ne comportera plus de réponse, n'offrant plus aucun sens déterminé" (p. 17).

(5) Specifically, if n is 1,000 then $z^*_{1,000}$ will—in virtue of its construction—be "the smallest integer that cannot be identified in English by a text of fewer than thousand letters."

(6) However—and here lies the paradox—we have just identified the integer z^*_{1000} by far fewer than a thousand letters, namely just exactly as "the smallest integer that cannot be identified in standard English by fewer than a thousand letters."

Here there is no easy escape from acknowledging the quantity at issue. To do so, one must here tackle the most problematic premiss—number (3)—by a frontal assault.

Perhaps the most plausible way to effect this break in the chain of inconsistency is to introduce the distinction between direct and indirect integer-identification. An integer is *directly identified* if it is specified either by its standard name or by an identifying formula that it alone instantiates such as "the fourth power of 35." It is *indirectly identified* when it is specified by some contingent relationship such as "the integer written on the piece of paper at such-and-such a location" or "the integer that John mentioned on such-and-such an occasion" or "the integer identified in such-and-such a way in such-and-such a language." Clearly, *any* integer whatsoever can in theory be identified by a brief text of the indirect type. So premiss (3) is tenable only with respect to *direct* but not with respect to indirect identification. However the claim of Z_n^*'s existence at issue in (4) – (6) rests upon a process of *indirect* identification. The paradox can thus be resolved by noting the crucial equivocation at issue with its key idea of integer-identification. That purportedly identifying expression of premiss (6) simply does not identify.

The point becomes even clearer when viewed from another angle. Consider the sentence in the following box:

> Now is the time for all good men to come to the aid of the party.

How many words must I use to instruct you to write this sentence?
There are various alternatives here:

(1) Write the sentence: "Now is the time for all good men to come to the aid of the party."

(2) Write the standard typing practice sentence.

(3) Write the sentence in the box.

Short of specifying the eligible ways of presenting the instruction at issue, that italicized question is simply not well-defined. It is like asking you how many dollars must be spent in getting from New York to Los Angeles without indicating whether this is to be by boat, on foot, by train, by plane, by cab, and so forth. The question as it stands is lost in a fog of meaning-obscuring indefiniteness.

One can also question premiss (3) from another angle, namely that of the difference between the prospective and the retrospective standpoint. Consider "Every book has a title." This is true (or at least presumably so) retrospectively: every book we have dealt with so far has a title. But it is not true—or at least not true yet—for the books of the future that have not yet been produced, let alone titled. And similarly with "Every number has a name." This is certainly true of any and all real numbers that we specifically consider. But since the real numbers are uncountably infinite while the available names are at best countably infinite, there are too few names to go around. Any and every number that we might come to discuss can (ipso facto) be named and identified. But this is not true for all numbers in toto. (If we have only ten minutes, I can introduce you to *any* person in the ballroom, but not to *every* person.)

The perplexity at issue is also akin to that of the puzzle: What are we to call some thing that has no identifying name? Well—let's adopt the convention: It shall be *Nameless*. But now—lo and behold!—it is not this any more. But the fact is that there is an equivocation going on here, as between the level of discourse at the *initial* state of things antecedent to the renovation of terminology and the *ultimate* state of things that ensues thereafter. In the post-designation circumstances, there indeed is something that has no name; in the post-designation circumstances, there is

not. Contradiction is thus averted by drawing a suitable distinction (just as Aristotle said it has to be).

Accordingly, we need not look to mathematics for paradoxes of this sort. For consider the purportedly identifying expression at issue in the following narrative:

> Some persons are mentioned in a written text of some sort—a biography or a "wanted" bulletin or perhaps a birth certificate. Other persons are never mentioned in any written text—like a remote Eskimo fisherman or Anatolian shepherd, they live out their existence in unmentioned obscurity. But now consider the descriptive expression: *The oldest living textually unmentioned individual.* Note the anomaly that we just now have— to all appearances—managed to mention this individual. ⌐

This paradox is essentially of the same type as that of Berry. A similar mistaken presupposition is at work, seeing that we once more have a purportedly identifying expression that violates the Successful Identification Principle (SIP) which effectively embargoes the problematic idea of defining an "unmentioned individual" as "one not adverted to in any text—that of the present discussion included."

9.7 Richard's Paradox

The perplexity known as Richard's Paradox emerges from the following line of thought.[13]

> Let D be the set of decimals that can be specified in a finite number of words. We can, of course, present this set by means of an infinite list, by listing first (in alphabetical order) all those decimals that can be specified by one word (such as zero = .0000...), then by two words, and so on. But now construct a new decimal as follows: Begin with the first decimal in the list and look at its first decimal place. Should this be n, then let

13. Richard's paper "Les principes de la mathématique et la problème des ensembles" was originally published in the *Révue générale des sciences pures et appliquées* in 1905. It is translated in Heijenoort 1967, pp. 143–44.

the first decimal place of our newly constructed decimal be
$n + 1$, unless n is 9 in which case use 0. Then go to the second
decimal in the list and look at its second decimal place. Should
this be n, then let the second decimal place of our newly con-
structed decimal also be determined by the preceding rule.
And then on to the third decimal on the list with the same
process. What we are thus constructing is (1) a decimal that is
specified by a finite number of words (note the utility of "and
so on" here"), but (2) that nevertheless *cannot* be present on
that initial infinite list of all of the members of *D*.

One way of attacking this paradox is to deny its (tacit) premiss
that any given (finite) verbal formula can only specify a certain
number and not others, and in any case only a limited number of
numbers. There just is no such thing as "the maximum number
that an expression of length n can identify." Think, for example, of
the formula: "The number of numbers which I am thinking
now," or "The number written in the book on the table." (Recall
the preceding discussion of Berry's paradox on the equivocal
nature of "number identification.") Accordingly, the Successful
Introduction Principle (SIP) is again violated. Giuseppe Peano
put his finger on the crux of the problem in objecting: "Richard's
example does not belong to mathematics but to linguistics. For an
element that is fundamental in the definition of [the diagonalized
number] *N* cannot be defined in an exact way via mathematical
rules."[14] After all, that initial starting list of "decimals specified by
a given number of words" is not—and cannot be—generated by
arithmetical means alone, but calls for settling mathematically
imponderable matters of linking verbal formulas to numbers
where these verbal formulas belong to unformalized rather than
rigidly formalized languages—in much the same way as with the
previous discussion of Berry's paradox.

　　However, Richard's Paradox has interesting larger ramifica-
tions. For consider the following contentions:

(1) With real numbers, *to be is to be arithmetically identifiable.*
　　It is inappropriate here to claim the existence of

14. Heijenoort 1967, p. 142.

something that lies outside the realm of arithmetic tractability.

(2) In view of (1), formalized real number arithmetic is adequate to the real numbers.

(3) The identification-formulas that can be stated in any formalized language (that of real-number arithmetic included) can be set out in toto in a suitably constructed infinite list. Hence the formulas available for the possible specification of real numbers are *countable*.

(4) It can be demonstrated (by a diagonal argument due to Georg Cantor) that the real numbers themselves cannot be fully enumerated and that their number is *uncountable*.

(5) In view of (3)–(4), formalized real number arithmetic is not adequate to the real numbers

(6) (5) contradicts (2).

Here (1), (3), (4) constitute an inconsistent triad.

How should this inconsistency be addressed? Since demonstrable facts are at issue with (3)–(4) while (1) is at best a plausible claim, we should—in this context!—be prepared to abandon (1). The result would be to accept the idea that as far as the arithmetical systematization of real numbers is concerned explicit identification is one thing and actual existence another—and a greater.

Real numbers are uncountably many in quantity: the number of reals is nondenumerably infinite. However, the number of number specifications—of number "names" that can be articulated in a formalized system—is countable. The real numbers play musical chairs with the number names—there just are not enough names to go around. There is nothing wrong with the idea that even for real numbers *To be is to be nameable—to be arithmetically identifiable*. It is clear that *any* real number could be named/identified. —But not *every* real number is ever named/identified. If we said that for real numbers, *to be is to be named* (instead of *nameable*) we would severely underestimate the reals.✓

Painful or not, we are impelled towards the idea that there is more to the manifold of real numbers—informally understood—

than any axiomatically formalized systematization of the arithmetic involved is able to capture explicitly.[15]

9.8 Burali-Forti's Paradox

The paradox due to the Italian mathematician Cesare Burali-Forti involves mathematical complications that make it too technical for detailed consideration here.[16] The basic idea is that the series of *all* ordinal numbers, duly arranged in order of magnitude, must itself have an ordinal number, say Z. But it can be shown that the series of all ordinals up to and including any given ordinal is greater than that ordinal itself (specifically that it is that ordinal plus one). And this would mean that Z has to be greater than itself (by one). And the arithmetic of ordinals is such that there, as elsewhere, this sort of self-surpassing is impossible.✓

The most readily practicable line of attack here is to abandon the idea that every series of ordinals must itself have an ordinal and specifically that this is the case with the series of all ordinals. After all, "the ordinal of the set of all ordinals—itself included" is a specification that once again violates the Successful Introduction ✓Principle (SIP). The upshot would be rejection of a totalization ordinal for the set of *all* ordinals. (Compare the discussion of illicit totalization in other contexts such as the Kantian antinomies (above, pp 147–51).) But these issues are too technical for further elaboration here.

9.9 Addressing the Mathematical Paradoxes

In the course of the twentieth century, mathematical logicians have proposed a variety of devices for dealing with the paradoxes arising in this domain. In each case their general strategy has been the same: the articulation of a rationale for holding that one or another of the propositions essential to the paradox is untenable.

15. For a more detailed discussion of this issue see Alonzo Church, "The Richard Paradox," *American Mathematical Monthly*, vol. 61 (1934), pp. 356–361.

16. See Cesare Burali-Forti, "Una questione sui numeri transfinite," *Rendiconti di Palermo* (1897), trans. Heijenoort 1967.

And in the search for such a rationale they have been guided by the "many birds with one stone" guideline of seeking for a mechanism that can at one stroke accomplish the needed work with various—and indeed ideally with *all*—of the paradoxes. This search has not been entirely successful, but useful progress has nevertheless been made. In particular, following Peano, F.P. Ramsey distinguished two types of paradoxes: (1) the mathematical invoking the concepts of set, element, or number, and (2) the semantical invoking the concepts of truth, reference, or identification.[17] The former, so Ramsey held, could all be handled by the simple theory of types (without type ramification and the axiom of reducibility). And latter could be handled by a variety of restrictions upon proper linguistic usage. This point of view has been widely accepted.

But another option can also be envisioned that dispenses with the cumbersome machinery of type theory. For as regards the mathematical paradoxes themselves, these can be divided into two main groups:

- *The Cantor-Russell Style Paradoxes*

 This group includes Cantor's Paradox, Russell's Paradox, Curry's Paradox, Grelling's Paradox, and Russell's Relational Paradox. The crux of the problem here is the vitiating self-involvement arising from the combination of self-reference with totalization at issue in identificatory specifications like "the set of all sets such that," "the property of all properties such that," "the relation of all relations such that," "the number of all numbers such that," etc.).

- *The Berry-Richard Paradoxes*

 These include Berry's Paradox and Richard's Paradox. The crux of the problem here is that there is a discrepancy between the intra-systemic identification of numbers in a formalized system and their externalized identification by informal means.

17. See Quine's account in Heijenoort 1967, p. 152.

Now the paradoxes of the second group are not too alarming. For one thing, they can be averted as actual contradictions by observing that they rest upon inappropriate presuppositions regarding the relation between the formalized definitions of numbers and their informal, extra-systematic specification. Moreover, these paradoxes call into question not so much the *consistency* of formalized mathematics as its *completeness* in relation to looser, informal ideas. They indicate a Gödelian discrepancy between what can be said *within* a formalized system of arithmetic and what can be said *about* it by externalized means. And they indicate that the second will always press beyond the limits of the former: that no formalization can capture the whole of what can truly be said about arithmetic.

However, the paradoxes of the former group are threatening to the very consistency of mathematics itself. And a variety of far-reaching strategies have therefore been proposed for their elimination, preeminently the following four:[18]

I. *Self-Reference Proscription* (Early Russell)

No statement is to be accepted as meaningful and proper that involves a reference to itself, however oblique.

II. *The Vicious Circle Principle* (Poincaré, Later Russell)

A supposed item of any particular sort ("the set of sets such that . . . ," "the predicate of predicates such that . . . ," or the like) cannot exist if its specification refers—directly or obliquely—("all sets belonging to it," "all predicates bear it" etc.) to that item itself.

III. *Theory of Type Levels* (Russell-Whitehead)

All properly defined statements about objects possess a type level. And a feature being attributed to an object can make mention only of items which themselves are of a

18. For the relevant discussions see Heijenoort 1967.

lesser type then this object, so that every meaningful asser-
tion about a totality is of a higher type than that totality
itself. Accordingly, no meaningful statement about a set
can attribute to it any members that are not of a lesser
type. (Note that this precludes the meaningfulness of
$x \in x$, which attributes to an object (x) a feature (element-
possession) that mentions an object of equal type-level,
namely x itself.)

IV. *Language Level Theory Language/Metalanguage
Distinction* (Tarski)

Discourse always proceeds at a particular level in a hierar-
chy of languages. And talk about an object at some level
automatically shifts what is said to the next level. Hence
expressions like "All statements (or all predicates) such
that . . . " must be construed as "All level i statements (or
predicates) such that . . . " And this statement, being at
level $i + 1$, does not—cannot—refer to itself. Statements
of the format "This statement is . . ." are automatically ill-
formed—in effect non-statements.

In the context of this fourth approach, Tarski was able to show
that if the usual logical principles are accepted, then no language
is semantically self-encompassing in the sense of providing the
means for discussing the truth and falsity of its own expressions.
For with those conditions satisfied it will always be impossible to
construct an assertion of the Liar-Paradox type which attributes
falsity to itself. Given that a coherent language is inadequate to
self-characterization we are driven to a hierarchy of languages of
different levels where we can ascend to level $n + 1$ to discuss a
language of level n, but where the means of totalization to all lev-
els at once is not and cannot be made available. In particular we
cannot even speak of generalization as being true or false flat-out,
but only as being so at this or that level of the hierarchy of lan-
guages and meta-languages. However, this paradox-averting
upshot is purchased at the great price of forgoing the unencum-
bered generality of discourse that we would clearly like to have in
mathematics as elsewhere.

9.10 The Efficacy of the Successful Introduction Principle (SIP)

The problem common to all of the standard avoidance-devices for the mathematical paradoxes that we have been considering is that they all invoke a large-scale and cumbersome restriction on the meaningfulness of language. In this regard the present chapter's focus on how items can meaningfully be brought upon the stage of discussion (namely by identifications that do not violate the Successful Introduction Principle) has a substantial advantage in ✓ point of simplicity and naturalness.

Consider once more the item-specifications at issue in these mathematical paradoxes:

- the set of all sets—itself included (Cantor's Paradox)

- the set of all non-self-containing sets (Russell's Paradox)

- the set of all sets the claim of whose self-inclusiveness allows an "articulating assertion to be made" (Curry's Paradox)

- the property characterizing all properties that are not self-characterizing (Grelling's "Heterological" Paradox)

- the relation that obtains between all pairs of relators wherever the former of these does not hold between itself and the second (Russell's Relational Paradox)

- the ordinal of all ordinals—itself included—that satisfy a certain condition (Burali-Forti's Paradox)

- the number relevant in a certain way to any number—itself included (Berry's and Richard's Paradoxes)

The critical fact to note here is that all of these paradoxes pivot on an item-introducing descriptive specification of the format "the item meeting such-and-such a condition" $(\iota x)Cx$. But the identification operator at issue here so functions that this so-called item is specified in a deeply problematic way. For what is at issue throughout is a violation of the Successful Introduction Principle (SIP).

Two modes of *communicative anomaly* can be distinguished. One is a matter of *propositional meaninglessness*—be it hermeneutically concept-based or semantically truth-based. But there is also the *referential vacuity* by way of flawed identification or introduction of terms that leaves $(\iota x)Cx$ as not properly specified (defined or identified). And when we treat as meaningfully specified an item that is not actually so, then the result is that the claims that we make are bound to be semantically meaningless. We commit the semantic equivalent of dividing by zero. Our contentions are meaningless on the basis of identificatory presuppositions that go unsatisfied.

It's clear that referential vacuity lies at the root of the mathematical paradoxes of the Cantor-Russell variety. All of them result from a common cause—the inappropriate presupposition that something exists which in fact does not. Now this may seem odd on first view because in mathematics one can define things into existence—we can bring things into being by assumption or supposition. Or so it seems—but the seeming is not quite right. For there is one very crucial limit to defining things into existence—namely the preservation of consistency. Even in the realm of mere possibility you must at least keep your stipulations compatible with your own commitments. And the very fact of paradox here indicates that something has gone awry—that some condition crucial to the maintenance of consistency has been violated.

Another instructive lesson also emerges from these considerations. Paradox management calls for noting *that*, *where*, and *how* certain premises go awry. All this is a matter of *diagnosis* and is in general relatively straightforward. But *therapy* (that is, *treatment*) is something else again. Determining exactly how to fix things—that is, positing a cogent rationale for the specific steps required to eliminate the difficulty—is all too often a large and difficult challenge. For the medicaments needed to put things right should be:

- *natural*—by way of being inherently plausible and not arbitrary or ad hoc to the particular case in hand.

- *not too weak*—by way of failing to deal with other versions or reformulations of the paradox at issue.

- *not too strong*—by way of forcing us to forgo propositions we want for the sake of eliminating those we do not.

The avoidance of referential vacuity through honoring the conditions of proper identification and introduction seems a promising prospect in this regard.

To be sure, it is easy enough to offer the paradox-avoiding recommendation: "Do not make unwarranted presuppositions!" Yet this tautology is of no real help. The devil is in the details, which is why we need to lay all our cards explicitly on the table in paradox analysis. The problem in each case is to pinpoint that putatively unwarranted presupposition, and then, having done so, to establish the rationale of its untenability. This aspect of paradox analysis is not something that is altogether automatic, and the mathematical paradoxes examined here show only too clearly that complex considerations are at work in providing a rationale for the thesis abandonments which alone can resolve such paradoxes. Prescribing the appropriate remedy that will restore health to our cognitive organisms in the wake of a paradox is—or can be—the single most challenging part of aporetics.

The resolution of paradoxes is an invitation to innovation exactly because it requires the adoption of novel mechanisms by way of distinctions, prioritizations, and presuppositions. The mathematical paradoxes invite close attention to the identification of objects and their referential introduction. The Sorites Paradox provides a pathway to plausibility theory and the sort of vagueness manipulation afforded by "fuzzy logic." The Liar Paradox encourages the exploration of pathways to lack of meaning as per type theory and the doctrine of language levels. The paradoxes of equivocation calls for the development of a diversified manifold of conceptual distinctions. In this way we encounter the bracing atmosphere of theoretical innovation throughout the realm of paradox.

Paradoxes Considered in Chapter 10

- Self-Counterexampling Paradoxes

- Self-Falsification Paradoxes

- The Liar Paradox of Epimendes the Cretan (and its cousins)

- Self-Falsification Paradoxes (single and dualized)

- Self-Negation Paradox

- The Dualized Liar Paradox

- The Liar Chain Paradox

- Box Paradoxes

- Truth-Status Assignment Paradoxes

- The Instantiation Paradox

- The Preface Paradox

Semantical Paradoxes that Involve Conflicting Claims Regarding Truth

10.1 Self-Falsification

Any contradiction-in-terms (*contradictio in adjecto*) is automatically paradoxical. To speak of "learned ignorance" is at once to attribute and to deny sagacity. To locate something in a *utopia* (literally a "noplace") is to gainsay the very locatedness that is being claimed. But such "paradoxes" are mere rhetorical tropes, and sensible interpreters at once recognize that caution is needed with such literary flourishes because one must not take them too literally, even as is the case with metaphor or analogy.

However discourse that is blatantly self-falsifying is something else again. There are different forms of self-negation: A statement can occur in a context such that it

- is incompatible with its own claim to meaningfulness (by somehow proclaiming the claim's own meaninglessness). (Example: "This statement is nonsense.")

- is incompatible with its own claim to truth (by maintaining the claim's own falsity or indeterminacy). (Example: "This statement is false.")

- is at odds with asserting the claim itself. (Example: "No claim made by statements on this page is true.")

- contradicts the substance of the claim itself. (Example: "No statement at all is made on this page." or "This sentence has six words.")

This last case is a particularly striking form of anomaly. Thus consider: "No proposition is negative," "All propositions are negative," "Everything said in print is true," "I never say anything about what I say," "This statement is interesting." Such statements are not just false but themselves present an instance of their falsity. They instantiate the idea of self-counterexemplifying paradoxes. Medieval logicians examined such statements but were reluctant to characterize them as insolubilia.[1] A real insoluble, so they held, is such that it will be false if viewed as true, but the reverse must hold as well—the statement's truth must also somehow follow from the assumption of its falsity.

The indicated examples show that single statements can engender apories. However, they rarely pull off the rather difficult feat of having some semblance of plausibility while nevertheless being self-inconsistent. In this regard they differ from:

(G) All global generalizations are false.

Given our vast experience with facile generalizations that go awry, this thesis has an air of plausibility about it. Nevertheless, this statement is self-falsifying in the same manner in which a thesis like "Some statements are true" is self-verifying. Resolving the paradox created by such single-statement examples is easy: we have to abandon the statement itself. Thus in this present case we can take (G) at face value and dismiss it as false in line with its own contention. Here too a conflict of truth claims stands before us.

A statement will clearly be paradoxical if it does not merely *manifest* its own falsity but *proclaims* it outright. Thus consider the statements:

- This statement is false.

- Every statement I make today is false.

1. See Ashworth 1974, pp. 102–03.

- Everything said on this page is false.
- If this statement is true, then I'm a monkey's uncle.

This line of thought leads us back to John Buridan's insolubilium "This statement [the n-th on the present page] is false," or that engendered when Socrates supposedly says "Everything that I say today is false," or again "What I am (now) saying is false."[2] Contentions of this sort are not semantically viable. They straightaway give rise to a *Self-Falsification Paradox* along such lines as:

(1) By definition, all (semantically) meaningful statements are either true or false but not both.

(2) The statements in question are semantically meaningful.

(3) By (1) and (2), the statements in question are either true or false but not both.

(4) Thanks to their content, both statements are false if true and true if false. Hence we must either class them both as true or both as false.

(5) By (1) and (4), the statements in question are not semantically meaningful.

(6) (5) contradicts (2).

Here {(1), (2), (4)} constitutes an inconsistent triad. But save for intuitionist logicians (1) constitutes a truth embodied in our definitional understanding of what is at issue with semantical meaningfulness. And (4) is a fact-of-life in the situation at hand.

2. See Prantl, *Geschichte*, Vol. IV, p. 37, pp. 145 and 146; and G.E. Hughes, *John Buridan on Self-Reference* (Cambridge: Cambridge University Press, 1982), pp. 51, 58. See also Albert of Saxony as discussed in Norman Kretzmans and Eleonore Stump's, *The Cambridge Translations of Medieval Philosophical Texts*, Vol. I, *Logic and Philosophy of Language* (Cambridge: Cambridge University Press, 1988), pp. 342–43. As the medievals saw it as insoluble (*insolubilium*) it is not just a sophism, but specifically a proposition that poses a truth-value amphiboly, that is, a proposition such that there are structurally equivalent arguments for classing it as true and as false.

Precisely because *insolubilia* were not really outside the range of the soluble—and indeed the authors who discussed them all proposed solutions—renaissance writers preferred the Ciceronian term *inexplicabilia*, which, of course, has problems of its own. (See Ashworth 1974, p. 114.)

However, (2) is no more than a plausible supposition. Hence we obtain the priority order (1) > (4) > (2) in virtue of which (2) must be abandoned.✓

The general contentions "Every statement I make today is false" and "Every statement on this page are false," although self-negating and indeed paradoxical, nevertheless have perfectly unproblematic negations, namely "Some statement I make today is true" and "Some statement on this page is true" respectively. However, this is not the case with "This statement is false." For its negation is "That statement—namely, 'This statement is false'—is true." And this continues to be every bit as paradoxical as the original was. Such a self-falsifying statement has the feature that one can neither class it as true nor as false: there is no alternative but to abandon it as semantically deficient and meaningless.

Things can get worse yet. Consider the following statement:

(*S*) This sentence is (semantically) meaningless [that is, it lacks a truth value in being neither true nor false].

We ourselves can assign no truth value to (*S*). For consider the following:

(1) *Truth-value assigned to S*	(2) *Truth-value of S if the assignment of (1) is appropriate*	(3) *Agreement between (2) and the sentence itself?*
T	F	No
F	F	No

Only by refusing to give *S* a truth-value can we bring what it claims into consonance with the prevailing situation, and even then we do not render the sentence true seeing that in doing so ✓ we would at once falsify it. The only way to treat *S* is to class it not just as semantically meaningless but as hermeneutically meaningless. There is no viable way to make sense of it.

However, as we saw above meaningfulness involves yet another more subtle and complex issue, namely that of referential adequacy. At this point we revert to the Successful Introduction

Principle (SIP) of the preceding chapter. It is clear that in the light of this principle the purported specification:

(*L*) *L* is false.

is an inappropriate and unavailing introduction of the statement *L*. For its identification here as "the statement which says of *itself* that *it* is false" [or for that matter *true*!] clearly requires that "it" have a prior specification if that anaphoric back-reference is to take hold of anything. Accordingly the trouble with (*L*) or with "This sentence is false" is that this crucial principle is violated. To be meaningful, the claims "*L* is false" or "It is false that *L*" presuppose that *L* is *already* available for consideration, and we cannot embark upon a purportedly *identifying* introduction that presupposes this.

And generally, use of the anaphoric phrase "this sentence" presupposes that the sentence at issue has already been identified in a prior specification. Indeed any self-referential statement *introduction* of the format:

(*L*) *L* is such-and-such ["*L* is the sentence of which it holds that this sentence is such-and-such."].

is inappropriate, seeing that the standard process of substituting their definitions for defined terms here embarks us on an infinite regress as per:

- (*L* is such and such) is such and such.
- ((*L* is such and such) is such and such) is such and such.

and so on. That supposed definition does not enable us to take anything stably meaningful into view. Here a thesis that is (putatively) being introduced as a (purportedly) meaningful assertion simply does not qualify as such. No such meaningful statement exists. Thus a Self-Falsification Paradox and its cognates are semantically meaningless because they resist the stable assignment of any truth value through their plunge into paradox.

And it should be emphasized that this is equally true of the harmless seeming

(*L*) *L* is true.

For the real problem in this context is not self-falsification as such but self-characterization in a way that vitiates the sort of identification required for access to a meaningful referent.
 To be sure, the contention that "This statement is such-and-such" or equivalently:

(*L*) *L* is such-and-such.

could be reformulated free of explicit self-reference as

$\forall p \, [\, p = L$ iff p asserts that L is such-and-such$]$.

But in this formulation the thesis does not purport to *define* or ✓*introduce L. And the problem can now be sidelined by observing that its paradoxical nature precludes L from lying within the range of the propositional variable p, namely the set of semantically meaningful presuppositions.* That "reformulated" thesis is not a well-formed statement.
 The study of these *insolubilia* formed a key component of the arts curriculum of the major medieval universities—usually in the third or fourth year which focussed upon public disputation. Some of the medieval schoolmen took a line that actually makes very good sense. The term "statement," they in effect maintained,
- is equivocal. For we must draw the important distinction between a *sentence or assertion (oratio)* which is something merely verbal, and an actual *proposition (propositio)* which is a communicatively meaningful item of information. Normally and when all goes well, sentences convey propositions. But things do not always go well—and in particular they do not go well with sophisms and insolubilia.[3]
 Specifically they held that this happens with what we would characterize as semantically meaningless propositions. Thus Buridan maintained that statements which cannot in the nature of things be classed as true or false are thereby inherently

3. An insolubilium, says Paul of Venice, is only a *verbal proposition (propositio vocalis)* but one that is not authentically communicative *(propositio scripta vel mentalis improprie dicta)*; Prantl, *Geschichte* Vol. IV, p. 139 n569).

untenable.[4] And Paul of Venice was even more explicit. He held that such a statement as "What I now say is false" is not a proper ✔ statement at all.[5] It is neither true not false but stands in an indif-· ferently untenable vacillation between the two (*non est verum nec falsum, sed medium indifferens ad utrumque*; *ibid.*, pp. 138–39). It is, strictly speaking, no proposition at all. (*Nullum insolubile est verum et falsum, quia nullum tale es propositio*; *ibid*, p. 139, n539.)

10.2 The Liar and His Cousins

Concern for problems of self-reference originated with the Liar Riddle (*pseudomenos*) of Eubulides: "Does the man who says 'I am lying' lie?" (Also "Does the witness who declares 'I am perjuring myself' perjure himself.")[6] The problem that arises here was posed via the following dilemma:

The declaration that I lie will be either true or false. But if this declaration is true, then I lie, and my declaration will be false. But if that declaration is false, then what it says—namely that I lie—is not the case and I must be speaking the truth. Thus - either way the truth status being assigned is inappropriate.

Eubulides's riddle was immensely popular in classical antiquity.[7] And it gave rise to the problem encapsulated in the ancient story of Epimenides the Cretan, who is supposed to have said that "All Cretans are liars"—with "liar" being understood in

4. Prantl, *Geschichte*, Vol. IV, p. 37 n146.

5. *Socrates dicens, se ispum dicere falsum, nihil dicit.* (Prantl, *Geschichte*, Vol. IV, p. 139 n569.) It became a commonly endorsed doctrine in late medieval times that paradoxical statements are not proper propositions and for this reason cannot be classed as true or false. (See Ashworth 1974, p. 115 for later endorsements of this approach.) Thus later writers dismissed insolubles as not being propositions at all, but "imperfect assertions" (*orationes imperfectae*). (See Ashworth 1974, p. 116.)

6. Aristotle, *Soph. Elen.*, 180a35; *Nicomachaean Ethics*, 1146a71. Prantl, *Geschichte*, Vol. I, pp. 50–51. *Si dicis te mentiri verumque dicis, mentiris.* (Cicero, *Academica priora*, II, 30, 95–96; and compare, *De divinatione*, II, 11).

7. It was discussed not only by Aristotle and Cicero (see the preceding note) but by the Stoics (Prantl, *Geschischte*, Vol. I, p. 490). In medieval times it was a staple in the extensive discussions of insolubilia. See Prantl, *Geschichte*, Vol. IV, pp. 19, 41.

the sense of a *"congenital* liar," someone incapable of telling the
truth.[8] What we have here is a self-falsifying statement that
- involves a conflict of truth claims. For if we accept the claim of.
Epimendes as true, then it itself will have to be false so that the
statement implies its own negation. However, nothing untoward
results from classing the statement of Epimenides as false—there
is no problem about the idea that some Cretans sometimes do not
lie. Self-falsifying statements ("I am lying,"[9] "This statement is
too complex to formulate," "All universal statements are false")
are self-contradictory and therefore false, seeing that a conflict
arises between the statement and its own consequences. We have
a paradox alright, but one that is readily resolved—both as
regards culprit identification and as regards the diagnosis of
involving a referential failure.

The Epimenides problem is thus not as grave as the classic Liar
Paradox, which poses larger and deeper issues. And there is noth-
ing novel about this claim. Rüstow enumerates sixteen approaches
to the resolution of the Liar Paradox that were offered in ancient
and medieval times. (Paul of Venice already listed fifteen.) These
fall into four groups: (1) charges that a standard fallacy is commit-
ted (for example, *secundum quid,* equivocation *per accidens, non
causam ut causam*); (2) self-destruction through self-negation;
(3) semantic meaninglessness through failing to be either true or
false; and (4) referential failure (*non potest supponere pro tota illa
propositione cuius est pars.*"[10]

Semantical paradoxes arise when matters of truth, falsity, and
reference are explicitly at issue. And here, as elsewhere, appear-
ances can be deceiving. In this regard consider the variant version
of Eubulides's Liar paradox, posed by the riddle: "Does the per-

8. Several Greek philosophers, preeminently including the Aristotelian Theophrastus
and the Stoic Chrysippus, wrote treatises about the Liar Paradox. See Diogenes Laertius,
Lives of Eminent Philosophers, V 49 and VII 196. The poet Phietas of Cos is said to have
worried himself into an early grave by fretting over this perplex, and its notoriety was such
that even St. Paul adverted to it in *Titus* I: 12–13. The history of the Liar Paradox is dis-
cussed in substantial detail in Alexander Rüstow's *Der Lügner: Theorie, Geschichte, und
Auflösung* (Leipzig: B.G. Treubner, 1910; reprinted, New York: Garland, 1987).
9. This anomaly gives rise to the comic variation of the "King of Beasts" who could
not get his subjects to believe him when he said "I'm lion." See also Martin Gardner,
Aha! Gotcha (San Francisco: Freeman, 1982), pp. 4–7.
10. Rüstow 1908, pp. 114–16. For a contemporary analysis of the difficulties involved
see Barwise and Etchemendy 1987 as well as Martin 1990 and Martin 1993.

son who says that he is now lying speak truly?" This *Self-Falsification Paradox* now at issue roots in the thesis:

(S) This statement (that is, this very statement now being enunciated) is false.

This statement confronts us with the perplex:

We class S as	The truth-value of S according to itself, in consequence of the preceding status of what it claims
T	F
F	T

✓ In no case can we bring these two into alignment. Nor will it help to introduce a third truth value ("indeterminate" or "undecided."). For consider:

(S') This statement is false or undecided.

The situation now becomes:

We class S as	Truth-value of S' in consequence of the preceding status of what if claims
T	F
U	T
F	T

✓ Again there is no way of bringing these two columns into accord. The only viable alternative is to view such statements as S and S' as semantically meaningless, that is, as lacking any stable truth-value status whatsoever—even "indeterminateness" insofar as this is seen as a truth-value.

The explicitly self-falsifying claim "This statement is false" is clearly paradoxical. Yet we could not simply class it as false

because in doing so we would in effect verify it. Instead we can—and indeed should—proceed to view this statement (*S*) in a wider context:

(1) S is a semantically meaningful statement—that is, it is either true or false and not both.

(2) Given what it asserts, if *S* is true—that is, if it is true that *S* is false—then it is false. And—

(3) Given what is asserts, if *S* is false, then it is true.

(4) No semantically meaningful statement can be both true and false.

✔ (5) If *S* has one truth value (if *S* is true or false) then it also has the other. By (2), (3).

(6) *S* is semantically meaningless—it is neither true nor false. (From (4), (5).)

(7) (6) contradicts (1).

Since (4) is fixed in place as the consequence of a definition, the inconsistency of the quartet {(1), (2), (3), (4)} means that we are driven to a choice between (1) and the coordinated pair (2), (3). But (2) and (3) are parts of the issue-defining hypothesis, while (1) is no more than a plausible supposition, and one to which an intuitionist logician might well take exception. Thus the plausibility priority situation is:

$$(4) > [(2), (3)] > (1)$$

Accordingly (2), (3), (4)/(1) with its retention profile of {1, 1, 0} represents the plausibility-optimal resolution and *S* must ✔therefore be dismissed as a semantically meaningless statement. The paradox thus admits of this decisive resolution which uniquely averts abandoning a proposition of the first priority level. *S* is the culprit and has to be abandoned. But note that *S* alone does not constitute the paradox here all by itself; rather, it opens the door to paradox via (1)–(5). Moreover, (1)-dismissal—though certainly in order—is not the end of the matter. We need to determine of validating rationale for this step that principles like SIP provide.

There is also the *Self-Negation Paradox* where truth and falsity are now not at mention. It pivots on the proposition P which asserts: "This proposition—viz. P itself—does not obtain." We thus have:

$$(P) \quad \text{not-}P$$

This directly gives rise to a paradox, as follows:

(1) $P \leftrightarrow \text{not-}P$ — From (P) because that is what this affirms

(2) $P \rightarrow \text{not -}P$ — From (1)

(3) $\text{not-}P \rightarrow P$ — From (1)

(4) $\text{not-}P$ — From (2) by standard logic

(5) P — From (3) by standard logic

(6) (5) contradicts (4)

Here (1) is the source of the difficulty all by itself. But what exactly is wrong with it? It is simply untenable because it concurrently claims and disclaims P. In consequence, (1) does not specify a hermeneutically meaningful statement—we can make no sense of it. As we have seen time and again, such statements that violate the SIP principle are a fertile source of paradox. ✓

10.3 Problems of Self-Reference

When we assume too incautiously that various items are already available for use in their own specification we may well run into trouble. Thus consider the purportedly self-denying statement introduced by the following specification:

$$(S) \quad \text{not-}S$$

It is clear on the surface of it that this is something paradoxical. The question, "Is it or is it not the case that S?" at once plunges us into a contradiction. The SIP-prohibited self-involvement at issue here leads us *ad absurdum.*✓

And again, consider a statement that is specified as the conjunction of itself with some claim:

$$(S) \quad S \,\&\, c$$

For example, if c is $2 + 2 = 4$, the question "How many times is the number two mentioned in S?" becomes problematic. The very idea of counting all of this statement's twos leads to difficulties. (Only for infinite N can we have it that $N = N + 1$, but any actualizable statement must be one of finite length.) In this context we are dealing with specifications whose meaningfulness and viability are erroneously presupposed.

Consider next the regress generated by the following question-answer cycle:

Statement: (S) This statement has feature F.

Question: (Q) But what statement are you talking about? What is the referent of your own statement?

Response: (R) Go back to that initial statement. The referent is S itself.

The cycle never closes. The question of a referent is never fully resolved. Self-involving identification is effectively toothless: it has no identifactory bite. The situation is akin to that of the exchange: Q: "Is this a proper question?" A: "Only if this is a proper answer to it." In its own bizarre way, this exchange actually works out. For the question is not a proper one exactly because the "answer" to it is No. And the answer is not a proper one either, so that its negative standing provides what is, in the circumstances, an appropriate sort of response.

The difficulty in all these cases is again one of unsuccessful identification. For in each case we have a thesis identified via a format that violates the SIP principle of successful identification. To be sure, in addressing problems of this sort, an accusing finger is sometimes pointed at self-reference as the source of the difficulty, and some writers—Russell for example—accordingly suggest a general embargo on all self-referential statements. But this is going too far. What is problematic is not self-referential asser-

tion as such, but *self-referential statement introductions or specifications.* Self-referential statements are often not only unproblematic in meaning but even true.[11] There is nothing anomalous about "This sentence contains a verb." and "This sentence occurs on p. 205 of this book" or "This sentence is written in English." There is nothing wrong with the self-referential contention "This statement is an affirmative proposition formulated in English" or with "This denial that cats are crustaceans is a true statement ✓about felines." What does go amiss is the *introduction* of an item on the stage of discussion in a way that presupposes it as *already* available as a term of the kind at issue. For example, to write

$$(L) \quad L \text{ is a truth.}$$

is to indicate on the one hand that we are introducing (specifying) the statement indicated by L, and on the other that L is already available for a reflective claim to be made about it (viz. that it is ✓true). And this just will not work.

Against those who want to proscribe overt self-reference altogether in the interests of avoiding paradox, one can urge two points (among others) as prime reasons not to adopt this policy.

(i) It throws out the baby with the bath water. Self-reference of and by itself cannot be the problem. For there are many informative and unproblematic self-referential statements such as "This statement is made by means of an English sentence." And many instructive generalizations have such statements as consequences (for example): "All statements made in this chapter are relevant to paradoxes").

(ii) Various useful and important logical and mathematical theses have to be formulated by means of self-referential ✓ or self-inclusive statements. (For example, "Semantically meaningful statements have some truth-value or other.") And some statements in metamathematics (including assertions pivotal to Gödel's proof of the incompleteness of arithmetic) have to be formulated self-referentially.

11. This was emphasized in Kurt Gödel, *op. cit.*

Only a very few assertoric processes will engender paradox automatically and invariably. Direct or indirect self-negation of the following sort is an obvious example:

- The statement preceding the next statement is meaningless.
- All generalizations have exceptions.[12]

However, the difficulty is more subtle with statements which themselves *counter-exemplify* that which they overly assert:

- No proposition is negative.
- All generalizations are true.

Here the first statement is a negative proposition (something whose existence it itself denies) and the second is a false generalization (again something whose existence it itself denies). Since the mere existence of these statements establishes their own falsity, there is no way to establish harmony as between what statement *T is* and what it claims.

In the end, then, it is best to take a discerning and differentiated view of self-reference, recognizing that it can take both lawful and illicit forms. A general point is at issue here, namely that there is a great difference between saying that something is a process that *can* engender paradox and that it is a process that *must* engender paradox. The sorts of paradox-inviting assertoric processes that we have considered here—equivocation, self-reference, questionable totalization and problematic presupposition, for example—are merely paradox *facilitating* and not paradox *necessitating*. And one must accordingly always distinguish between illicit and innocuous uses of such a process. The sensible policy is to indicate more specifically the conditions under which such processes are likely to produce inconsistencies. And this means that wholesale measures of paradox avoidance—an embargo on self-reference, for example—are generally involved in overkill by eliminating much that is harmless along with the inappropriate.

12. This statement is obviously a generalization. According to its own assertion it thus has exceptions. But generalizations with exceptions are false. Ergo if true, then it is false—and false on the basis of its own explicit content.

10.4 Paradoxes of Truth-Claim Dissonance

Semantical paradoxes generally involve a conflict between what we are saying *in* the (internal) content of a statement and the (external) claim involved *by* making it. Thus with the self-falsifying statement:

$$(P) \quad \text{not-}P$$

we are claiming that *P* by making the statement, but saying that not-*P in* the statement itself. Or again with

All propositions are negative.

we are stating an affirmative claim by making the statement but denying this prospect in the statement itself.

An analogous clash can also occur within a plurality of statements. Thus consider a dualization of the self-falsifying statement *P* above:

$$(P_1) \quad \text{not-}P_2$$

$$(P_2) \quad P_1$$

Irrespective of how we assign truth-values here, there is no way to bring our truth-classification of those statements into alignment with what the statements themselves say. The statements at issue have to be dismissed as semantically meaningless in the circumstances.

But note that what has gone wrong here is a matter of the *identificatory* self-reference that is proscribed by the Successful Identification Principle (SIP). For when we return to (P_1) and (P_2) and replace defined terms by their definitions we get:

$$(P_1) \quad \text{not-}P_1$$

$$(P_2) \quad \text{not-}P_2$$

Both involve the same sort of self-negation that is at issue with P above.

Again, consider the following pair of statements:

(A) B is true.

(B) A is false.

These statements issue in the *Dualized Liar Paradox*:

(1) Statement *A* declares "*B* is true."

(2) Statement *B* declares "*A* is false."

(3) *A* and *B* are semantically meaningful statements (ones that are true or false).

(4) Thanks to their content, neither *A* nor *B* can stably be categorized as true or as false.

(5) (4) contradicts (3).

Here statements (1)–(4) are collectively inconsistent and constitute an aporetic cluster, as we have already seen in detail. Now the only candidate for rejection here is (3), since (1) and (2) obtain by the defining stipulation of the problem and (4) is part of the situational realities of the case. With the dismissal of (3) we achieve a decisive resolution.

Or consider the closely related paradoxical pair:

• The immediately succeeding statement is true.

• The immediately preceding statement is false.

Note that unlike the single self-contradictory statement "This statement is false" the paradoxical character of this pair is *contingent*. It is a matter of just what those succeeding or preceding statements happen to say. Each of these two statements is self-referential—but only conditionally and contingently so, not directly and by nature. What we have here is merely *circumstantial* self-reference and merely *contingent* paradoxicality. The crux lies not in the meaning of what is said but on the *circumstance* of the saying of it, exactly as with other ostensive statements such as "That object is a knife." Here Plato effectively maintains: "'What Plato says is false' [= what Socrates says] is true." And Socrates effec-

tively maintains" "'What Socrates says is true' [= what Plato says] is false." Both enmesh themselves in self-annihilating contentions. ✓

The Dualized Liar Paradox also gives truth to the longer (sorital) version of the *Liar Chain Paradox* as per:

A: What *B* says is false.

B: What *C* says is false.

C: What *A* says is false.

Again, no matter what truth-status we propose to assign to these statements we run into contradiction.[13]

Medieval logicians were very devoted to such variations on the Liar paradox. Thus one twelfth-century theorist posed the conundrum: "Plato says 'What Socrates says is true' and Socrates says 'What Plato says is false.' Neither says anything else. Is what Socrates says true or false?"[14] And this sort of thing can occur in innumerable other ways. Consider the pair of truth-value attributive sentences: "The next sentence is ———. The preceding sentence is ———." Of the four possible ways of filling in the blanks—namely TT, TF, FT, and FF—only the first and last are ✓nonparadoxical. And this means that no paragraph of the format "Just one of the next two sentences is ———. The next sentence is ———. The preceding sentence is ———." can possibly be rendered consistent. Such a cluster is bound to be paradoxical. ✓

Thus consider the *Truth-Status-Assignment Paradox* posed by the two statement in the following display:

(A) The statements in this display differ in truth-value.

(B) George Washington was the first president of the U.S.A.

13. On this paradox, due to Albert of Saxony, see Kretzmann and Stump 1988, p. 353.

14. See William and Martha Kneale, *The Development of Logic* (Oxford: Oxford University Press, 1985), p. 228. Another version of this paradox envisions a card with one sentence written on each side. The one reads "The sentence on the other side of this card is true" and the other reads "The sentence on the other side of this card is false."

The paradox at issue here runs as follows:

(1) (B) is true. (A well-known fact.)

(2) (A) is false. From (A), (1).

(3) The statements in the box agree in truth-value. From (2)'s stipulation of (A)'s falsity.

(4) Both statements are true. From (1), (3).

(5) Both statements are false. From (2), (3).

The only viable way out here is to dismiss A as (semantically) meaningless in the prevailing context.

Box paradoxes of this kind were initiated by Henry Aldrich (1647–1710), who offered the example of the box that contains only a sentence saying that every sentence in this box is false:[15]

Omne enunciatum intra hoc quadra-
tum scriptum est falsum.

Again consider:

It is ——— that a ——— statement is
presented in this box.

Here let the blanks be filled in by true (*T*) or false (*F*). Note now the following survey of possibilities.

15. Henry Aldrich, *Artis logicae compendium* (London, 1691). See Ashworth 1974, pp. 18, 114.

The truth-values we supply are	On this basis the boxed statement is
TT	T
TF	F
FT	F
FF	T

Consider now the pair of assertions.

(1) The boxed statement reads as indicated.

(2) The two blanks of the boxed statement are filled in by opposite truth-values.

This pair of statements is clearly aporetic: there is no way to get
– them to be true together. The only way out is to deny the (tacit) premiss of the paradox that within the parameters of the problem the boxed statement qualifies as (semantically) meaningful. (Note,
– however, that this upshot is entirely contextual. If assertion (2) read "identical" for "opposite" the situation would be radically altered.)

Again, consider the *Box Paradox* engendered by the following display:

> (1) Every sentence in this box is false.
>
> (2) Isaac Newton wrote the plays attributed to Shakespeare.

Since (1) is self-contradictory (paradoxical), it must be false. But (1)'s falsity means that its negation must be true. In consequence
✔ some sentence in the box must be true. Since (1) is out of bounds in this regard, this means that (2) must be true.[16] Clearly any absurdity can be "demonstrated" on this basis. The paradoxicality of (1) means that anything we put into (2)'s place will be "innocent by association." And the appropriate exit from paradox here

16. This paradox is due in essence to Popov and Popov, *Dodkalny Mathenalizy*, 1996. I owe this reference to Alexander Pruss.

again lies in rejecting the culprit statement (here (1)) as semantically meaningless.

Another case that merits consideration is the variant <u>*Truth-Status Misallocation Paradox*</u> presented by the following two groups of statements:

Group A

1. Most statements of Group *B* are true

T 2. $2 + 2 = 4$

F 3. $2 + 2 = 3$

Group B

1. Most statements of Group *A* are false

T 2. $2 + 2 = 4$

F 3. $2 + 2 = 3$

Here the only way to make *A*1 true is to make *B*1 true, yet the only way to make *B*1 true is to make *A*1 false. Again, in reverse, the only way to make *B*1 true is to make *A*1 false, yet the only way to do this is to make *B*1 false. Thus neither *A*1 nor *B*1 can be true. But, by analogous reasoning, neither *A*1 nor *B*1 can be false. The only way out is again to dismiss some of the key statements involved—specifically *A*1 and *B*1—as (semantically) meaningless in the present context. As in the previous examples there is here a clash between the external (semantical) status of the problematic statements and their (internal) meaning-content. Such explicitly or obliquely (contextually) self-falsifying statements are also a fertile source of paradox. Collectively unsatisfiable statement groups of the sort at issue here are the verbal analogue of the geometric anomalies of Escher drawings.

A generic contention regarding an otherwise unspecified item, "*X* is a Siamese cat" or "*X* is an odd integer" or "*X* is an affirmative statement"—a propositional function, as it is called—will be true of some things and not true of others. In particular some propositional functions will be true of themselves, for example "*X*

is a propositional function" or "*X* is a statement schema that can be rendered true by a suitable instantiation." Such propositional functions are self-instantiating. But now consider the generic thesis

(1) *X* is a non-self-instantiating generic thesis.

Is this statement schema self-instantiating or not? Suppose we accept that it is. Then we have

"*X* is a non-self-instantiating generic thesis" is a non-self-instantiating generic thesis.

But this immediately falsifies our supposition. On the other hand, suppose it is not. Then we have:

"*X* is a non-self-instantiating generic thesis" is a self-instantiating generic thesis.

And this contradicts the supposition. And so neither alternative is viable.

With this *Instantiation Paradox* the only escape from inconsistency lies in rejecting (1) itself. The idea that a meaningful concept is at hand with the specification of a "non-self-instantiating generic thesis" must be abandoned.✔

This paradox closely parallels Russell's previously discussed *Impredicability Paradox* regarding predicates (see above, pp. 173–74). However, via the pivotal role of truth in the ruling conception of "is true of" at issue with generic theses (rather than "is predicable of" with predicates), this propositionalized version of the paradox makes clear its status as a semantical paradox involving conflicting claims to truth.

10.5 The Preface Paradox

Consider the following situation that defines what has become known as *The Preface Paradox*. An author's preface reads in part as follow: "I realize that, because of the complex nature of the issues involved, the text of the book is bound to contain some errors. For these I now apologize in advance." There is clearly

something paradoxical going on with this otherwise far from out-
landish disclaimer because the overall set of implicit truth-claims
at issue here is, in aggregate, incoherent. The statements of the
main text are flatly asserted and thereby claimed as truths while
the preface statement affirms that some of them are false. Despite
an acknowledgement of a collective error there is a claim to dis-
tributive correctness. Our author obviously cannot have it both
ways.[17]

To clarify the situation it is helpful to let T serve as abbrevia-
tion for the conjunction of statements of the text and P analo-
gously for the preface. On this basis we straightaway establish the
aporetic nature of our author's declarations. For we have both of
the following:

(1) T, that is, "T is true," which is tantamount to "All com-
ponents of T are true."

(2) P, that is, "Some few of the (otherwise unspecified com-
ponents of T) are false."

Something has to give way here. But how are we to resolve this
perplex?

Perhaps the most sensible way to look at the matter is some-
thing like this. The prominence our author gives to P through its
synoptic role in his preface prioritizes it over T. Thus P must be
accepted while T is abandoned in its composite totality. (However
the plausibility of T gives us an incentive to salvage as much as we
can, so that we would presumably settle for prefixing to the text
T the (otherwise tacit) preliminary statement "All but some few
of the statements that follow are true.") The course of subsequent
events can then be allowed to determine just which of the other-
wise unidentified statements turn out to be falsehoods.

The idea of plausible claims yields a prospect for authorship
that is seldom exploited. For authors who advance their claims in
the mode of plausibility can proceed on a tentative basis and need
not present their assertions as categorical claims to truth. In con-

17. On the Preface Paradox se A.N. Prior, "On a Family of Paradoxes," *Notre Dame
Journal of Formal Logic*, Vol. 2 (1961), pp. 26–32. See also D.C. Makinson, "The Paradox
of the Preface," *Analysis*, vol. 25 (1965), pp. 205–07.

sequence, they need not be intensely concerned to maintain the compatibility of their statements. The prospect of an occasional inconsistency will not distress them. They need not view consistency as the hobgoblin of *small* minds, but rather as that of minds that are fearful and overcautious, somewhat neurotically reluctant to run the risk of error in the pursuit of truth and information.

Their perhaps overliberal policy of information management leads such authors to be prepared to risk maintaining too much in the interests of assuring that they maintain enough. Given that we are finite creatures, the pursuit of truth is impracticable for us if we are unwilling to run the risk of error. And as these authors see it, the prospect of an occasional and limited inconsistency constitutes no additional and thereby no graver and more portentous threat. In their view neither epistemic self-respect nor cognitive credibility requires a commitment to consistency at all costs. In the pursuit of truth, consistency is a great asset but not an absolute and non-negotiable demand—a categorical requirement.

There are but a few authors who take this line openly and explicitly and flatly put their readers on warning to be prepared to take an occasional inconsistency in their stride. But there is certainly no tellingly cogent reason why there should not be more of them. To be sure they should, in due candor, avow their policy position and inscribe *caveat emptor* on their title pages.

The semantical paradoxes all root in one or the other of two sorts of error. On the one hand, with particular statements there is identificatory self-reference of the sort proscribed by the Successful Introduction Principle (SIP). On the other hand, with general statements there is auto-inclusion in a group that the aporetic premisses at issue reject. "This statement is false" is a paradigm example of the former problem. And "All statements made in this book are false" is a paradigm example of the latter. The invalid introduction of items (in the case of particulars) and auto-destruction by self-impugnment (in the case of generalizations) are the prime access-roads to semantical paradox.

Paradoxes Considered in Chapter 11

- Equivocal Evidence Paradoxes

- The Of-Two-Minds Paradox

- The Lottery Paradox

- Hempel's Raven Paradox

- Goodman's Grue/Bleen Paradox

Inductive Paradoxes
(Conflicts of Probability
and Evidence)

11.1 Evidential Indecisiveness

An important source of paradox is constituted by evidential situations where the epistemic issues are so complicated and knotty that their upshot is indecisive. We find ourselves confronted with a series of claims for each of which there is much to be said by way of support and substantiation, but which are nevertheless collectively inconsistent. Just what to conclude now becomes a problematic issue.

Such a situation of conflicting evidence arises, for example, when one credible witness or source of information declares p and another not-p. Or again when one evidential datum speaks for p and another for not-p, as when we want to determine somebody's height and are informed both that she is expert at gymnastics (most good gymnasts being rather short) and at basketball (most basketball adepts being very tall).

It is a plausible principle of inductive reasoning that where the available evidence (E) gives strong inductive support (\Rightarrow) to a certain conclusion (C) then this conclusion can be inferred as per the inferential pattern of *modus ponens*:

(MP) $E \Rightarrow C$

 \underline{E}

 $\therefore C$

However ambivalence can arise when the evidence at our disposal is indecisive in such a way that either of two incompatible conclusions can reasonably be drawn from it—when, as in a detective story, there is good reason for suspecting both the ne'er-do-well nephew and the unexpected guest of the murder. Such cases yield *Equivocal Evidence Paradoxes* of the following format:

(1) Principle MP as stated above

(2) E_1 & E_2 The aggregate body of equivocal evidence

(3) $E_1 \Rightarrow C_1$ By hypothesis

(4) $E_2 \Rightarrow C_2$ By hypothesis

(5) C_1 From (1), (2), (3)

(6) C_2 From (1), (2), (4)

(7) (6) contradicts (5) A fact of logic in the prevailing circumstances

Here {(1), (2), (3), (4)} are an inconsistent quartet. Now (2) is (by hypothesis) a given fact, and (3)–(4) are also fixed in place the defining stipulation of the problem. We thus have the priority ranking: [(3), (4)] > (2) > (1). Accordingly, the proper link at which to break the chain of inconsistency is with the principle (P). The fact is that this is not a universally valid principle that deserves flat-out acceptance, but only a plausible rule of inductive inference that can only be employed in circumstances devoid of counter-indications, unlike those of the situation that we presently confront.

This example also conveys another lesson. It is sometimes said that paradox occurs when apparently acceptable premisses yield apparently unacceptable conclusions by apparently cogent arguments.[1] But the present example shows that we can speak simply of valid arguments here. For that "seemingly cogent argumenta-

1. See, for example, R.M. Sainsbury, *Paradoxes*, 2nd ed. (Cambridge: Cambridge University Press, 1995), p. 1.

tion" can itself always be transposed into just another of those explicit "seemingly acceptable premiss"—exactly as was done at step (1) here.

11.2 Self-Deception

Not only are people sometimes deceived, but they can also deceive or delude themselves about all sorts of things—about being a good driver for example. (Paradoxically, some 80 percent of drivers think they drive better than the average driver.) To be sure, there are, strange though it may seem, some issues about which people cannot possibly deceive themselves. For example, one cannot deceive oneself about:

- being liable to self-deception.

- being sometimes mistaken.

Here "deceiving oneself" would simply substantiate the point at issue.

Self-deception can occur when it is we ourselves rather than the evidence that are indecisive. It involves accepting in one frame of one's mind or in one phase of one's thinking something that one rejects in another without acknowledging the incompatibility.[2] It is effectively a matter of "being of two minds" about something, so that here both "*X* is minded to reject *p*" and "*X* is minded to accept *p*" come to figure as concurrently applicable contentions. The *Of Two Minds Paradox* that results stands roughly as follows:

(1) *X* accepts *p* (on the basis of certain considerations).

(2) *X* rejects *p* (on the basis of others).

(3) *X* qualifies as a fully rational person who keeps his beliefs compatible and consistent.

2. On paradoxical aspects of self-deception see T.S. Champlin, *Reflexive Paradoxes* (London: Routledge, 1988), pp. 10–23.

Here the only available exits from inconsistency are:

(1) - or-(2)-abandonment. Holding that someone who can appropriately be said to "reject" a proposition p cannot with yet another breath appropriately be said to "accept" it—and conversely.

(3) - abandonment. Rejecting the idea that someone caught up in such a situation of ambivalence can qualify as a fully rational being.

Accordingly there are two avenues to paradox resolution: One can abandon the idea that the "accept"/"reject" demarcation has to be drawn in a way that renders these two stances mutually exclusive. Alternatively, one can abandon the idea that rationality must be so understood that no one who wittingly "accepts" a contradiction can possibly qualify as rational. In introducing the contrast between acceptance *as true* and acceptance *as plausible* we have sought to negotiate this paradox through a guarded and qualified endorsement of the second alternative.

11.3 The Lottery Paradox

Probabilities afford one of the possible routes to plausibility appraisal. But here too we must acknowledge and accommodate the prospect of possible entanglement in aporetic situations. After all, the nonoccurrence of any and every *particular* outcome of a die toss is rather probable. But nevertheless one of them must occur. This clearly means that we must not use probabilities as a basis for acceptance-as-true since truth admits no contradictions and is therefore bound to be paradox-free. However, the shift to plausibility averts such problems, seeing that plausibilities, unlike truths, need not be mutually consistent.

Let us consider this situation in the light of the so-called Lottery Paradox.[3] Suppose a lottery with 100 markers inscribed 1,

3. On this paradox see Henry Kyburg, *Probability and the Logic of Rational Belief* (Middletown, CT: Wesleyan University Press, 1961), L.J. Cohen, *The Probable and the Provable* (Oxford: Clarendon, 1977), and Robert Stalnaker, *Inquiry* (Cambridge, MA: MIT Press, 1984). Compare also pp. 52–53 above.

2, 3, . . ., 100. Here each outcome one is only an "one-in-a-hundred shot." each is very unlikely. So if we have the following manifold of outcomes:

O(i) = the outcome of the lottery drawing is i.

then any and every *particular* outcome-claim is distinctly improbable. (And we could make it even more so by letting the lottery have a thousand or even a million entries.)

Now if we were to let high probability be our guide to outright acceptance, then clearly we would have to accept "Not O(i)" systematically, for any particular i. This leads straightaway to paradox. For on the one hand we now accept:

X(i) = Not-O(i)

for every value of i in the range 1, 2,. . ., 100. But on the other hand we must also accept:

X = O(1) v O(2) v . . . v O(100)

which reflects the limits of the pertinent outcome range at 100. After all, some outcome *must* result, so that this disjunction is a flat-out truth. But now the overall collection of all 101 of these claims—X together with all of the X(i)—is logically inconsistent. So we certainly cannot accept all these theses as true. But matters stand quite differently if our "acceptance" of the X(i) is merely an acceptance *as plausible* (unlike that of X itself) since plausibilities as such need not be constant.

The lesson is that we can accept sufficiently probable propositions as *plausible* but not as *true*.

To be sure, an aporetic situation still remains. But we can now approach it from the angle of our general methodology. Thus consider:

1. Aporetic cluster: {X(1), X(2), . . . , X(100), X}

2. Maximal consistent subsets:

 {X(1), X(2), . . . , X(100)} plus 100 sets of the format {X, X(1)–X(100) with exactly one omission among the last 100.

3. Acceptance alternatives:

All 100 posibilities for the group X, $X(1)$–$X(100)$ with
one omission among the X(i) and also $X(1)$–$X(100)$

5. Priority ranking:

$X > [X(1), X(2), \ldots, X(100)]$

6. Optimal resolution:

A disjunction of all the R/A alternatives that exclude
exactly one of the $X(i)$.

Here we would, as ever, want to break through the "chain of
inconsistency" by seeking out the weak links of the chain. But
unfortunately, the circumstances of the example do not permit us
to differentiate among those plausible theses $X(i)$, all of which lie
on the same plane—to all visible appearances. Apart from recog-
nizing that at least one of the $X(i)$ must be false, any more defi-
nite resolution of the paradox is impracticable. The specifics as to
the choice between one alternative and another remain unde-
cided, so that this resolution of the apory again represents an
inconclusive disjunction of uneliminable alternatives.

11.4 Hempel's Paradox of the Ravens

A substantial literature has grown up over a problem of inductive
reasoning first posed by C.G. Hempel in 1946, the so-called
"Paradox of the Ravens."[4] It is rooted in the fact of deductive
logic that "All X is Y" is interdeducibly equivalent by contraposi-
tion to "All non-Y is non-X." Accordingly, "All ravens (R) are
black (B)" is deductively equivalent to "All non-black-objects
(non-B) are non-ravens (non-R)." Now the problem is thus:
given this equivalence, why should it be that in inductive contexts
one is inclined to accept black ravens as confirming instances of
that initial lawful generalization but not white tennis shoes?

4. C.G. Hempel, "A Note on the Paradoxes of Confirmation," *Mind* 55 (1946), pp.
79–82. See also Rudolf Carnap, *Logical Foundations of Probability*, pp. 223–24.

The situation at issue here is such that we confront the following aporetic cluster:

(1) The theses

(H₁) All ravens are black

(H₂) All non-black objects are non-ravens

state logically equivalent hypotheses.

(2) If two hypotheses are logically equivalent, then any datum that confirms the one must also confirm the other—and will do so to the same extent.

(3) A black raven will confirm H_1 (to some nontrivial extent), and analogously a non-black non-raven (such as a white shoe) will similarly confirm H_2 (to some nontrivial extent).

(4) However, a white shoe will not confirm H_1 (or at least will not do so to any extent worth mentioning).

It is clear that these theses are inconsistent, seeing that (1)–(3) entail the denial of (4).

Since (1) is an unproblematic fact of logic, and (3)–(4) represent rock-bottom intuitions of inductive thought, it is thesis (2) that attracts our suspicions. The priority situation stands at (1) > [(3), (4)] > (2). We are thus led to the R/A option (1),(3),(4)/(2) as the appropriate resolution, exhibiting as it does the resolution optimal priority profile {1, 1, 0}.

But what reason is there for thinking (2) to be the weak link in the chain here? Let us consider this question more closely.

It helps to clarify matters to consider the situation as represented in a Venn diagram of the following sort:

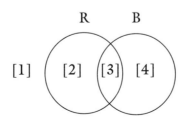

Here the regions represent different classes of objects. Specifically the R are the Ravens and the B the black objects. Now clearly the emptiness of [2]—which is tantamount to "All R is B"—is quite equivalently verified by going to the R's = [2] + [3] and seeing that only [3]'s are encountered here as by going to the non-B's = ✓[1] + [2] and seeing that only [1]'s are encountered here. Either way, we are simply monitoring the emptiness of compartment [2]. There seems to be no logico-theoretical reason for granting one of these approaches a preferred status over the other.

But appearances are misleading here. For there is a crucial informative difference between the two approaches to verifying our hypothesis H_1. To check the emptiness of [2] by the "natural" approach (through the R's) means going to the R's = [2] + [3] and checking their color. To establish it by the "unnatural" approach (through the non-B) means going to the non-B's = [1] ✓ + [2] and checking their type.

But note that the size of these compartments is critically different. The R's of [2] + [3] may run in the millions but the non-B's of [1] + [2] will run in the zillions. Hence a satisfactory member of [2] + [3] (viz. one that is in [3] like that black raven) will make a contribution of one-in-some-millions towards assuring that "All ravens are black." But a satisfactory member of [1] + [2] (viz. one that is in [2] like that white shoe) will only make a one-in-many-zillions contribution to ascertaining that "All ✓ ravens are black."

There is thus a striking evidential disparity between these two strategies of verification—one that puts black ravens and white tennis shoes on an altogether different plane in inductive contexts. Someone who hands us a verified black raven, has made a modest but nontrivial contribution to the whole project of verifi- ✓ cation. But the contribution of a white tennis shoe, albeit nonzero, is vanishingly small.

As these considerations indicate, thesis (2) is the weak link in this chain of inconsistency. It is in fact simply false that the evidentially confirmatory contribution of black ravens and white ✓ shoes is the same. That "to the same extent" clause of thesis (2) is simply false. Logically equivalent general propositions are indeed inductively equivalent, but does not means that their *instances* will bear equal evidential weight.

11.5 Goodman's Grue/Bleen Paradox

In an influential essay of 1953, Nelson Goodman presented a problem for the theory of inductive inference that has occasioned a substantial literature over the ensuing years.[5] This problem is based on a distinctly unorthodox pair of color concepts:

grue = green if examined before the temporal reference-point t_0 and if examined thereafter blue. (t_0 is an arbitrary moment of future time.)

bleen = as above but with green and blue reversed.

Goodman noted that if we do our inductive reasoning on the basis of *this* color (or "grulor") taxonomy, we shall seemingly obtain excellent inductive support for the thesis that all emeralds will eventually have the appearance we have standardly indicated by the description "blue" (after t_0)—since all that have been examined to date are grue. On this basis, our "normal" inductive expectations would be totally baffled, and we arrive at a Hume-like result from a rather un-Humean point of departure.[6] Nature becomes predictively inscrutable.

Various considerations mark this issue as an inductive paradox that cuts deeper than one at first might think:

1. No amount of empirical evidence can differentiate the "abnormal" grue/bleen color taxonomy and the normal green/blue one. Empirical evidence relates in the nature of things to past-or-present and there is (*ex hypothesi*) no difference here.

2. We cannot object that grue and bleen make explicit reference to time (to t_0), because this only seems so from our

6. The situation would be quite otherwise if the "big change" came about in a gradual and unnoticed way, as a slow shift with no rude shocks to our memory of how things used to look, or else with a gradual readjustment, so that the recollection of discrepancies would fade away in the manner of an image-inversion experiment. For then we would continue to make our inductive projections on the old basis; for example, grass would still be described as *green*, even thought it "really" looks blue.

own parochial standpoint. From the perspective of the grue-bleeners, it is *our* color taxonomy that is then time-dependent:

green = examined before t_0 and grue or not examined before t_0 and bleen.

blue = examined before t_0 and bleen or not examined before t_0 and grue.

Neither perspective is evidentially privileged. The situation is entirely symmetric from *their* perspective, and what's sauce for the goose is also sauce for the gander as far as any theoretical objections on the basis of general principles go. The case thus looks to be one of total parity as between our color talk and that of the grue-bleeners, with no theoretical advantage available to decide the case between us.

In the face of this parallelism Goodman himself effectively gave up on finding a preferential rationale for choice on a basis of *theoretical* general principles. Instead he relied on an appeal to the essentially practical factor of "linguistic entrenchment." The pivotal consideration is accordingly seen to lie in the fact that custom and habit has settled the issue preemptively in favor of our familiar color discourse. The descriptors blue/green unlike grue/bleen have a securely established place in our actual communicative practice. However, few commentators have found this resolution by an appeal to the mere custom of things to be convincing.[7]

But let us reexamine the paradox from the standpoint of the present approach. In effect it invites us to contemplate two conflicting general claims:

(A) All emeralds are green.

(B) All emeralds are grue.

7. For a survey of objections and positions see Henry E. Kyburg, Jr., "Recent Work on Inductive Logic," (*American Philosophical Quarterly*, vol. 1 [1964]), who summarizes his discussion with the observation "The problem of finding some way of distinguishing between sensible predicates like 'blue' and 'green' and the outlandish ones suggested by Goodman, Barker, and others, is surely one of the most important problems to come out of recent discussions of inductive logic" (p. 266).

And now consider the following aporetic cluster:

(1) The available evidence speaks equally for A and for B (seeing that as far as our observational evidence goes each is confirmed—and confirmed equally—by exactly the same supporting instances).

(2) Claims for which the available evidence speaks equally are equally credible.

(3) A is highly credible.

(4) B is not credible.

(5) (4) and (5) are incompatible.

Goodman himself effectively resolves this perplex by holding that (1) is the weak spot here. For, as just indicated, he saw a generalization's evidentiation as hinging on the linguistic "entrenchment" of the predicates in whose terms the generalization is formulated. On this basis it becomes a pivotal consideration of Goodman that "green" is a widely used familiar and customary conception. For Goodman, principles of inductive reasoning are "justified by their conformity with our inductive practice"—as indeed holds analogously with principles of deductive reasoning also.[8] Goodman characterizes this conformity with practice as "entrenchment," and in this regard "green" wins out easily over "grue" because, plainly, "green," as the subject of innumerably more prior projections (predictions), has a more impressive biography. The predicate "green," we may say, is much better *entrenched* then the predicate "grue."[9]

However, the basic problem with this approach—and the reason why most theorists have found it unsatisfying—is that accustomed "entrenchment" as such does not seem able to bear the weight of the structure that is being built upon it. For the crux is clearly a matter not simply of the fact *that* a predicate is entrenched but of the underlying issue of *why* it is entrenched. It is a matter not just of custom but of the greater utility and effi-

8. See Goodman 1955(3), p. 63.
9. Ibid., p. 94.

cacy in application on the basis of which the custom of a rational community is ultimately shaped.

Yet notwithstanding whatever problems it may have, Goodman's overall analysis surely moves in the right direction. For consider our aporetic cluster {(1), (2), (3), (4)}. Here (2) is to all intents and purposes a non-negotiable principle of inductive rationality. And (3) and (4) are "facts of life" that we have little choice but to accept at face value. We thus arrive at the priority ranking: (2) > [(3), (4)] > (1). Thesis (1), with its problematic supposition that evidentiation turns only on the amount (and not the quality!) of available instantiation, is thus the most vulnerable contention here.[10] And so, irrespective of whether one agrees with Goodman's diagnosis of the *rationale* of (1)'s vulnerability and remains sceptical about his reason-why analysis of the situation, the fact remains that (1) is the weakest chink in the armor of argumentation here.[11]

As this survey of examples indicates, the same general methodology of paradox analysis that operates elsewhere applies in these evidential and inductive situations as well. Here too we encounter an aporetic overcommitment that can be resolved—insofar as such resolution is possible—by looking to plausibilistic considerations to identify the vulnerable members of the circle of inconsistency through which the aporetic perplexity at issue arises. Careful heed of the considerations that support comparative assessments of plausibility can prove critically useful here.

An important point deserves emphasis here. The various flaws we have been considering—vagueness, equivocation, unjustified presupposition, problematic self-reference, counterfactual ambiguity, evidential fragility, and so forth—are not guarantors of paradox any more than crossing a street blindfolded guarantees an accident. But all of these are risk factors: they issue an invitation to paradox that is all too readily accepted. We are well advised to post a warning "Thin ice!" wherever these factors come upon the scene.

10. Note that (1) suffers from the frailty that its invocation of equally weighty support it exhibits exactly the same flaw encountered in Hempel's Paradox of the Ravens. (See pp. 224–26.)

11. See Stalker 1999.

Paradoxes Considered in Chapter 12

- Counterfactual Hypothesis Paradoxes (various)
- *Reductio* Style Paradoxes
- The Incommensurability of the Diagonal
- Thompson's Lamp Paradox
- *Per-Impossibile* Style Paradoxes

Paradoxes of Hypothetical Reasoning (The Problem of Assumptions that Conflict with Accepted Beliefs)

12.1 Hypotheses and Burley's Principle

To this point the focus has been upon paradoxes that arise in contexts where the choice between retention and abandonment is a matter of how loudly the probative considerations of evidence and conceptual cogency speak for the truth or plausibility of the relevant contentions. But we shall now deal with contexts of supposition—of postulation, assumption, or hypothesis where claims of actual truth are put aside and disbelief suspended. When a statement is stipulated in this way it thereby acquires a priority status that is independent of and indifferent to whatever supportive indication for its truth there may or may not be in other regards. In virtue of their status as such, hypotheses acquire an automatic priority in our reasoning. Like it or not we have to take them in stride and make the best and most of things on that basis—at least for the time being.[1]

A "counterfactual conditional" along the lines of "If Napoleon had stayed on Elba, the battle of Waterloo would never have been

1. The treatment of suppositions presented in this chapter was initially set out in the author's "Belief-Contravening Suppositions," *The Philosophical Review*, vol. 70 (1961), pp. 176–196. It was subsequently developed in *Hypothetical Reasoning* (Amsterdam: North Holland, 1964).

fought" is, in effect, *a conditional that elicits a consequence from an antecedent which represents a belief-contravening hypothesis.*[2] Any such conditional will accordingly exhibit the same problems and difficulties found to be generally present in aporetic situations. For the reality of it is that in the context of prevailing beliefs *counterfactual hypotheses are always paradoxical.*[3]

The interlinkage of our beliefs is such that belief-contravening suppositions always function within a wider setting of accepted beliefs B_1, B_2, . . ., B_n of such a sort that when one of them, for simplicity say B_1, must be abandoned owing to a hypothetical endorsement of its negation, nevertheless the resulting group $\sim B_1$, B_2, . . . , B_n still remains collectively inconsistent. The reason for this lies in the logical principle of *the systemic integrity of fact.* For suppose that we accept B_1. Then let B_2 be some other claim that we flatly reject—one that is such that we accept $\sim B_2$. Now since we accept B_1, we will certainly also accept $B_1 \vee B_2$. But now consider the group of accepted theses: B_1, $B_1 \vee B_2$, $\sim B_2$. When we drop B_1 here and insert $\sim B_1$ in its place we obtain $\sim B_1$, $B_1 \vee B_2$, $\sim B_2$. And this group is still inconsistent.

Facts engender a *dense* structure, to employ the mathematicians' use of this term figuratively. Every determinable fact is so drastically hemmed in by others that even when we erase it, it can always be restored on the basis of what remains. The fabric of fact is woven tight. Then suppose that we make only a very small alteration in the descriptive composition of the real, say by adding one pebble to the river bank. But which pebble? Where are we to get it and what are we to put in its place? And where are we to put the air or the water that this new pebble displaces? And when we put that material in a new spot, just how are we to make room for it? And how are we to make room for the so-displaced material? Moreover, the region within six inches of the new pebble used to hold N pebbles. It now holds $N + 1$. Of which region are we to

2. Sometimes what looks like a counterfactual conditional is only so in appearance. Thus consider "If Napoleon and Alexander the Great were fused into a single individual, what a great general that would be!" What is at issue here is not really a counterfactual based on the weird hypothesis of a fusion of two people into one. Rather, what we have is merely a rhetorically striking reformulation of the truism that "Anybody with all of the military talents of Napoleon and of Alexander combined, is certainly a great general."

3. Compare Roderick M. Chisholm, "Law Statements and Counterfactual Inferences," *Analysis,* vol. 15 (1955), pp. 97–105 (see especially pp. 102–05).

say that it holds $N - 1$. If it is that region yonder, then how did the pebble get here from there? By a miraculous instantaneous transport? By a little boy picking it up and throwing it? But then which little boy? And how did he get there? And if he threw it, then what happened to the air that his throw displaced which would otherwise have gone undisturbed? Here problems arise without end.

Every hypothetical change in the physical make-up of the real sets in motion a vast cascade of physical changes either in the physical makeup of the real or in the laws of nature. For what about the structure of the envisioning electromagnetic, thermal, and gravitational fields? Just how are these to be preserved as they were, given the removal and/or shift of the pebbles? How is matter to be readjusted to preserve consistency here? Or are we to do so by changing the fundamental laws of physics?

Such deliberations indicate that we cannot make hypothetical redistributions in the make-up of the real without thereby raising an unending series of questions. And not only do *redistributions* raise problems but even mere *erasures*, mere cancellations do so as well because reality being as is they require redistributions to follow in their wake. If by hypothesis we zap that book out of existence on the shelf, then what is it that supports the others? And at what stage of its production did it first disappear? And if it just vanished a moment ago then what of the law of the conservation of matter? And whence the material that is now in that book-denuded space? Once more we embark upon an endless journey. ✔

Their density means that facts are so closely intermeshed with each other as to form a connected network. Any change anywhere has reverberations everywhere. This condition of things is old news. Already in his influential *Treatise on Obligations*[4] the medieval scholastic philosopher Walter Burley (ca. 1275–ca. 1345) laid down the rule: *when a false contingent proposition is posited, one can prove any false proposition that is compatible with it.* His reasoning was as follows. Let the facts be that:

4. Translated in part in N. Kretzman and E. Stump, *The Cambridge Translation of Medieval Philosophical Texts*, Vol. I: Logic and Philosophy of Language (Cambridge: Cambridge University Press, 1988), see pp. 389–412.

(*P*) You are not in Rome.

(*Q*) You are not a bishop.

And now, of course, also:

(*R*) You are not in Rome or you are a bishop. (*P* or not-*Q*)

All of these, so we suppose, are true. Let us now posit by way of a (false) supposition that:

Not-(*P*) You are in Rome.

Obviously (*P*) must now be abandoned—"by hypothesis." But nevertheless from (*R*) and not-(*P*) we obtain:

You are a bishop. (Not-*Q*)

And in view of thesis (*Q*) this is, of course, false. We have thus obtained not-*Q* where *Q* is *an arbitrary true proposition.*
 It is clear that this situation obtains in general. For let *p* and *q* be any two (arbitrary but nonequivalent) facts. Then all of the following facts will also of course obtain: ~(~*p*), *p* & *q*, *p* v *q*, *p* v ~*q* v *r*, ~*p* v *q*, ~(~*p* & *q*), and so forth. Let us focus upon just three of these available facts:

(1) *p*

(2) *q*

(3) ~(~*p* & *q*), or equivalently *p* v ~*q*

Now let it be that you are going to suppose not-*p*. Then of course you must remove (1) from the list of accepted facts and substitute:

(1') ~*p*

But there is now no stopping. For together with (3) this new item at once yields ~*q*, contrary to (2). Thus that supposition of ours that runs contrary to accepted fact (viz., not-*p*) has the direct consequence that *any other arbitrary truth must also be abandoned*.

On this basis Burley's Principle has far-reaching implications. As far as the logic of the situation is concerned, you cannot change anything in the domain of fact without endangering everything. Once you embark on a contrary-to-fact assumption, then as far as pure logic is concerned all bets are off. Nothing is safe any more. To maintain consistency you must revamp the entire fabric of fact, which is to say that you confront quite a sizable task. (This is something that people who speculate about other possible worlds all too easily forget.)

The reality of it is that *all counterfactual propositions are contextually ambiguous.* For once we assume that not-p in a context where p is already in place, we embark on an endless succession of yet-unresolved choices. Let it be that we accept p. Then for any arbitrary q we are also committed to $p \lor q$. And let it be that we accept not-q. We thus (by hypothesis) stand committed to:

p

$p \lor q$

not-q

But now when p is replaced by not-p so that the first thesis is negated, we shall have to reject at least one of the other two. But logic alone does not tell us which way to go. The situation is totally ambiguous in this regard. When an inconsistency arises, all that logic can do is to insist *that* consistency must be restored. It will not tell us *how* to do this. This requires some altogether extra-logical resource.

And this is always the case. If we assume, say "Napoleon died in 1921" we have to choose between keeping his age (and thus having him born in 1769) and keeping his birthday (and thus having him live to age 152). And nothing about the counterfactual itself provides any guidance here. The situation in this regard is totally ambiguous and indeterminate: we are simply left in the dark about implementing the counterfactual assumption at issue. To decide matters in one way or the other and remove the ambiguity at issue we need to have additional, hypothesis-transcending information—a mechanism of precedence and priority to enable us to chose among the alternatives that confront us. Let us see

how this sort of program is to be implemented in the context of
~ counterfactual conditionals.

12.2 Counterfactual Conditionals

Consider the counterfactual "If the letters *A* and *B* were indistin-
guishable—say that both alike looked like *X*—then the random
series *ABBABAAAB*. . . would become the uniform series
XXXX. . . ." The situation issues in the following paradox:

(1) The given *A–B* series is not uniform. (A known fact.)

(2) *A* is indistinguishable from *B*. (The issue-definitive suppo-
sition, which contradicts our realization that *A* can in fact
be distinguished from *B*.)

(3) The series is uniform. (Given (2) *every A–B* series is now
uniform.)

Since (2)'s consequence (3) contradicts (1), the pair {(1), (2)}
represents an aporetic duo. But owing to (2)'s priority status as an
issue-definitive hypothesis, (1) must give way to it. And so we
~ arrive at the counterfactual conditional under consideration.

Again, consider the more complex situation of counterfactual
reasoning in the context of the conditional: "if this stick were
made of copper, it would conduct electricity." The situation is as
follows:

(1) This stick is made of wood.

(2) This stick is not made of copper.

(3) Wood does not conduct electricity.

(4) Copper does conduct electricity.

(5) This stick does not conduct electricity.

And now let us introduce the (1)-modifying assumption:

(6) This stick is made of copper.

How is consistency now to be restored?

Note that our initial givens fall into two groups: general laws (3), (4), and particular facts (1), (2), (5). Now when (6) is introduced as an issue-definitive hypothesis we of course have to abandon (1) and (2) in the wake of this assumption. But that still does not restore consistency since (6) and (4) still yield not-(5). However, the aforementioned standard policy of *prioritizing more general principles such as laws over particular facts in counterfactual contexts* leads to the priority schedule: [(3), (4)] > (5). And this means that it is (5) rather than (4) that should now be abandoned. We thus arrive at the natural (5)-rejecting counterfactual conditional:

- If this stick were made of copper, then it would conduct electricity (since copper conducts electricity).

in place of the "unnatural," (4)-rejecting counterfactual conditional:

- If this stick were made of copper, then copper would not conduct electricity (since this stick does not conduct electricity).

Suppose, however, that for the sake of contrast we take the radical step of altering the fabric of natural law by contemplating the assumption:

(6') Wood conducts electricity.

We would now of course have to abandon (3) in the wake of this issue-definitive hypothesis. But again this is not enough, seeing that (6') and (1) will again yield not-(5). At this point, however, we must resort to the principle: *in counterfactual contexts, particular mode-of-composition statements take priority over particular mode-of-behavior-statements.*[5] And this means that the priority schedule will be: (6') > (1) > (5). Accordingly, it is once more

5. But why should thing-type characterizations be taken as more fundamental than mode-of-behavior characterizations? The answer lies in the processual perspective that to be an X is to behave as X's do: that to be wooden is to behave as wooden things do. Since such systemic comportment encompasses the whole range of relevant lawful behavior, it is

(5) that should be abandoned. We thus arrive at the "natural" counterfactual:

- If wood conducted electricity, then this stick would conduct electricity (since it is made of wood)

in place of the "unnatural" counterfactual:

- If wood conducted electricity, then this stick would not be made of wood (since it does not conduct electricity).

Since *alternative* outcomes are always possible in such cases, a logical analysis of the situation will not of itself be sufficient to eliminate the basic indeterminacy inherent in counterfactual situations. We once again require a principle of precedence and priority to spell out what has to give way in case of a clash in conflict.

Observe that the choice between (A) and (B) above offers us an option between abandoning a law of nature ("Copper conducts electricity") and readjusting the features of a particular object, that stick. Following the policy of minimizing the scope of environmental changes in the wake of hypotheses we will obviously opt for the second alternative.

Now as Chapter 3 has indicated, the general policy of prioritization in factual contexts is to give established facts precedence over otherwise well-confirmed generalizations. A kind of specificity favoritism is at work here. But in *counterfactual* contexts this prioritization is reversed. When we play fast and loose with the world's facts we at least need the security of keeping its laws in place. Accordingly it is standard policy that *in counterfactual contexts well-confirmed generalizations take priority over particular facts.*

To deal effectively with counterfactual conditionals we must be in a position to distinguish, within the group of logically eligible alternatives, between more and less "natural" ways of reconciling a belief-contravening hypothesis with the entire set of residual beliefs which continue to be collectively inconsistent with it. And

inherently more general than a specific item—and one particular mode of behavior. The prioritization at issue is thus provided for by the standard policy of giving precedence to what is more general, pervasive, and fundamental.

once the problem of counterfactuals is seen in this light, its assim-
ilation to the broader issue of aporetic reasoning becomes
straightforward, seeing that counterfactual conditionals cry out
for analysis in terms of the priority-geared machinery of paradox-
management with which we have been operating throughout. (It
is just that the principles of priority determination are distinctively
different in this domain.)

For the sake of another illustration, consider the counterfac-
tual "If Puerto Rico were a state of the Union, the U.S. would
have 51 states." Here the following three propositions may be
taken as known givens:

(1) Puerto Rico is not a state of the Union.

(2) There are 50 states.

(3) The list of the states includes *all* the following: Alabama,
 Arizona, and so on.

(4) The list of the states includes *only* the following: Alabama,
 Arizona, and so on.

Now consider introducing the fact-contravening supposition: *sup-
pose that not-(1), that is, suppose Puerto Rico to be a state.*
In embarking on this assumption we obviously now have to
jettison (1) and (4) and replace them by their negation. But this is
clearly not enough. The set {not-(1), (2), (3)} still constitutes an
aporetic trio. To keep within the limits of consistency we must
also abandon either (2) or (3). Of course we have a choice
between these two. And with it we arrive at a choice between two
alternative counterfactuals.

(A) If Puerto Rico were a state, then there would be 51 states
 since all of the following are states: Alabama, Arizona, and
 so on. (Here we retain (3) and abandon (2).)

(B) If Puerto Rico were a state, then one of the present states
 would have departed, since there are just 50 states. (Here
 we retain (2) and abandon (3).)

Now it is clear that the first of these is plausible and the second
distinctly less so. The question comes down to a matter of priority

and precedence. And the answer is (3) > (2), its justifying ratio-
nale being as follows: The number of states has repeatedly
changed throughout U.S. history as new states were added to the
Union. But no state has ever dropped out—and the attempt on
the part of some to do so proved a disastrous failure. The general-
ization "States can enter the union" is a more tenable contention
than "States can leave the union." The crux is that in these coun-
terfactual contexts (unlike the fictional case), well-established
generalizations take precedence over particular facts. Hence (3) is
distinctly more tenable than (2) and the first of the indicated
counterfactuals accordingly is more eligible then the second.

The example accordingly illustrates a general situation.
Counterfactuals arise when assumptions that conflict with some
of the factual beliefs at our disposal are introduced into the wider
setting of other accepted beliefs. And the process of consistency
restoration via plausibility that is effective with other paradoxes
also applies straightforwardly and constructively in this present
case—subject, however, to the crucial considerations (i) that
hypotheses and their logico-conceptual consequences now
assume a position of prime priority and (ii) that the usual princi-
ple of specificity prioritization familiar from *factual* contexts is
now reversed seeing that well-established generalizations will
take precedence here.

12.3 Further Examples

Consider the counterfactual contention: "if the Eiffel Tower were
in Manhattan, then it would be in New York State." This condi-
tional introduces a fact-contravening hypothesis

The Eiffel Tower is in Manhattan.

into a context where the following statements are in place as
accepted truths:

(1) The Eiffel Tower is in Paris, France.

(2) The Eiffel Tower is not in Manhattan.

(3) Manhattan is in New York State.

As usual, the result of replacing a thesis by its counterfactual negation still leaves an obviously inconsistent situation.

How is this inconsistency to be overcome? We are now confronted by the need to choose between (1) and (3). Here (3) will have the upper hand as long as general geographic facts such as (3) are granted priority over the location of specific structures —such of the sort at issue with (1). Accordingly, (1) would have to be abandoned as well. And we would thus arrive at the conditional: "If the Eiffel Tower were in Manhattan, then it would not be in France but in New York State."

In theory, to be sure, our counterfactual hypothesis leaves two alternatives open: namely the more natural "If the Eiffel Tower were in Manhattan then it would be in New York State" and its anomalous reverse: "If the Eiffel Tower were in Manhattan then Manhattan Island would be in Paris (just like the Isle de la Cité)." In the former case we would leave Manhattan Island in New York State, while in the latter we would have to shift it to Paris. We have a choice between moving an individual structure and moving a whole island. And subject to the policy of minimizing change by granting precedence to which is more general and fundamental we keep that island in place.

The preferred resolution here is underwritten by a definite priority order: Hypotheses take precedence, and beyond this systemic fundamentality is our guide. And this policy enables us both to validate counterfactual conditionals and to explain how it is that some counterfactuals are natural and acceptable and others unnatural and unacceptable.

This distinction between "natural" and "unnatural" counterfactuals is crucial. For the sake of a further illustration consider the following example due to David Lewis. The case at issue is by stipulation one where we are taken to know:

(1) J.F. Kennedy was assassinated.

(2) L.H. Oswald assassinated Kennedy.

(3) No one other than Oswald assassinated Kennedy.

Suppose now that we are instructed to suppose not-(2), and assume that Kennedy was not killed by Oswald. Then we clearly cannot retain both (1) and (3), since in the presence of not-(2),

(3) entails that no one assassinated Kennedy which contradicts (1). Either (1) or (3) must go—one must be subordinated to the other. And now the very way in which a counterfactual is formulated instructs us as to the appropriate resolutions:

(A) If Oswald did not assassinate Kennedy, then someone else did. (Subordinates (3) to (1).)

(B) If Oswald had not assassinated Kennedy, then Kennedy would not have been assassinated at all. (Subordinates (1) to (3).)

However, if we were to supplement our beliefs (1)–(3) with a conspiracy theory by way of adopting

(4) Kennedy was the assassination victim of a successful conspiracy.

then we would also arrive at

(C) If Oswald had not assassinated Kennedy, then someone else would have. (Subordinates (3) to (4).)

The very way in which these conditionals are formulated informs us about (and corresponds to) the sorts of subordination relationships that are at work among those "factual" items that we take ourselves to know within the information-context of the counterfactual at issue.

12.4 The Crucial Difference between Factual and Hypothetical Contexts

It's important for the proper understanding of counterfactual reasoning to note the difference between reasoning from purely hypothetical and reasoning from putatively actual counterinstances. For these lead to very different results in the face of real or supposed laws of nature. Thus assume as given a law of the form: All X's are Y's (say "All copper bodies are electricity conductors" or "Copper conducts electricity" for short). If in the

course of empirical inquiry into their status we were to discover a copper object that did *not* conduct electricity, then of course we would have to withdraw and revise that universal generalization, thereby making it yield way to the newly discovered observational fact. (Here we have the situation noted in Herbert Spencer's quip that Henry Buckle's idea of a tragedy is a promising theory destroyed by a recalcitrant fact.) In counterfactual contexts, however, a different rule of prioritization prevails. The priority situation of empirical inquiry ("Laws give way to facts") is thus radically altered. For while putative laws viewed as mere theories do and must give way to *real* facts, accepted laws need not and will not give way to merely hypothetical or suppositional facts. ✓

The preeminent status enjoyed by suppositions in hypothetical contexts has other ramifications. When we encounter a disjunctively underdetermined paradox in matters of factual inquiry, we see this as a sign of incomplete information and an invitation to look for additional considerations to effect a further definite resolution. But with hypothetical contexts we have to take such underdetermination at face value: we have no choice but to see it as final. ✓

12.5 *Reductio-ad-Absurdum* Reasoning

Reductio-ad-absurdum reasoning is also a version of reasoning from a belief-contravening supposition—but now with a very particular sort of end in view. For the aim of the enterprise is to establish a certain thesis T. To do so we proceed as follows. We begin by assuming not-T by way of a hypothetical supposition. From not-T, together with certain pre-established facts or principles P_1, P_2, \ldots, P_n that are already at our disposal, we then derive a contradiction:

$$\text{not-}T, P_1, P_2, \ldots, P_n \vdash \text{contradiction}$$

To restore consistency to the group of theses to the left of the \vdash symbol we must abandon (and thereby endorse the denial of) at least one of them. But since all of the theses P_1, P_2, \ldots, P_n are (by hypothesis) established principles, while not-T is no more than a tentatively adopted *provisional assumption*, we grant priority to ✓

those preestablished principles, and must accordingly abandon ✓not-*T*. On this basis we can now class *T* itself as an established ✓ fact.

Here once again we have an aporetic cluster {not-*T*, P_1, P_2, . . ., P_n} and resolve the inconsistency by the standard process of "breaking the chain of inconsistency at its weakest link." On this basis, not-*T* emerges as an inexorable result of the only acceptable option for restoring consistency.

An example will help to clarify the issue. A classic instance of *reductio* reasoning in Greek mathematics relates to the Pythagorean discovery—revealed to the diagram of his associates by Hippasus of Metapontum in the fifth century B.C.—of the incommensurability of the diagonal of a square with its sides. The reasoning at issue runs as follows:

Let *d* be the length of the diagonal of a square and *s* the length of its sides. Then by the Pythagorean theorem we have it that $d^2 = 2s^2$. Now suppose (by way of a *reductio* assumption) that *d* and *s* were commensurable in terms of a common unit *n*, so that $d = n \times u$ and $s = m \times u$, where *m* and *n* are whole numbers (integers) that have no common divisor. (If common divisor there were, we could simply shift it into *u*.) Now we know that

$$(n \times u)^2 = 2(m \times u)^2$$

We then have it that $n^2 = 2m^2$. This means that *n* must be even, since only even integers have even squares. So $n = 2k$. But now $n^2 = (2k)^2 = 4k^2 = 2m^2$, so that $2k^2 = m^2$. But this means that *m* must be even (by the same reasoning as before). And this means that *m* and *n*, both being even, will have common divisors (namely 2), contrary to the hypothesis that they do not. Accordingly, since that initial commensurability assumption engendered a contradiction, we have no alternative but to reject it. The incommensurability thesis is accordingly proven.[6]

6. On the historic background see T.L. Heath, *A History of Greek Mathematics* (Oxford: Clarendon, 1921).

In mathematics this sort of proof of a fact by deriving a contribution from its negation is characterized as an *indirect proof.* -
The contrast between hypothetical and *reductio* reasoning is instructive. In hypothetical reasoning the assumptions we make are *issue definitive* stipulations and consequently allowed by fiat to prevail come what may. In *reductio* reasoning, however, our assumptions are *merely provisional* and must in the end give way in cases of a conflict with established facts. The situation is thus altered radically from that of counterfactual reasoning. There assumptions were seen as fixed points around which everything else had to revolve. Their priority was absolute. With *reductio ad absurdum* reasoning, however, the matter is reversed. Here assumptions are viewed as merely provisional hypotheses and accordingly become frail and vulnerable: they stand at the foot of the precedence-priority scale. And the circumstance that established propositions prevail over mere hypotheses in this context makes *reductio-ad-absurdum* reasoning a relatively straightforward business. -

12.6 Thompson's Lamp as an Illustration of *Reductio* Reasoning

The *Thompson's Lamp Paradox* was suggested by the English philosopher James Thompson,[7] who posed the following question:

A lamp has two settings: ON and OFF. Initially it is ON. During the next 1/2 second it is switched OFF. During the subsequent 1/4 second it is switched ON. And so on with a change of switch setting over every interval half as long as the preceding, alternating ON and OFF. Question: What is its setting at exactly one second after the start?

This situation gives rise to the following apory:

7. See James F. Thompson, "Tasks and Super-Tasks," *Analysis*, vol. 15 (1954), pp. 1–13; reprinted in R.M. Gale, *The Philosophy of Time* (London: Macmillan, 1968).

(1) A lamp of the hypothesized kind is possible.

(2) At any given time, the lamp is ON or OFF, but not both. Moreover,

(3) Physical processes are continuous. A physical condition that prevails at some time within every \in-sized interval prior to t, no matter how small \in may be, will prevail at t as well.

(4) Within every \in-sized interval prior to $t = 1$ second the lamp is frequently ON.

(5) Within every \in-sized interval prior to t= 1 second the lamp is frequently OFF.

(6) At $t = 1$, the lamp is ON. (By (3) and (4))

(7) At $t = 1$ the lamp is OFF. (By (3) and (5))

(8) (5) and (6) contradict one another.

Here $\{(1), (2), (3), (4), (5)\}$ is an inconsistent cluster. Now in the context of *reductio* argumentation, the basic hypothesis (1) has to be seen as no better than the provisional assumption of a merely plausible supposition, while (2), (4), (5) are defining stipulations of the problem. (3) is a fundamental physical principle. The resulting priority profile is $[(2), (4), (5)] > (3) > (1)$. Clearly (1) has to go here and we can interpret the apory in question as a reductio ad absurdum of that conjectural lamp.

A variant prospective also yields the same result. For consider:

(1) A lamp of the hypothesized kind is possible.

(2) At any given time the lamp is ON or OFF but not both.

(3) The lamp situation is entirely uniform (symmetric) as between ON and OFF. (It is only a matter of which interval we choose to *call* "the first.")

(4) Symmetric conditions yield symmetric results.

(5) Therefore: the final, $t = 1$ setting of the lamp must be indifferent as between ON and OFF.

(6) (5) contradicts (2)

Here {(1), (2), (3), (4)} is an inconsistent quartet. Moreover (2) and (3) are defining stipulations of the problem, (4) is a fundamental principle of physics, and (1) is a plausible supposition. We thus have the priority profile: [(2), (3)] > (4) > (1). Once more (1) has to be abandoned. The lamp is again abolished through a *reductio*. And of course once the lamp is abolished so is the issue of its supposed comportment.

And the physical situation itself lends further credence to this result. For one thing, it would ultimately require unendingly swifter velocities to accomplish that hypothetical switching—in clear violation of the strictures of special relativity theory. For another, the supposition that the lamp is ON or OFF at any given time unrealistically sidelines the prospect that it might simply blow up—that is, cease to exist as a lamp. Underlying the analysis is thus the reality that one would not be prepared to sacrifice physical principles fundamental here to a mere "thought experiment" such as Thompson's Lamp.

The lesson here is that when a hypothesis-engendered paradoxical situation becomes *too* paradoxical, the appropriate course may be to *dissolve* the paradox by concluding that the underlying suppositions on which it rests are simply inappropriate. Here the paradox at issue effectively self-destructs by constituting its own *reductio ad absurdum*.

One final—and important—point. When *p* yields a contradiction upon being superadded to a family of *true* propositions we can infer not-*p*. (That is exactly how *reductio* argumentation works.) However, when *p* yields a contradiction upon being superadded to a family of *plausible* propositions, the situation is different. For everything now depends on the priority ranking of the proposition at issue. Only when *p* is of minimum priority can not-*p* now be inferred: otherwise the onus of untenability falls elsewhere. Truths cannot be destabilized by incompatible additions. But with merely plausible propositions everything will depend on considerations of precedence and priority.

12.6 *Per-Impossibile* Reasoning

Impossible suppositions are not just false but *necessarily* false, that is, in logical conflict with some necessary truths, be the necessity

at issue logical or conceptual or mathematical or physical. Thus a
counterfactual's antecedent may negate:

- a matter of (logico-conceptual) necessity ("There are infi-
 nitely many prime numbers").

- a law of nature ("Water freezes at low temperatures").

Suppositions of this sort give rise to *per impossibile* counterfactuals
(in the physical and conceptual modes, respectively). "If (*per
impossibile*) water did not freeze, then ice could not exist" and "If
(*per impossible*) there were only finitely many primes, then there
would be a largest prime number" afford examples.[8] Nevertheless,
in validating such counterfactuals we proceed—as usual—by prin-
ciples of priority that keep the more fundamental principles of the
domain intact.

Thus consider the counterfactual, "If 2 + 1 were even, then (2
+ 1) + 1 would be odd. Here we have the aporetic cluster:

(1) 2 + 1 is odd, not even.

(2) (2 + 1) + 1 is even, not odd.

(3) The successor of an integer N is $N + 1$.

(4) Whenever an integer is even, its successor is odd.

(5) Whenever an integer is even, its successor is odd.

(6) By supposition: 2 + 1 is even.

In view of (6), we must abandon (1). But the remaining group
(2)–(6) is still inconsistent since the trio (6), (3), (4) yields that
(2 + 1) + 1 is odd, contrary to (2). Now here (6) is a problem-
definitive supposition, (3) a definition, (1) a particular arithmetic
fact, and (4)–(5) general principles (arithmetical laws). The result-
ing priority situation is (6) > (3) > [(4), (5)] > (1) with the result
that (2) must be abandoned. And this validates the counterfactual

8. A somewhat more interesting mathematical example is as follows:

If, *per impossibile*, there were a counterexample to Fermat's Last Theorem, there
would be infinitely many counterexamples, because if $x^k + y^k = z^k$, then $(nx)^k + (ny)^k = (nz)^k$, for any k.

at issue: "If (*per impossible*) 2 + 1 were even, then (2 + 1) + 1 would be odd."

With both *reductio* and with *per impossibile* reasoning we intro-
- duce an "absurd" or "logically untenable" hypothesis. But the aim of the enterprise is different. With *reductio* argumentation the aim is to make this absurdity patent through the detection of impossible consequences. With *per impossible* reason the aim is to indicate interesting consequences that bring instructive implica-tions of the "impossible" supposition to light. With *reductio* the derivation of a contradiction is essential to the project, with *per impossible* reasoning it defeats the aims of the enterprise and frus-trates its very reason for being.

Consider such counterfactuals as:

- If (*per impossible*) 9 were divisible by 4 without a remain-der, then it would be an even number.

- If (*per impossible*) Napoleon were still alive today, he would be surprised at the state of international politics in Europe.

Our real interest in such cases is not in the impossible antecedent but in the general status of the consequence. A virtually equiva-lent formulation of the very point at issue with these two con-tentions is:

- Any number divisible by 4 without remainders is even.

- By the standards of Napoleonic France the present state of international politics in Europe is amazing.

Per impossibile suppositions pose special challenges when the impossibility at issue is not merely one that runs afoul of laws of nature ("Suppose one could travel at a speed faster than the speed of light") but violates matters of logico-conceptual necessity ("Suppose there were a circle with zero radius"). For in the latter case we need to distinguish between more and less fundamental principles—as we need generally not do with matters of logico-conceptual necessity.

An interesting lesson emerges here. Both with *reductio ad absurdum* and with *per impossibile* reasoning we set out from an "impossible" or "absurd" assumption that stands in contradiction

with what we know. But there is a crucial *purposive* difference between the two modes of thought. (Whoever said that purposes do not enter into logic?) In the case of *reductio* the aim is to *establish* the absurdity at issue by indicating that and how the contradiction in question follows. In the case of *per impossibile* reasoning, the impossibility is conceded but waived. We simply want to show that a certain consequence follows. Our interest is not really in the impossible antecedent, but in the larger import of the consequent.

Paradoxes Considered in Chapter 13

- The Voting Paradox
- The Demands of Reason Paradox
- The "Chicken" Paradox
- The Unachievable Wisdom Paradox
- The Prisoner's Dilemma Paradox
- Newcomb's Perverse Predictor Paradox
- The Predictive Competition Paradox
- Allais's Paradox
- The St. Petersburg Paradox
- The Dr. Psycho Paradox
- The Buridan's Ass Paradox

Paradoxes of Choice
and Decision
(Conflicting Reasons
for Action)

13.1 A Sample Paradox of Decision

Matters of decision and action will have to be subject to the same consistency-preserving safeguards that obtain with matters of assertion and denial, and the same general processes are operative in both cases alike. The so-called *Voting Paradox* is a prime example of a paradox of decision.[1] It roots in the fact that an otherwise natural use of the principle of majority rule can lead to a contradictory result. For example:

> Three individuals agree (unanimously) in the abstract that one of them should enjoy a certain privilege. Yet in no case are the other two willing to let the third enjoy this benefit.

The paradox runs as follows:

(1) Whatever the majority agrees upon is to be done.

(2) Everyone agrees that one of the trio should do *X*.

(3) By (1) and (2): One of the trio is to do *X*.

1. On paradoxes of voting, decision, and political processes in general see Steven J. Brams, *Paradoxes in Politics* (New York: The Free Press, 1976).

(4) A majority is against having trio member #1 do X.

(5) By (1) and (4), trio member #1 is not to do X.

(6) As with #1 in theses (4)–(5) so also with #2 and #3. By the "majority rule" principle of (1), they too are not to do X.

(7) By (5), (6), none of the three is to do X.

(8) (7) contradicts (3).

Here {(1), (2), (4) plus its two analogues} constitutes an inconsistent quintet. But since (2), (4), and the (4)-analogues are simply given facts, while (1) is no more than a plausible principle, it is clear that (1) should be sacrificed here. Evidently the principle of majority-rule cannot be maintained flat-out, but only qualifiedly, subject to its restriction to circumstances where problems of implementational infeasibility do not ensue.

Decision paradoxes often root in conflicting evaluations. They frequently relate to conflicts of advantage arising when there are conflicting pro's and con's regarding competing alternatives, so that different ones win out from alternative points of view, while nevertheless the prospect of a combined or overall point of view is impractical. In these circumstances one of those conflicting assessments must simply be subordinated or sacrificed to the other, unless (more drastically) both of them are abandoned together.

Paradoxes of decision have played a particularly prominent part in twentieth-century philosophy because of their instructive bearing upon one of its central topics: rationality. The determination of the rational thing to do in various sorts of problematic circumstances and conditions is, after all, one of the best ways of approaching this topic. It is here instructive as a matter of stage-setting to begin with what might be called *The Demands of Reason Paradox* which arises from the potential conflict between real and apparent advantage:

(1) Reason requires us to choose the (really and actually) best available alternative.

(2) We can do no more toward determining what *is* best than to determine what *looks* best: that is, we can get no closer to the *real* optimum than to determine the *apparent* optimum.

(3) In letting the *apparent* optimum stand surrogate for the *real* optimum, we might very well be off the mark: the apparent best may well not be anything like the actual best.

(4) Reason can appropriately demand no more of us than the best that can be done in the circumstances.

(5) From (2) and (4) it follows that reason can do no more than to require of us that we choose the best apparent alternative among the discernibly available options. And (3) indicates this apparent best might well not be the actual best.

(6) (5) conflicts with (1)

Here {(1), (2), (3), (4)} constitutes an inconsistent quartet. Now (2) and (3) are unquestionable facts of life, while (4) and (3) are reasonable-looking general principles, with the latter rather more securely in place than the former. We thus obtain the priority ranking [(2), (3)] > (4) > (1) as a guide for resolving the contradiction at issue. The most promising way to restore consistency is accordingly to abandon (1) and rest content with (4) because (1), despite its seeming plausibility, is less plausible than its competitors. What reason demands of us is not the best as such, but the best that we can effectively realize. (Note, however, that premiss (1) would be in better shape were it to distinguish between what it requires us *to do* and what it requires us *to try to do*.)

Decision theorists also deliberate about "Chicken," the rather idiotic "game" that seems to have originated in the depression era and was later popularized by the film *Rebel Without a Cause* set among Californian teenagers in the 1950s. As two drivers approach each other head on at high speed on a narrow road, each has the choice of swerving to the right or continuing on a collision course. The resulting outcome possibilities are:

#1	#2	*Result*
swerves	swerves	a draw
swerves	persists	#2 wins
persists	swerves	#1 wins
persists	persists	a collision

The resulting *Chicken Paradox* runs as follows:

(1) In playing a game a player should adopt a strategy that affords some chance of winning.

(2) Only by persisting will a player have a chance of winning in this instance.

(3) By (1) and (2), the players will both persist.

(4) No decision maker will risk actual disaster when the best possible outcome is a trivial gain such as "winning" in a silly game.

(5) Only by swerving can a player insure against disaster.

(6) Therefore the players will both swerve.

(7) (6) contradicts (3)

The pathway to resolution lies in noting that in deliberating about what "a player" would or would not have to do, this has to be ✓understood as referring to a *rational or sensible* player. But of course a rational or sensible person will not play this game at all.[2] The problem dissolves over this consideration that the crucial rationality presupposition which underlies the paradox at issue is just not satisfied.

A challenging paradox of rational decision arises from the situation at issue in the <u>*Unachievable Wisdom Paradox*</u> which emerges from the following narrative:[3]

2. To be sure, if forced to play the "game" in circumstances where some great disaster can only be averted by my "winning," the rational upshot would be not simply *swerve*, but *swerve last*. And if my opponent was in the same position, a collision would become inevitable.

3. The example is adapted from H. Gaifman, "Infinity and Self-Applications, I," *Erkenntnis*, vol. 20 (1983), pp. 131–155 (see pp. 150–52). On this paradox see also

The Arranger offers you a choice between two bills of money, one worth $1 and the other worth $10. And he says, "Let me offer you some reassurance. You are not to worry. For if you fail to choose wisely, I will compensate you with an additional $10." Which bill do you choose?

The following line of reasoning looms before you:

- If I choose $1 rather than $10, that would clearly be unwise. So it will earn me that extra $10 for a total of $11.

- Let us take the preceding reasoning at face value. Then obviously taking that $1 will be the sensible choice—the wise thing to do. So to act unwisely I must choose that $10 and will thereby realize a total of $20.

- But let us now take step 2 reasoning at face value. This would mean that opting for $10 is the wise choice. So for a maximum gain I must return to step 1 and choose that $1 so as to settle for $11.

And this cycle goes back and forth without end. In these circumstances, it would accordingly seem that there is *nothing* that one can sensibly do. But in doing nothing one would forgo the benefit of a sure gain of $10. So that does not offer a good prospect either.

How is this perplex to be resolved? Note first of all that the paradox that confronts us here is as follows:

(1) By the stipulations of the problem situation, proceeding unwisely assures one of a gain greater than what one would otherwise obtain.

(2) Maximizing one's overall gain is the wise thing to do.

(3) A wise course of action is available in the specified circumstances.

Robert C. Koons, *Paradoxes of Belief and Strategic Rationality* (Cambridge: Cambridge University Press, 1992), pp. 17–19. The paradox is sometimes called "The Two Envelopes Paradox."

This trio is collectively inconsistent since (1) assures that the course of *unwisdom* will—if available as per (3)—be the more rewarding, while (2) indicates that this cannot be so. Where is this chain of contradiction to be broken?

Here (1) is fixed as a defining condition of the problem. And (2) is more or less axiomatic as a basic principle of economic rationality. Of the theses at issue (3) is therefore the most questionable. We thus have the priority ranking: (1) > (2) > (3). In consequence, (3) has to give way here. We have to acknowledge that in the circumstances there is really no such thing as "the wise thing to do" and the arranger should come up with that bonus come what may. (Here one might as well take the $10 and run.[4])

So here we have another paradox of decision, one whose seeming conflict of advantage is straightforwardly resolvable on the basis of plausibilistic considerations.

13.2 The Prisoner's Dilemma

The *Prisoner's Dilemma Paradox* has been debated for over half a century, having initially been propounded by Melvin Dresher and Merril M. Flood of the RAND Corporation around 1950.[5] It emerges from a story that runs as follows:

> You and your accomplice have committed some crime. The two of you are eventually arrested and charged. The public prosecutor offers you a plea bargain: Confess and turn state's evidence

4. The reasoning here is based on the following line of consideration:

I CHOOSE	I GET IF THE WISE CHOICE IS ACTUALLY $1	I GET IF THE WISE CHOICE IS ACTUALLY $10	I GET IF THERE IS NO WISE CHOICE
$1	$1	$11	$1
$10	$20	$10	$10

By choosing $10 I sustain a trivial comparative loss if worst comes to worst and am substantially better off in any other case.

5. For a many-sided discussion of the problem see Richmond Campbell and Lawring Sowden (eds.), *Paradoxes of Rationality and Cooperation: Prisoner's Dilemma and Newcomb's Problem* (Vancouver: University of British Columbia Press, 1985). See also Brams 1976.

against your accomplice and she will ensure that the courts will treat you leniently—provided that your confession turns out to be useful for her case. Note further: (1) The utility of your confession depends on whether or not your accomplice keeps silent. (If he does, your confession is valuable, while if he too confesses, its value is substantially diminished.) (2) If neither of you confesses, then the prosecutor's case is in fact so weak that both of you will almost certainly receive no more than a rather light penalty. Accordingly we may suppose the following punishment schedule, measured in years lost in incarceration:

Action		Years of Incarceration for	
You	Accomplice	You	Accomplice
confess	confess	5	5
confess	not confess	1	10
not confess	confess	10	1
not confess	not confess	2	2

It is to be assumed here that both of you are rational agents who make choices in line with the usual principles of prudential rationality. And the paradox is that by doing the decision-theoretically rational thing—namely opting for that alternative where you might gain but cannot lose, no matter which way the opponent acts—you and your similarly circumstanced opponent are condemned to confession, thereby foregoing the prospect of arriving at an option that is clearly preferable—namely mutual nonconfession with the result of a much diminished penalty for each of you.

The following contentions make explicit the paradox that arises here:

(1) Other things equal, the rational thing is to prefer an option that can only leave one better off. (A fundamental principle of economic rationality.)

(2) In the sort of situation at issue here, it is rational to select that "casewise dominant" option by which one comes out ahead regardless of how the opponent chooses. (A reasonable principle of decision-theoretic procedure.)

(3) In view of the defining features of the problem this means that: both agents will choose C, and thereby arrive at mutual confession with the result –5/–5. (From (1) and (2).)

(4) Each agent would actually fare better if both kept silent and neither one confessed. (A defining feature of the case.)

(5) Both agents—being rational themselves and presuming the other to be so as well—will therefore choose nonconfessions and thereby arrive at (–2, –2).

(6) (5) contradicts (3).

Here the set {(1), (2), (4)} presents an aporetic cluster that needs to be reduced to consistency. And the appropriate priority ranking is (4) > (1) > (2). For this situation casts a shadow of doubt over thesis (2) with its assertion of the decision-theoretic casewise domain standard. It is thus by abandoning (2) as its weakest link — that the chain of inconsistency is optimally broken.

Yet another way of addressing the paradox at issue here is to proceed as follows:

(1) Other things equal, the rational thing is to prefer an option that can only leave one better off. (A fundamental principle of economic rationality.) [Just as before.]

(2) In the sort of situation at issue here, it is rational to select that "casewise dominant" option by which one comes out ahead regardless of how the opponent chooses. (A reasonable principle of decision-theoretic procedure.) [Just as before.]

(3) In view of the defining features of the problem this means that: both agents will choose C, and thereby arrive at mutual confession with the result –5/–5. (From (1) and (2).) [Just as before.]

(4') It is inherent in the description of the situation that both agents are in exactly the same boat: the situation is

entirely symmetric as between the two. (A defining feature of the problem.)

(5') Rationality is impersonal and uniform: what is rational for one person is rational for any other who is in exactly the same circumstances. (A general principle.)
Therefore—

(6') The agents must both choose alike (that is either both C or both not-C): these are the only "realistically available" alternatives. (From (5).)

(7') The agents will both choose not-C and arrive at –2/–2. (From (1), (6').)

(8') (7') contradicts (3).

This second dilemma roots in the inconsistency of {(1), (2), (4') (5')}, and has to be viewed in the light of the following priority schedule:

$$(4') > [(1), (5')] > (2)$$

So here once more the abandonment of the minimally plausible ¬(2) serves to break the chain of inconsistency.

It is clear that the problem here turns on pitting the decision-theoretic construction of rationality via casewise dominance against other, more elemental and common-sensical construals of this conception.

What is noteworthy in this case is that we here have a compound paradox with two interlocking aporetic clusters, namely the inconsistent trio {(1), (2), (4)} and the inconsistent quartet {(1), (2), (4'), (5')}. And while our dismissal of (2) is in each case dictated by plausibility considerations, it is interesting—and most convenient—that in this case one stone kills both of these aporetic birds together (which is by no means necessarily the case).

13.3 Newcomb's Perverse Predictor Paradox

In 1960 the American physicist William A. Newcomb propounded a paradox that has beguiled theorists in recent decades.[6] Newcomb's Paradox is presented by the problem situations of the following narrative:

> The Predictor says: "Here are two boxes A and B. You may pick one or both. You see that I am now putting this $1,000 into box A. And as regards box B, be informed that I have already put in a million dollars if I predicted that you will choose just one box, but nothing if I predicted that you would choose both boxes. Knowing my extensive track record as a good predictor, you would be well advised to heed that prediction." How do you choose?

This problem straightaway engenders a paradox because the following theses are all plausible in this situation.

(1) The reasonable thing to do is to pick both boxes. (After all you will then get whatever there is to be gotten.)

(2) The reasonable thing is to be guided by expected value calculations.

(3) An appropriate expected-value assessment can be carried out as follows:

Let p be the probability *that the Predictor has forecast your picking both boxes.* Then your gain will be as follows:

You choose A only: $1,000

You choose B only: $p(0) + (1-p)(1,000,000) = (1-p)(1,000,000)$

6. On Newcomb's Paradox see Robert Nozick, "Newcomb's Problem and Two Principles of Choice" in N. Rescher (ed.), *Essays in Honor of Carl G. Hempel* (Dordrecht: Reidel, 1969), pp. 114–146. See also: R. Campbell and L. Sowden, *Paradoxes of Rationality and Cooperation* (op. cit.); Martin Gardner, "Mathematical Games," *Scientific American*, July 1973, pp. 102–08; Isaac Levi, "Newcomb's Many Problems," *Theory and Decision*, vol. 6 [1975], pp. 161–175, as well as Brams 1976. Michael D. Resnick, *Choices: An Introduction to Decision Theory* (Minneapolis University Press, 1987), pp. 109–112.

You choose both: the sum of the two preceding amounts.

Here choosing both wins out—automatically so because its expected value is greater than that of either of the alternatives.

(4) An appropriate expected-value assessment can be carried out as follows:

Let p be the probability *that the Predictor has forecast your choice correctly*. Then your expected return will be as follows:

You choose A only: 1,000

You choose B only: $p(1,000,000) + (1 - p)[\frac{1}{2}(0) +$
$\frac{1}{2}(1,000,000)] = 500,000(1 + p)$

(Note: This assumes a 50:50 division of how the predictor goes wrong as between choosing "Both," and "A only.")

You choose both: $1,000 + p(0) + (1 - p)$
$(1,000,000) = 1,001,000 -$
$1,000,000p$

Since p cannot be negative, *B*-only *automatically* wins out over *A*-only. Moreover *B*-only will win out over Both whenever:

$500,000(1 + p) > 1,001,000 - 1000,000\,p$

$500,000 + 500,000\,p > 1,001,00 - 1000,000\,p$

$1,500,000\,p > 501,000$

$p >$ roughly one-third

On this basis it transpires that you are well advised to choose *B*-only as long as you are convinced that the Predictor has a better than roughly one-third chance of predicting your choice correctly.

And so, the indicated cluster of contentions again puts us into an aporetic situation. For (2) and (3) agree with (1) in ruling "Both," while (2) and (4) combine in ruling "B-only" in suitable circumstances. And we clearly cannot have it both ways. Either (4) must be abandoned or (1) and (3) must go since there are but two A/R-alternatives: (1), (2), (3)/(4) and (2), (4)/(1), (3). (Here (2) is inevitable, given that we are talking about economic rationality.)

How to choose? Theses (1) and (2) to all appearances represent equiplausible construals of the demands of choice-theoretic rationality, while (3) and (4) offer competing means for an implementing process of precedence determination. So we arrive at the priority ranking [(1), (2)] > [(3), (4)]. On this basis (1), (2), (3)/(4) with retention profile { $\frac{1}{2}$, 1} wins out over (2), (4)/(1), (3) with retention profile { $\frac{1}{2}$, $\frac{1}{2}$}. In effect we see (2) + (3) and (2) + (4) as canceling each other out and let (1) carry the day.

The rationale that undergirds this analysis goes something like this: "the probabilities at issue in (3) and (4) are problematic; they may very possibly fail to be well-defined, meaningful quantities. (After all, both presuppose that there are correct probability-evaluations regarding otherwise imponderable human choices.) So let us refrain from commitment either way and let (1) be determinative.

As we saw above, Prisoner's Dilemma casts a shadow of doubt across the standard decision-theoretic criterion of "casewise dominance" as a universal instrument of rational choice. By contrast, Newcomb's Problem highlights the potential shortcomings that expected value calculations encounter in the presence of problematic probabilities.

To be sure, one can also view this problem in a very different light. This would be to view it as a reductio ad absurdum of a predictor with the capability at issue. For if there can be one such Predictor—short of God himself—then there could also be two of them. And these two can then be pitted against each other in a matching game, as follows. Each gets to circle A or B on a card. If the cards match, Predictor No. 1 wins, if they do not, then No. 2 wins. Now if No. 1 were to write A, then No. 2, foreseeing this, would write B. But then A, foreseeing this, would have to write B, and so on. This *Predictive Competition Paradox* indicates that an assumption of predictive competence with respect to other free agents can be deeply problematic.

13.4 Allais's Paradox and the St. Petersburg Paradox

The inner stresses of the standard theory of rational decision are further illustrated by *Allais's Paradox,* which emerges from the following considerations:

(1) Rational people make their choices in line with expected-value contributions.

(2) Consider a choice between two alternatives. If you pick alternative one you get a million dollars minus a couple of dollars. If you pick alternative two, we'll toss a coin and you get a 50:50 chance of getting two million dollars or nothing.[7]

(3) In view of (1), rational people confronted with this situation must pick alternative (2) since this has the greater expected-value. They should thus chance everything on the toss of a coin.

(4) But in real life, most people—and we must presume that the bulk of them is rational—would actually opt for alternative one and would settle for that almost-a-million.

(5) Thus contrary to (3), it seems that rational people could, would, and should prefer that sure-thing alternative, expected values to the contrary notwithstanding.

Paradoxes of this sort, which cast a shadow of doubt across the claims of expected value calculations to serve as principles of rationality, were investigated by the French economist Maurice Allais. They strongly suggest once more that in a broad range of cases it is well advised to acknowledge the rationality of sure-thing preferences over against expected-value juggling. However, taking this line means that one must abandon the idea that expected-value comparison suffices as a rationally failproof guide in matters of probabilistic choice.[8]

7. Strictly speaking the units of reward should be measured in "utility" rather than in money.

8. For a discussion of Allais's paradox situations see R. Duncan Luce and Howard Raiffa, *Games and Decisions* (New York: Wiley, 1957).

Such an approach is supported by yet another obstacle to the standard theory of decision based on expected value analysis. This is the so-called *St. Petersburg Paradox* which is based on the following hypothetical game:

> A fair coin is to be tossed until a "heads" appears. Now if this should happen on the n-th toss, then the player is to get a payoff of 2^{n-1} units (which again should be units of "utility" as economists conceive of this). Question: How much should a rational person be willing to play this game?

The expected value here is going to be the infinite sum (over n) of the product:

$$prob(\text{heads appears first on the } n\text{-th toss}) \times 2^{n-1}$$

Since the probability at issue is $(\frac{1}{2})^n$ it transpires that this product is uniformly $\frac{1}{2}$, and the sum in question is therefore $\frac{1}{2} + \frac{1}{2} + \frac{1}{2} + \ldots$, which is to say that it is infinite (that is, larger than any finite quantity). The upshot would be that no price would be too large for the opportunity to play this game. And yet this gambling scenario seems distinctly counterintuitive—and not just because it requires a bank with infinite patience and infinite resources.

We arrive on this basis at the following paradox:

(1) The St. Petersburg scenario describes a practicable game that defines a real choice.

(2) The expected utility-value of this game is a meaningful, well-defined quantity, albeit an infinite one.

(3) Being guided by expected-value considerations, a rational person could deem no price too large to play the St. Petersburg game.

(4) But nevertheless it is clear on general principles that no sensible person would play this game if the price were truly enormous.

Given that (4) seems intuitively unavoidable and that (1) is to be accepted as a formative hypothesis of the problem situation, there

are only two exits from inconsistency here:

(2) - abandonment. Rejecting the idea that infinite utilities are meaningful quantities. ✓

(3) - abandonment. Rejecting the idea that expected-value calculations provide an appropriate guide to rational choice (at least in exotic cases such as this one).

Decision theorists generally opt for the first of these alternatives, while people less ardently committed to the decision-theoretic view of rationality are inclined to opt for the second.[9]

13.5 The Dr. Psycho Paradox

The *Dr. Psycho Paradox* affords yet another instructive example, which involves a clash of two different but equally plausible ways of implementing the process of expected-value maximization.[10] Consider the problem posed by a somewhat eccentric friend of yours, Dr. Psychic Psycho, an otherwise intelligent, serious, reliable, and generally sagacious and self-assured biochemist who fancies himself a clairvoyant psychic and indeed has a good track record for oddball predictions. After you have just eaten apples together, he proceeds to astonish you with the following announcement:

> I have interesting news for you. You must seriously consider taking this pill. As you know (since we have recently determined it together) it contains substance X which (as you also know—but consult this pharmacopoea if in doubt) is fatally poisonous by itself, while nevertheless furnishing unfailing antidote to poison Z—though it does have some minorly unpleasant side effects. Now the apple I gave to you, which

9. On the origin of the problem in the work of Nicholas and Daniel Bernoulli see Isaac Todhunter, *A History of the Mathematical Theory of Probability* (New York: G.E. Stechert, 1931), pp. 134 and 220–22.

10. On this problem see the author's "Predictive Incapacity and Rational Decision" in *The European Review*, vol. 3 (1995), pp. 325–330.

you have just finished eating, was poisoned by me with Z—or not—in line with my prediction as to your taking or not taking the antidote pill. Benign old me of course only poisoned the apple if I foresaw that you were indeed going to take the antidote. And not to worry—I'm a very good predictor.

At this point your strange friend rushes off and vanishes from the scene. Any prospect of beating the truth out of him disappears with his departure. And an awful feeling comes over you—you cannot but believe him. In fact, you strongly suspect that he went through the whole rigamarole to get you to take that problem pill. What do you do? Your very life seems to depend on predicting the result of taking that pill.

Of course you proceed to do a quick bit of decision theoretic calculation. For starters, you map out the spectrum of available possibilities:

You	He	According to Him/You	Your System Contains	Result ?
take	predicts correctly	take	Z, X	survive
take	predicts incorrectly	not take	X	die
not take	predicts correctly	not take	neither	survive
not take	predicts incorrectly	take	Z	die

Not a pretty picture. After all, you stand a chance of dying whether or not you take that accursed pill. What to do?

Two lines of analysis are available here:

[B] *Analysis No. 1*

Let p = probability that he correctly predicts your action. In terms of an expectation-of-life measure we then have:

$$EV\,(\text{take}) = p\,(+\,1^-) + (1-p)\,(-\,1)$$
$$EV\,(\text{not take}) = p\,(+\,1) + (1-p)\,(-\,1)$$

Accordingly EV (take) < EV (not take), irrespective of the value of p. (Note that the small superscripted minus sign ⁻

means "a smidgeon less" and comes into play owing to the minor negative side effect of taking the pill.)

On this basis, the expected-value comparison envisioned in orthodox decision theory appears to rule against taking that pill, quite independently of any estimate of how good a predictor Dr. Psycho is or isn't.

[B] *Analysis No. 2*

Let p = probability that he actually poisoned the apple. Calculating the expected value in lives gained or lost, we now have:

$$EV\,(\text{take}) = p\,(+\,1^{\,-}) + (1 - p)\,(-\,1) = 2p^{\,-} - 1$$

$$EV\,(\text{not take}) = p\,(-\,1) + (1 - p)\,(+\,1) = -2p + 1$$

Note that:

$$EV\,(\text{take}) > EV\,(\text{not take})\ \text{whenever:}$$

$$2p^{\,-} - 1 > -2p + 1$$

$$4p^{\,-} > 2$$

$$p > \left(\tfrac{1}{2}\right)^{+}$$

Now let it be (*ex hypothesi*) that, additionally to the given information, you strongly suspect that he actually went through this bizarre exercise to induce you to take the pill (which, as he presumably sees it, you will do iff he poisons the apple). Then clearly the preceding condition on p—namely its being nontrivially greater than $\tfrac{1}{2}$ —is satisfied, and you are decision-theoretically well advised to take the pill.

Overall, we here face the aporetic puzzle created by the following theses:

(1) The rational and sensible thing to do is to follow the guidance of a decision theoretic analysis.

(2) The argumentation of Analysis No. 1 is decision-theoretically cogent.

(3) The argumentation of Analysis No. 2 is decision-theoretically cogent.

(4) The two rationally cogent analyses in question lead to discordant resolutions.

(5) Rationality is coherent: rationally cogent problem-resolutions do not lead to conflicting results.

Now (5) is a fundamental principle of rationality: there is no sensible alternative to accepting it. And (4) is simply a fact of the situation. (1) is a plausible but nevertheless problematic supposition. We thus arrive at the priority ranking (5) > (4) > (1) > [(2), (3)]. What we have here is an aporetically inconsistent family of theses, whose m. c. s. are the inconsistent quartets {(1), (2), (4), (5)} and {(1), (3), (4), (5)}. This leaves us so circumstanced that one of (2) and (3) must be jettisoned and one of those two expected value analyses has to be abandoned in consequence.

 ~ But which of these two discordant analyses is right? That is difficult to say—indeed effectively impossible. On all the available indications both available alternatives seem equally cogent. The abstract case that can be made for the one is every bit as good as that which can be made from the other. You pay your money and take your choice—or toss your coin.[11]

 The upshot is that we here again encounter a situation that reinforces the indication afforded by Newcomb's problem that in various contexts of decision the standard machinery of expected-value analysis may leave us in the lurch because the probabilities at issue may simply fail to be well-defined quantities.

 In the present aporetic situation it transpires that plausibilistic considerations, though generally helpful, cannot dictate a single uniquely definitive resolution but still leave matters in a state of total bafflement. And this should not be altogether surprising. For as is clear from games like "Rock, Paper, Scissors"—in con-

11. To be sure, if you knew for certain that one of the two analyses had to be correct, you might be able to effect a second-order expected value comparison.

trast to solvable games like Tic-Tac-Toe—there sometimes is no effective strategy of play, no definite way of making "the right choice." In such uncooperative circumstances the resources of rationality have no advice for us. No analysis of the range of options indicates one option to be superior to the rest: every alternative that confronts one has as much to be said for (or against) it as any other.

All of these paradoxes of choice and decision arise in a common way in that in each instance there is a seemingly equi-meritorious case for resolving a decision issue in either of two incompatible ways. And all these paradoxes admit of the same generic response. For since the case is equally good for those incompatible resolutions, we might as well "do what comes natural" whatever seems to be the most favorable, least burdensome of the choice alternatives. Rational decision in matters of truth cannot but await the preponderance of evidence. But in matters of practice we can let equivalent opposites balance each other out and do as the circumstances of the case might appeal to our fancy.[12]

The fact of it is that sometimes rational analysis *underdetermines* the choice of an advisable resolution: there are no good arguments for selecting one possibility over against some other alternative. And the present situation is, as it were, a cousin to that one. In both cases alike it accordingly becomes impossible to say with warranted confidence how even an ideally rational agent would proceed. Our only recourse here is brute random selection. And this points in the direction of a notorious paradox.

Another closely related example is provided by the *Buridan's Ass Paradox*, attributed to the medieval French philosopher Jean Buridan (ca. 1295–ca. 1358). This paradox is based on the story of a donkey, starving between two equally eligible bales of hay, unable to decide which one to eat. The moral of the story seems to be that absent a free will to force a choice between equally powerful motivations absurd consequences will ensue.[13]

12. On the different groundrules of decision in factual and practical contexts see the author's "Ueber einen zentralen Unterschied zwischen Theorie und Praxis," *Deutsche Zeitschrift für Philosophie*, vol. 47 (1999), pp. 171–182.

13. On the historical background of the Buridan's Ass perplex see the author's "Choice Without Preference" in his *Essays in Philosophical Analysis* (Pittsburgh: University of Pittsburgh Press, 1969), pp. 111–157.

The paradox at issue stands roughly as follows:

(1) A rational being would not starve in the presence of available food.

(2) A rational creature must decide between alternatives on the basis of preponderating reasons.

(3) Where there is an equilibrium of reasons—a balance where an equally good case exists either way—there is, ex hypothesi, no preponderating reason for going one way rather than the other.

(4) In consequence of (2) and (3), a rational creature cannot choose between equivalent alternatives.

(5) In view of (4), our donkey would starve—even though food is available.

(6) (5) contradicts (1).

Here {(1), (2), (3)} constitutes an inconsistent triad. And (2) seems to be the most vulnerable of these three plausible principles since both (1) and (3) are beyond reasonable cavil. For it seems sensible to argue that while it is indeed the case that where there are preponderating reasons a rational creature can and should heed them, it would nevertheless be totally irrational to let immobilization occur if—as Buridan was presumably trying to show—stalemates can be broken by the free agency of the will. Accordingly, (2) - abandonment is our best prospect for breaking through the chain of inconsistency here. We can however again save something of (2)'s message by a suitable distinction—this time between a narrower and a broader sense of "rationality." For while there indeed are no *immediate* reasons for preferring one bale of hay over the other, because of the symmetry that (*ex hypothesi*) obtains, there is excellent reason to prefer one to none, and thus for preferring an arbitrary choice to immobilization, an arbitrary choice which, even if beyond the capacity of the will itself, could be delegated by it to a random device.

There is something particularly problematic—particularly paradoxical—about paradoxes that arise in matters of decision and choice. In matters of theory—of question-answering and belief-acceptance—we can, as it were, temporize by suspending judg-

ment and deferring the matter for another day when ampler information becomes available. Or we can haver between the unresolvable alternatives *P* and *Q* by the simple device of disjunction, that is by adopting *P*-or-*Q* and being no more committal than that. But in practical matters of decision and action the situation wears a different aspect. Here inaction is itself a mode of action. Confronted with a choice between doing *A* and doing *B* we face the choice system:

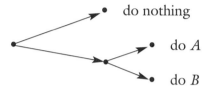

And here it may well be that doing nothing is the very worst of available alternatives—as the example of the Buridan's Ass paradox brings vividly to realization.

This aspect of the matter give a special bite to the paradoxes of practice.

In solving theoretical and practical paradoxes alike we want to minimize the damage. But damage is measured very differently in these two domains. Theoretical damage consists in the epistemic error of accepting what is false or implausible. But practical damage can be something even more troubling of a more grave and painfully affecting sort. And this is why those paradoxes like the Prisoner's Dilemma or the Dr. Psycho Paradox, whose difficulty lies in the fact that here *the very principles of proper damage assessment are in question*, are peculiarly troublesome.

13.6 Retrospect: The Pragmatic Dimension

When paradoxes arise, logico-inferential rationality alone avails but little. For when the data are inconsistent, inferential reason can only say that consistency should be restored, but cannot tell us how this must be achieved. Rational analysis can define the alternatives but cannot resolve them. In this regard paradox solution is not in general a matter of mechanical rules and automatic routine. Logic-transcending resources are required.

In the course of these deliberations we have met with a considerable array of "tools of the trade" in matters of paradox resolution. Prominent among these are:

- dis-ambiguation
- dissolution through equivocation removal
- presupposition rejection or invalidation
- meaningfulness denial and concept invalidation
- implausibility dismissal
- item abolition (on grounds of inappropriate hypostatization)
- prioritization of "deeper" principles and "superior" alternatives
- hypothesis invalidation (through *reductio*, for example)
- choice resolution through preferentiability validation

All of these processes can provide a means for reestablishing consistency when confronted with a family of inconsistent premises.

The striking feature of all of these resources is that in terms of their thematic locus in the cognitive scheme of things they all belong rather to the domain of rhetoric than to that of theoretical logic proper. In the sections devoted to sophisms and insolubilia in Prantl's classic *Geschichte der Logik im Abendlande* one encounters time and again a complaint to the effect that "this sort of thing belongs rather to rhetoric than to logic." And Prantl's sensibilities in this matter are entirely correct. (What one *can* object to is his reaction to this circumstance—based on the sentiment that if something does not belong to logic proper, then it is not all that important.)

Be this as it may, the problem of resolving aporetic conflicts recurs in a diversified variety of contexts, preeminently including the purely hypothetical, the proof-theoretic (*reductio ad absurdum*), the evidential, and the philosophical. But throughout,

one selfsame master principle is determinative for the process of resolving aporetic inconsistency: "restore consistency with minimal disruption, disruptiveness in terms of the purposive nature of the enterprise." And the nature of the context will play an important role here. In *factual* contexts, in particular, plausibilistic priorities are determinative. However, there are also *hypothetical* contexts of supposition and reductio argumentation. And matters are different here. Hypotheses and their implications are now paramount and other plausibilistic considerations are displaced and readjusted. It is all a matter of practical policies determined by the purposive considerations operative in the context at issue.

It must accordingly be emphasized that the priority or precedence at issue with propositions that conflict in these aporetic situations need not and generally will not be absolute or categorical; rather it is something that is variable and context-dependent. We proceed differently in different sorts of cases. Thus, for example:

- In *reductio ad absurdum* contexts we sacrifice hypotheses to givens; in purely hypothetical contexts we do the reverse.

- In evidential contexts we sacrifice generalities to specificities; in purely hypothetical contexts we do the reverse.

- In philosophical contexts we must take evidential considerations into account; in purely hypothetical contexts we do not worry ourselves about them.

What qualifies such rules as the natural or appropriate way of proceeding in these different cases is a matter of the purposive nature of the relevant domain at issue—its governing aims. In each case we proceed on the basis of guiding principles determined by the specific objectives of the particular endeavor at hand. The contextuality of the principles of propositional prioritization must therefore be noted and acknowledged. And it should accordingly be stressed that the priority among conflicting propositions in aporetic settings is not a matter of the personal preferences and predilections of individuals, but is determined objectively on the basis of the purposive orientation of different contexts of discussion.[14]

And here, as we have seen, one must distinguish the following four cases:

1. *Purely hypothetical* contexts. In restoring consistency, salvage as much information as you can. Hence give priority to the comparatively more informative—contextually stronger—statements. Keep what is more general and fundamental in place. The determinative issue is: "What are the informatively weakest links in the chain of inconsistency?"

2. *Reductio ad absurdum* contexts. In maintaining consistency give priority to what has already been established. Therefore, it will be those conflict-engendering assumptions themselves that must give way. The determinative issue is: "Which claims are minimally at odds with what is already established?".

3. *Evidential-inductive* contexts. In restoring consistency, preserve as much as you can of the probative/evidential fabric. Always make more weakly evidentiated claims give way to those that are more strongly evidentiated. The determinative issue is: "Where are the evidentially weakest, probatively most vulnerable links in the chain of inconsistency?"

4. *Counterfactual* contexts. In restoring consistency give prime precedence to issue-definitive assumptions. And from there on in opt for the least amount of factual disruption that can be managed, thus proceeding as in case 2 above.

5. *Philosophical* contexts. In restoring consistency maintain overall credibility. Give priority to those propositions that provide for the systematically optimal *combination* of plausibility (evidentiation) *and* problem resolving (informative-

14. The context-dependent nature of the project of conflict resolution means the aporetic approach is able to unify important aspects of the theory of reasoning in very different domains (proof theory, empirical inquiry, hypothetical reasoning, philosophical reasoning) within a single overarching integrating perspective. This unification patently integrates the author's approach to these various issues in such books as *Hypothetical Reasoning* (1967), *Plausible Reasoning* (1974), *Empirical Inquiry* (1982), and *The Strife of Systems* (1985), and thereby unifies in a synoptic perspective the pragmatic tendency of my overall position.

ness). (The process here is accordingly a hybrid mix—a balanced *combination* or *fusion* of the evidential and the hypothetical approaches.) The determinative issue is: "What are the least plausible links in the chain of inconsistency—those whose abandonment would minimally impede the construction of a coherent system of understanding?"

As this survey indicates, different purposes are at work in different contexts. The purposive/teleological character of the particular enterprise at issue provides the guiding basis for the different ground-rules of precedence-determination that are operative in these different contexts.

The salient point with respect to inconsistency-resolution is one of pragmatics, of rational practice and procedure. Different contexts of deliberation reflect different ranges of purpose. And it is this teleological issue of the purposive orientation of the relevant context that determines what sorts of principle of priority will be operative within it. For it is their capacity to facilitate the realization of the relevant purposes that determines the appropriateness of the requisite principles of prioritization. ✓

Bibliography

NOTE: Regrettably there is as yet no general history of paradoxes. However, the thinkers who dealt with them in classical antiquity are all discussed in Eduard Zeller's magisterial *Philosophie der Griechen in ihrer Geschichtlichen Entwicklung* published in Leipzig by O.R. Reisland in three massive double volumes, 6th ed., 1919. The paradoxes themselves are discussed in greater detail, albeit in general rather dismissively, in Carl Prantl's *Geschichte der Logik ime Abendlande*, published in Leipzig in three volumes in 1855 by S. Hirzel, which offers much information on ancient and medieval contributions to the subject. Salmon 1970 gives a comprehensive bibliography on Zeno's paradoxes. Rüstow 1910 gives a synoptic account of the history of the Liar Paradox and its cognates.

On paradoxes among the medieval schoolmen see the extensive bibliography presented in Ivan Boh, *Epistemic Logic in the Later Middle Ages* (London: Routledge, 1993). Medieval texts on insolubles and sophisms are available in Buridan 1977, Grabmann 1940, Heytesbury 1979, Hughes 1982, Kretzmann and Kretzmann 1990, Nicholas of Cusa 1954, Perreiah 1978, Rijk 1962–67, and Wyclif 1986. And for analyses on these topics see Biard 1989, Bottin 1976, Kretzmann et al. 1982, Read 1993, and Weidemann 1980. On semantic paradoxes in the sixteenth century see the section of that title in Ashworth 1974. And for the Renaissance see Colie 1966.

Ameriks, Karl. 1982. *Kant's Theory of Mind: An Analysis of the Paralogisms of Pure Reason*. Oxford: Clarendon.
Aristotle. 1908–31.*Oxford Translation of the Words of Aristotle*, ed. by J.A. Smith and W.D. Ross. Oxford: Clarendon.
Ashworth, E. J. 1974. *Language and Logic in the Post-Medieval Period*. Dordrecht: Reidel. [See Chapter IV on Semantic Paradoxes, pp. 101–117.]
Axelrod, Robert M. 1985. *The Evolution of Cooperation*. New York: Basic Books.
Bandmann, H. 1992. *Die Unendlichkeit des Seins: Cantors transfinite Mengenlehre und ihre metaphysischen Wurzeln*. Frankfurt: Peter Lang.

Bar-Hillel, Yehoshua. 1939. Le problème des antinomies et ses développements récents. *Revenue de Metaphysique et de Morale*, vol. 36, pp. 225–242.

Bartlett, Steven J., and Peter Suber, eds. 1987. *Self-Reference*. Dordrecht: Nijhoff.

Barwise, Jon, and John Etchemendy. 1987. *The Liar*. New York: Oxford University Press.

Behmann, Heinrich. 1937. The Paradoxes of Logic. *Mind*, vol. 46, pp. 218–221.

Bernardete, José A. 1964. *Infinity: An Essay in Metaphysics*. Oxford: Clarendon.

Biard, Joel. 1989. Les sophismes du savoir: Albert de Saxe entre Jean Buridan et Guillaume Heytesbury. *Vivarium*, vol. 27, pp. 36–50.

Bolzano, Bernard. 1955 [1851]. *Paradoxien des Unendlichen*. ed. F. Prihonsky. Leipzig: Publisher, 1851; reprinted Hamburg: F. Meiner, 1955. English version: *Paradoxes of the Infinite*. London: Routledge, 1950.

Borel, Emile. 1946. Les Paradoxes de l'infini. *L'avenir de la science*, No. 25, Part 3.

Bottin, Francesco. 1976. *Le antinomie semantiche nella logica medievale*. Padova: Antenore.

————. 1980. Gli 'insolubilia' nel 'Curriculum' scolastico tardomedevale. *Logica, Epistmologia, Storia della Storiografia* (Padova: Editrice Anternore, pp.13–32).

Brams, Steven, J. 1976. *Paradoxes in Politics: An Introduction to the Nonobvious in Political Science*. New York: Free Press.

Burali-Forti, Cesare. Una questione sui numeri transfiniti. *Rendiconti del Circulo Mathematico di Palermo*, vol. 11, pp. 154–164.

Buridan, Jean. 1977. *Sophismata*, ed. T.K. Scott. Stuttgart-Bad Cannstatt: Frommann-Holzboog. English version: *Sophisms on Meaning and Truth*, trans. T.K. Scott. New York: Appleton-Century-Crofts, 1966.

Burgess. Theodore C. 1902. *Epideictic Literature*. Chicago: University of Chicago Press.

Burns, L.C. 1991. *Vagueness: An Investigation into Natural Languages and the Sorites Paradox*. Dordrecht: Kluwer.

Campbell, Richard, and Lanning Sowden, eds. 1985. *Paradoxes of Rationality and Cooperation: Prisoner's Dilemma and Newcomb's Problem*. Vancouver: University of British Columbia Press.

Cargile, James. 1979. *Paradoxes: A Study in Form and Predication*. Cambridge: Cambridge University Press.

Carnap, R. 1934. Die Antinomien und ide Unvollständigkeit der Mathematik. *Monatshefte der Mathematik und Physik*, vol. 41, pp. 263–284.

Champlin, T. S. 1988. *Reflexive Paradoxes*. London: Routledge.

Chihara, Charles. 1979. The Semantic Paradoxes: A Diagnostic Investigation. *Philosophical Review*, vol. 88, pp. 590–618.

Church, Alonzo. 1934. The Richard Paradox. *American Mathematical Monthly*, vol. 41, pp. 356–361.

Colie, Rosalie L. 1966. *Paradoxica Epidemica: The Renaissance Tradition of Paradox*. Princeton: Princeton University Press, 1966.

Davis, Martin. 1965. *The Undecidable: Basic Papers on Undecidable Propositions, Unsolvable Problems, and Computable Functions.* Hewlett, NY: Raven Press.

De Laguna, Theodore. 1916. On Certain Logical Paradoxes. *Philosophical Review,* vol. 25, pp. 16–27.

de Morgan, Augustus. 1872. *A Budget of Paradoxes.* London: Longmans, Green; reprinted Freeport, NY: Books for Libraries Press, 1969.

Dumitriu, Anton. 1969. The Solution of Logico-Mathematical Paradoxes. *International Philosophical Quarterly,* vol. 9, pp. 63–100.

———. 1974. The Logico-Mathematical Antinomies: Contemporary and Scholistic Solutions. *International Philosophical Quarterly,* vol. 14, pp. 309–328.

Escher, Maurits Cornelis. 1967. *Graphic Work.* Revised ed. London: Dutton.

Ferber, Rafael. 1981. *Zenons Paradoxien der Bewegung und die Struktur von Raum und Zeit.* München: C.H. Beck.

Finsler, Paul. 1944. Gibt es unentscheidbar Sätze? *Commentarii Mathematici Helvetici,* vol. 16, pp. 310–320.

———. 1926. Gibt es Widersprüche in der Mathematik? *Deutsher Mathver.,* vol. 34, pp. 143–155; reprinted G. Unger, ed., *Aufsätze sur Mengenlehre.* Darmstadt: Wissenschaftliche Buchgemeinschaft, 1975.

———. 1927. Über die Lösung von Paradoxien. *Philosophischer Anzeiger,* vol. 2, pp. 183–192.

Fitch, F.B. 1946. Self-reference in Philosophy. *Mind,* vol. 55, pp. 64–73.

Franck, Sebastian. 1909. *Paradoxa.* Jena: H. Ziegler. English trans. E.J. Furcha: *Paradoxa: Two Hundred Eighty Paradoxes or Wondrous Sayings.* Lewiston, NY: Edward Mellon Press, 1986.

Frontera, G. 1891. *Etude sur les arguments de Zénon d'Elée contre le mouvement.* Paris: Hachette.

Gaifman, H. 1983. Infinity and Self-Applications: I. *Erkenntnis,* vol. 20, pp. 131–155.

Gale, Richard. 1993. *The Nature and Existence of God.* Cambridge: Cambridge University Press.

Garciadiego, A.R. 1992. *Bertrand Russell and the Origins of the Set-Theoretic 'Paradoxes'.* Basel: Birkhäuser.

Gardner, Martin. 1982. *Aha! Gotcha: Paradoxes to Puzzle and Delight* New York: W.H. Freeman.

———. 1971. Infinite Regress. In *Sixth Book of Mathematical Games from Scientific American.* San Francisco: W.H. Freeman.

———. 1968. The Paradox of the Unexpected Hanging. In *The Unexpected Hanging and Other Mathematical Diversions.* New York: Simon and Schuster.

Geyer, P., and R. Hagenbüchle, eds. 1992. *Das Paradox: Eine Herausforderung des abendländischen Denkens.* Tübingen: Stauffenburg, pp. 159–189.

Good, I.J. 1966. A Note on Richard's Paradox. *Mind,* vol. 75, p. 431.

Goodman, Nelson. 1955. *Fact, Fiction, and Forecast.* Cambridge, MA: Harvard University Press; 2nd ed. Indianapolis: Bobbs-Merrill, 1965; 3rd ed. 1973.

Grabmann, Martin. 1940. *Die Sophismataliteratur des 12. und 13. Jahrhunderts, mit Textausgabe eines Sophisma des Boetius von Dacien.* Münster: Aschendorff.

Grelling, Kurt. 1936. The Logical Paradoxes. *Mind,* vol. 45, pp. 481–86.

———. 1937. Der Einfluss der Antinomien auf die Entwicklung der Logik im 20 Jahrhunders, *Travaux du Ixième congrès international de philosophie, fasc,* vol. VI, pp. 8–17.

Grelling, Kurt, and Leonhard Nelson. 1907–1908. Bemerkungen zu den Paradoxien von Russell und Burali-Forti. *Abhandlungen der Fries'schen Schule n.s.,* Vol. 2, pp. 301–334.

Halldén, Soren. 1949. *The Logic of Nonsense.* Uppsala: Lundequistska Bokhandeln.

Hamblin, C.L. 1986. *Fallacies.* Revised ed. Newport News: Vale Press.

van Heijenoort, Jean, ed. 1967. *From Frege to Gödel: A Source Book in Mathematical Logic, 1879-1931.* Cambridge, MA: Harvard University Press.

———. 1967. Logical Paradoxes. In *The Encyclopedia of Philosophy.* Paul Edwards ed. New York: Macmillan.

Heiss, Robert. 1928. Der Mechanisumus der Paradoxien und das Gesetz der Paradoxienbildung. *Philosophischer Anzeiger,* vol. 3, pp. 403–432.

Helmer, Olaf. 1934. Remarques sur le problème des antinomies. *Philosophisches Jahrbuch der Görresgesellschaft,* vol. 47, pp. 421–24.

Helmont, J. B. van. 1650. *A Ternary of Paradoxes.* Ed. and translated by Walter Charleton. London: James Flesher.

Heytesbury, William. 1979. *On Insoluble Sentences: Chapter One of His Rules for Solving Sophisms.* Translated with an introduction and a study by P.V. Spade. Toronto: Pontifical Institute of Mediaeval Studies. Mediaeval Sources in Translation, No. 21.

Hinske, Norbert. 1965. Kant's Begriff der Antinomie und die Etappen seiner Ausarbeitung, *Kant-Studien,* vol. 56, pp. 485–496.

Hintikka, Jaakko. 1957. Vicious Circle Principle and the Paradoxes. *Journal of Symbolic Logic,* vol. 22, pp. 245–49.

Hofstadter, Douglas R. 1980. *Gödel, Escher, Bach: An Eternal Golden Braid.* New York: Random House.

———. 1986. *Metamagical Themes* New York: Basic Books.

Hofstadter, Douglas R., and Daniel C. Dennett. 1981. *The Mind's I: Fantasies and Reflections on the Self and Soul.* New York: Basic Books.

Hughes, George Edward. 1982. *John Buridan on Self-Reference: Chapter Eight of Buridan's Sophismata.* Cambridge: Cambridge University Press.

Hughes, Patrick, and George Brecht. 1975. *Vicious Circles and Infinity: A Panoply of Paradoxes.* Garden City, NY: Doubleday.

Hyde, M. J. 1979. Paradox: The Evolution of a Figure of Rhetoric. In. R.L. Brown Jr. and M. Steinman Jr., eds., *Rhetoric 78: Proceeding of Theory of Rhetoric: An Interdisciplinary Conference.* Minneapolis: University of Minnesota Center for Advanced Studies in Language, Style, and Literary Theory, pp. 201–225.

Intisar-Ul-Haque. 1969. *Critical Study of Logical Paradoxes*. Pakistan: Peshawar University Press.

Jourdain, P.E.B. 1913. Tales with Philosophical Morals. In *The Open Court*, vol. 27, pp. 310–315.

Kainz, Howard P. 1988. *Paradox, Dialectic, and System: A Contemporary Reconstruction of the Hegelian Problematic*. University Park: Pennsylvania State University Press.

Kneale, William, and Martha Kneale. 1962. *The Development of Logic*. Oxford: Clarendon.

Koons, Robert C. 1992. *Paradoxes of Belief and Strategic Rationality*. Cambridge: Cambridge University Press.

Koyré, Alexandre. 1946. *Épiménide le menteur*. Paris: Ensemble et catégorie, Actualités scientifiques et industrielles.

Kretzmann, Norman, and B.E. Kretzmann, eds. 1990. *The Sophismata of Richard Kilvington*. Cambridge: Cambridge University Press.

Kretzmann, Norman, and Eleanore Stump. 1988. *The Cambridge Translations of Medieval Philosophical Texts*, Vol. I. Contains an English translation of Albert of Saxony's *Insolubilia*. Cambridge: Cambridge University Press.

Kretzmann, Norman, Anthony John Patrick Kenny, and Jan Pinborg, eds. 1982. *The Cambridge History of Later Medieval Philosophy: From the Rediscovery of Aristotle to the Disintegration of Scholasticism, 1100–1600*. Cambridge: Cambridge University Press.

Kutschera, Franz von. 1964. *Die Antinomien der Logik*. Freiburg: K. Alber.

Lando, Ortensio. 1593. *The Defense of Contraries*. Translated by Anthony Munday. London: by John Windet for Simon Waterson.

Langford, C.H. and M. Langford. 1959. The Logical Paradoxes. *Philosophy and Phenomenological Research*, vol. 21, pp. 110–13.

Lubac, Henri de. 1946. *Paradoxes*. Paris: Éditions du Livre français.

———. 1958. *Further Paradoxes*. London: Longmans Green.

Mackie, J.L. 1973. *Truth, Probability and Paradox: Studies in Philosophical Logic*. Oxford: Clarendon.

Makinson, D.C. 1965. The Paradox of the Preface. *Analysis*, vol. 25, pp. 205–07.

Margalit, Avishai, and Maya Bar-Hilled. 1983. Expecting the Unexpected. *Philosophia*, vol. 13, pp. 263–288.

Martin, Robert L. 1968. On Grelling's Paradox. *The Philosophical Review*, vol. 77, pp. 321–331.

———, ed. 1970. *The Paradox of the Liar*. New Haven: Yale University Press; 2nd ed., Resada, Ca: Ridgeview, 1978. [An anthology of some dozen papers plus a very extensive bibliography.]

———. 1967. Toward a Solution to the Liar Paradox. *Philosophical Review*, vol. 76, pp. 279–311.

———, ed. 1984. *Recent Essays on Truth and the Liar Paradox*. New York: Oxford University Press.

McGee, Vann. 1991. *Truth, Vagueness, and Paradox: An Essay on the Logic of Truth* Indianapolis: Hackett.

Melhuish, George. 1973. *The Paradoxical Nature of Reality*. Bristol: St. Vincent's Press.

Mirimanoff, D. 1917. Les antinomies de Russell et de Burali-Forti et le problème fondamental de la théorie des ensembles. *L'Enseignement Math.*, vol. 19, pp. 37–52.

Nicholas of Cusa (Nicolas Cusanus). 1954. *Of Learned Ignorance*. Translated by Fr. Germaine Heron. New Haven: Yale University Press, and London: Routledge. Reprinted Westport, CT: Hyperion, 1991.

Nordau, Max. 1886. *Paradoxes*. Chicago: Laurd and Lee.

Northrop, Eugene Purdy. 1958 [1944]. *Riddles in Mathematics*. London: English Universities Press. Reprinted New York: Van Nostrand, 1966.

Nozick, Robert. 1974. Reflections on Newcomb's Problem. *Scientific American* (March), pp. 228–241.

O'Carrol, M. J. 1967. Improper Self-Reference in Classical Logic and the Prediction Paradox. *Logique et analyse*, vol. 10, pp. 167–172.

O'Connor, D.J. 1948. Pragmatic Paradoxes. *Mind*, vol. 57, pp. 316–329.

Pap, Arthur. 1954. The Linguistic Hierarchy and the Vicious-Circle Principle. *Philosophical Studies*, vol. 5, pp. 49–53.

Perelman, C.H. 1936. Les Paradoxes de la Logique. *Mind*, vol. 45, pp. 204–08.

Perreiah, Alan. 1978. *Insolubilia* in Paul of Venice's *Logica Parva*. *Medioevo*, vol. 4, pp. 145–171.

Prior, A.N. 1958. Epimenides the Cretan. *Journal of Symbolic Logic*, vol. 23, pp. 261–66.

———. 1961. On a Family of Paradoxes. *Notre Dame Journal of Formal Logic*, vol. 2, pp. 16–32.

Probst, P., H. Schröer, and F. von Kutschera. 1989. Das Paradoxe, Paradoxie. In *Historisches Workerbuch der Philosophie*, Vol. VII, pp. 81–97.

Quine, W.V.O. 1962. Paradox. *Scientific American*, vol. 206 (April), pp. 84–96.

———. 1966. *The Ways of Paradox and Other Essays*. New York: Random House.

Ramsey, F.P. 1925. The Foundations of Mathematics. *Proceedings of the London Mathematical Society*, series 2, vol. 25, part 5 (read 12 November), pp. 338-384. Reprinted in D.H. Millar, ed., *F.P. Ramsey: Philosophical Papers* (Cambridge: Cambridge University Press, 1990).

Rapaport, Anatol, and Albert M. Chammah. 1965. *The Prisoner's Dilemma*. Ann Arbor: University of Michigan Press.

Read, Stephan. 1993. Sophisms in Medieval Logic and Grammar. *Acts of the Ninth European Symposium for Medieval Logic and Semantics, St. Andrews, June 1990*. Dordrecht: Kluwer.

Rescher, Nicholas. 1961. Belief-Contravening Suppositions. *Philosophical Review*, vol. 70, pp. 176–195.

———. 1964. *Hypothetical Reasoning*. Amsterdam: North Holland.

Rescher, Nicholas, and Robert Brandom. 1980. *The Logic of Inconsistency*. Oxford: Oxford University Press.

Richards, T.J. 1967. Self-Referential Paradoxes. *Mind*, vol. 76, pp. 387–403.

Rijk, Lambertus Marie de. 1962–67. *Logica modernorum: A Contribution to the History of Early Terminist Logic*. 2 vols. Assen: Van Gorcum.

Riverso, Emanuele. 1960. Il Pardosso del Mentitore. *Rassengna di Scienze Filosofiche*, vol. 13, pp. 296–325.

Rivetti, Barbò. 1959. L'origine dei paradossi ed il regresso all'infinito. *Rivista di filosophia neo-scolastica*, vol. 51, pp. 27–60.

———. 1961. *L'antinomia del mentitote nel pensiero contemporaneo, da Peirce a Tarski, Studi-testi-bibliografia*. Milano: Società Editrice Vita e Pensiero.

Rozeboom, W.W. 1957–58. Is Epimenides Still Lying? *Analysis*, vol. 18, pp. 105–113.

Rudavsky, Tamar, ed. 1985. *Divine Omniscience and Omnipotence in Medieval Philosophy*. Dordrecht: Reidel.

Russell, Bertrand. 1903. *The Principles of Mathematics*. Cambridge: Cambridge University Press. Revised ed., London: XYZ, 1937 and New York: Norton, 1938.

———. 1906. Les paradoxes de la logique. *Rev. Met mor.*, vol. 14, pp. 627–650. English: On *Insolubilia* and the Solution by Symbolic Logic. In Russell, *Essays in Analysis*. D. Lackey, ed., London: Allen and Unwin, 1973, pp. 190–214.

———. 1908. Mathematical Logic as Based on the Theory of Types. *American Journal of Mathematics*, vol. 30, pp. 222–672. Reprinted in Heijenoort 1967.

———. 1918. *Introduction to Mathematical Philosophy*. London: Macmillan.

Russell, Bertrand, and A.N. Whitehead. 1910–13. *Principia Mathematica*. 3 vols. Cambridge: Cambridge University Press, 1910, 1912, 1913.

Rüstow, Alexander. 1910. *Der Lügner: Theorie, Geschichte, und Auflösung*. Leipzig: B.G. Teubner.

Ryle, Gilbert. 1961. *Dilemmas*. Cambridge: Cambridge University Press.

Sainsbury, Richard Mark. 1988. *Paradoxes* Cambridge: Cambridge University Press.

Salmon, Wesley C. 1970. *Zen's Paradoxes*. Indianapolis: Bobbes-Merrill.

Saperstein, Milton R. 1966. *Paradoxes of Everyday Life*. New Haven, CT: Fawcett.

Schilder, Klaas. 1933. *Zur Begriffsgeschichte des Paradoxons: mist besonderer Berücksichtung Calvins und des nach-kierkegaardschen Paradoxon*. Kampen: J.H. Kok.

Schröer, Henning. 1960. *Die Denkform der Paradoxalität als theologisches Problem*. Göttingen: Vandenhoeck and Ruprecht.

Scriven, Michael. 1951. Paradoxical Announcements. *Mind*, vol. 60, pp. 403–07.

Skyrms, Brian. 1970. Return of the Liar: Three-Valued Logic and the Concept of Truth. *American Philosophical Quarterly*, vol. 7, pp. 153–161.

Slaatte, Howard A. 1968. *The Pertinence of the Paradox: The Dialectics of Reason-in-Existence*. New York: Humanities.

Smullyan, Raymond M. 1978. *This Book Needs No Title*. Englewood Cliffs: Prentice-Hall.

———. 1978. *What Is the Name of This Book?* Englewood Cliffs: Prentice-Hall.

Stalker, Douglas, ed. 1999. *Grue!: The New Riddle of Induction*. Chicago: Open Court.

Stenius, Eric. 1949. Das Problem der Logischen Antinomien. *Societas Scientarium Fennica, Commentationes Physico-Mathematicae*, vol. 14.

Strawson, P.F. 1967. Paradoxes, Posits, and Preposition. *Philosophical Review*, vol. 76, pp. 214–229.

Stroll, Avrum. 1954. Is Everyday Language Inconsistent? *Mind*, vol. 63, pp. 219–225.

Tarski, Alfred. 1956. *Logic, Semantics, Metamathematics*. Translated by J.H. Woodger. Oxford: Oxford University Press.

Thines, Georges. 1974. *L'aporie*. Brussels: Leclerc.

Thompson, M.H., Jr. 1949. The Logical Paradoxes and Peirce's Semiotic. *Journal of Philosophy*, vol. 46, pp. 513–536.

Toms, E. 1952. The Reflexive Paradoxes. *Philosophical Review*, vol. 61, pp. 557–567.

Urbach, B. 1910. Über das Wesen der logischen Paradoxa. *Zeitschrift für Philosophie und Philosophische Kritik*, vol. 140, pp. 81–108.

————. 1927–28. Das Logische Paradoxon. *Annalen der Philosophie und philosophische Kritik*, vol. 6, pp. 161–176 and 265–273.

Urquhart, W.S. 1942. Paradox in Religious Thought. *The Contemporary Review*, vol. 161 (April).

Vailati, G. 1904. Sur une classe remarquable de raisonnements par réduction à l'absurde. *Revue de Métaphysique*, vol. 12, pp. 799–809.

van Fraassen, B.C. 1968. Presupposition, Implication, and Self-Reference. *Journal of Philosophy*, vol. 65, pp. 136–152.

Venning, Ralph. 1657. *Orthodox Paradoxes: Theoreticall and Experimentall*. London: J. Rothwell.

Visser, Albert. 1989. Semantics and the Liar Paradox. *Handbook of Philosophical Logic*, vol. IV. Dordrecht: Reidel, pp. 617–706. [Has an extensive bibliography.]

von Wright, G.H., 1974. The Heterological Paradox. *Societas Scientarium Fennica, Commentationes physico-mathematicae*, vol. 24.

Vredenduin, P.G.J. 1937–38. De Paradoxen. *Algemeen Nederlands tijdschrift voor wijsbegeerte en psychologie*, vol. 31, pp. 191–200.

Walton, Douglas N. 1991. *Begging the Question*. Westpoint CT: Greenwood.

Weidemann, Hermann. 1980. Ansätze zu einer Logik des Wissens bei Walter Burleigh. *Archiv für Geschichte der Philosophie*, vol. 61, pp. 32–45.

Weiss, Paul. 1952. The Prediction Paradox. *Mind*, vol. 61 (April), pp. 265–69.

Wolgast, E.H. 1977. *Paradoxes of Knowledge*. Ithaca: Cornell University Press.

Wormell, C.P. 1958. On the Paradoxes of Self-Reference. *Mind*, vol. 67, pp. 267–271.

Wyclif, John. 1986. *Johannis Wyclif Summa Insolubilium*. P.V. Spade and G.A. Wilson, eds. Binghamton: Medieval and Renaissance Texts and Studies, vol. 41.

Index